祖地寻情
Footprints
on the
Ancestral Land

蔡 登 辉
Tsai Deng-Huei's
福建
FUJIAN
纪 实 摄 影 集
Documentary Photography

堂 慶 衍

海风出版社
HAIFENG PUBLISHING HOUSE

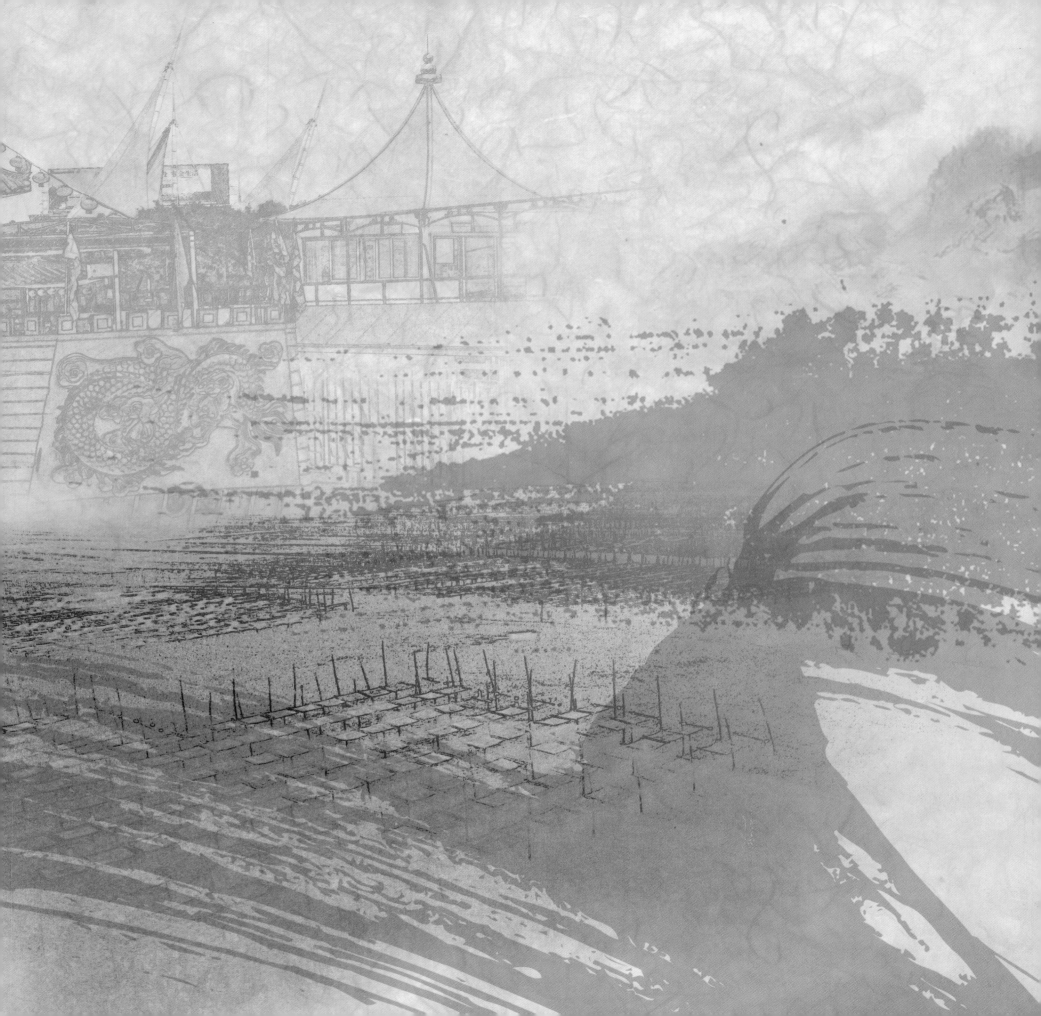

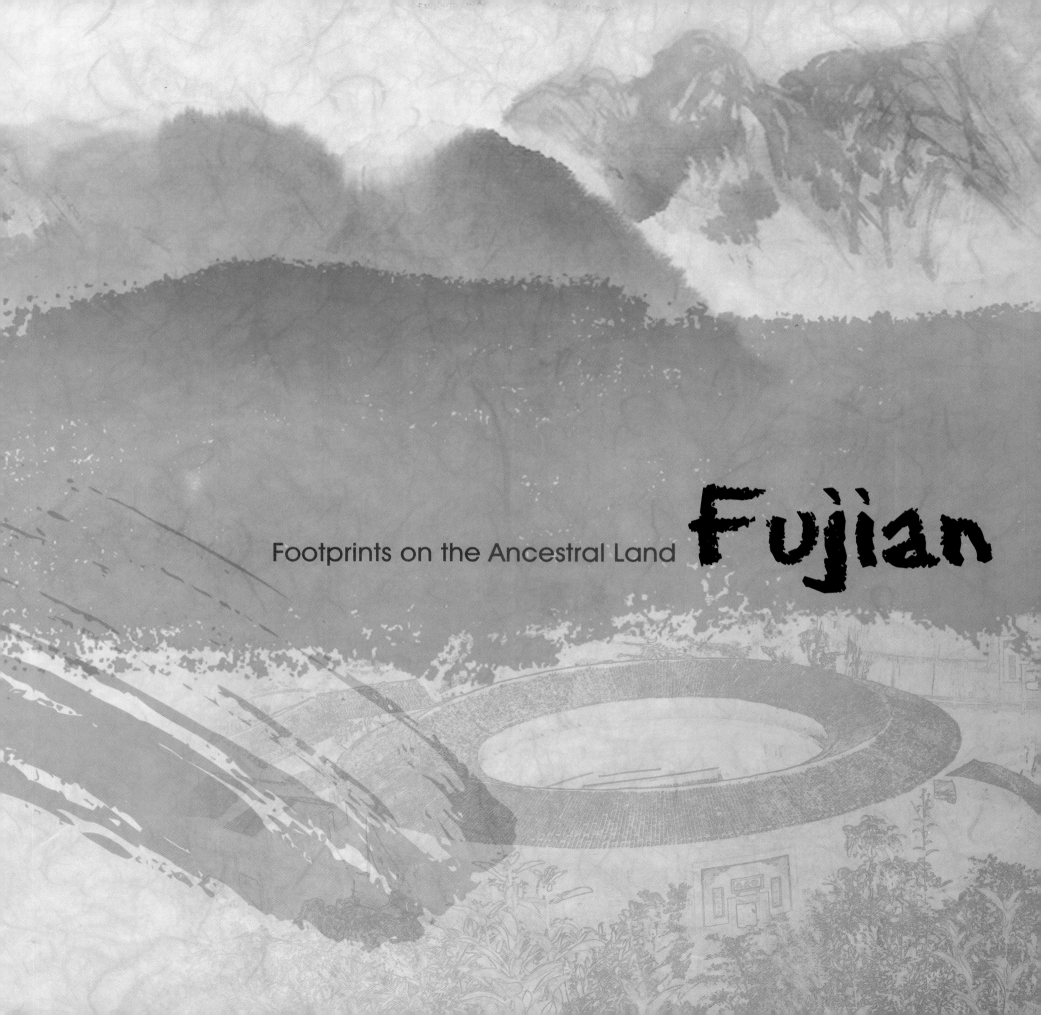

Footprints on the Ancestral Land **Fujian**

中国摄影家协会 副主席
福建省摄影家协会 主 席 序

海峡彼岸的蔡登辉先生给我来电话，说他要出版个人摄影画册，希望我为其作序。我与蔡登辉先生是多年的老朋友了，便欣然应允。

记得 2002 年仲秋时节，海风出版社社长焦红辉先生向我推荐一位台湾摄影界的中坚人物，希望我去见见他——这是我第一次见到蔡登辉先生。他那强健有力的体魄和谈笑风生、幽默感十足的谈话风格给我留下了深刻的印象。临别时我们说好，以后常联系，隔了没多久，他就带着几位台湾摄影家来我家做客。

那次会面很开心，我当即在画室里"挥毫泼墨"。我对蔡先生一行说，我是大陆第一位访问台湾的摄影家，当时 102 岁的摄坛泰斗郎静山先生和台湾中华摄影学会的全体理事在台北热情地接待了我。郎老以为我也是一位老先生，就提前写好了一幅书法作品"影坛硕彦"赠送给我。于是我也当场写下一幅"摄坛硕彦"交给蔡先生，希望两岸摄影界今后交往更加频繁密切。此后，我曾两度随团赴台湾进行文化交流，都受到蔡登辉夫妇及其全家热情的家宴款待，我还注意到那幅我写的 "摄坛硕彦"就悬挂在蔡家的客厅里，那是两岸摄影家友谊的象征。

蔡登辉先生祖籍福建，他对故乡情有独钟。为了完成《祖地寄情》这本纪实摄影集，他多次到祖籍地进行摄影创作，拳拳之心，跃然纸上。在这特别值得提到的是，蔡先生的摄影集即将出版之时，正是蔡登辉先生与大陆摄影界开启交流与合作 12 周年。在岁月的长河里，12 年也许微不足道，可是对于两岸摄影文化交流来说，这 12 年，却是跨越时空，连接友谊的重要岁月。

据我所知，2002 年初海风出版社启动了"两岸摄影家 · 两岸行"系列交流活动，至今已连续举办了 12 年。12 年来，在海风出版社、福建省摄影家协会和台北摄影学会的共同推动下，两岸摄影家借助镜头先后多次在台湾、福建、四川凉山、安徽黄山、湖北、山东和贵州等地采风，8 次在台北、台南，5 次在福州、山西和上海等地举办两岸摄影家作品联展。共同拍摄、共同办展、共同出书是"两岸摄影家·两岸行"活动最大的亮点。"三个共同"在 12 年间虽然普通但并不平凡，看似简单，实则很不容易。

12 年中，从台湾东海岸渔家凌晨闪烁的灯火到福建的客家文化、武夷美景，从"古徽州·新黄山"那秀丽的自然风光和人文景观到凉山那熊熊燃烧的火把节民俗，从"跨越三个世纪"的福州影像再到 2010 年世人瞩目的上海世博会…… 摄影家们踏遍了两岸的名山大川，跨过从传统民俗到现代大都市发展的文化足迹，展现了一个全景式的文化中华。"两岸摄影家·两岸行"的摄影家们来自海峡两岸的不同地域，但都有一个共同的理念——记录真实，传播我中华文化，建立两岸摄影人的友情。12 年来，在福建省摄影家协会副主席焦红辉和台北摄影学会前理事长、台湾两岸和平文化艺术联盟副主委蔡登辉的牵头下，内容不断丰富，交流不断深化，人们的感情日益加深，被两岸同行津津乐道的"两辉相映"一词，即是对他们致力于两岸文化交流努力的最大肯定和褒奖。

12 年，摄影家的镜头与光影伴随着两岸摄影家遍布神州大地，凝结成一幅幅精彩而动人的影像。他们共同将历次采风内容集结出版，由海风出版社先后推出的《凉山火把节》、《古徽州·新黄山》、《闽西北风情》、《两岸城市巡礼》、《光影世博》、《荆楚文化行》、《台北花博》、《齐鲁映像》、《跨越三个世纪的影像》等九种系列画册，都是两岸摄影家用光影共同书写下的中华传统文化与壮丽山河的崭新篇章。

12 年光影，两岸摄影家用镜头记录了时间，飞越了空间，凝聚了友谊，共享了果实。这一切，是两岸摄影人共同留下的珍贵记忆，更是开创两岸摄影文化交流的历史见证。相信在以后的岁月里，两岸摄影界一定会有进一步的交流、了解和融合。这种交流会携着同胞的深情跨越海峡的阻隔，与时代同行。

我们完全有信心期待这种"十二年如一日"的交流与合作会发扬光大，并随着时间的推移，结出更加丰硕的果实。
是为序。

张宇

Foreword

Mr. Tsai Denghuei telephoned me from Taiwan, and said he would publish his personal photography collection and hoped I could write a preface to it. Since we have been friends for years, I delightfully assented.

In the mid autumn of 2002, Mr. Jiao Honghui, president of the Haifeng Publishing House, recommended a core figure in Taiwan photography community to me. It is the first time I met Mr. Tsai Denghuei. His strong body and humorous conversation style gave me a deep impression. When parting, we promised to keep in contact with each other in the future. But to my surprise, shortly afterwards, he came to visit me with several Taiwan photographers.

It was a pleasant meet. In my studio, I immediately "took up the writing brush and dipped it in black ink", writing down my feelings. I told Mr. Tsai and his friends that I am the first mainland photographer visiting Taiwan. During that trip, then 102-year-old Mr. Lang Jingshan, the leading authority in photography, and all the directors of the Photographic Society of Taiwan warmly received me. As Mr. Lang thought I must be an aged man, he wrote a piece of calligraphy reading "Ying Tan Shuo Yan" (great talent in photography) in advance as a present to me. So I also wrote a calligraphic work reading "She Tan Shuo Yan" (also "great talent in photography") as a present to Mr. Tsai, hoping photographers across the straits would exchange more frequently. Afterwards, I have been to Taiwan twice with a delegation for cultural exchanges. Each time, Mr. and Mrs. Tsai and their family members treated me cordially at home. And I also noticed the calligraphy I wrote, which symbolizes the friendship between photographers across the straits, was hung in his sitting room.

Fujian is the ancestral home of Mr. Tsai, to which he has showed special love. In order to complete the documentary photography collection of Footprints on the Ancestral Land, he went back to his progenitor land many times to take photographs. His sincere heart is vividly shown in his works. It is worth mentioning that when Mr. Tsai's photography collection is published, it will be the 12th anniversary of his exchanges and cooperation's with Mainland photographers. In the long history of years, twelve-year may be unworthy of mentioning. But to the photographic cultural exchanges across the straits, the twelve-year is the important days for linking friendship cross time and space.

As far as I know, in the early 2002, the Haifeng Publishing House launched a series of exchange activities with the theme "Photographers between Taiwan and Mainland". Up to now, the activities have been held for consecutive 12 years. With the joint promotion of the Haifeng Publishing House, Fujian Photographers Association and the Photographic Society of Taipei, photographers from both sides of the straits explored the folk life with their lens in such places as Taiwan, Fujian, Liangshan District of Sichuan Province, Huangshan Mountain of Anhui province, Hubei, Shangdong and Guizhou. The cross-strait collaborative photography exhibitions were held eight times in Tainan and Taipei, and five times in Fuzhou, Shanxi and Shanghai, etc. Those activities are highlighted by the photographers' collaboration in photo-taking, exhibition-holding and book-publishing. "Joint efforts in the above three aspects" are ordinary but not mediocre, and seems simple but aren't easy.

Over the past twelve years, from the fishermen's twinkling lights at dawn on the east cost of Taiwan to the Hakka culture and the Wuyi Mountain's picturesque scenery of Fujian; from the natural beauty and the cultural landscape of "Ancient Huizhou and New Huangshan Mountain" to the blazing folk customs of the Torch Festival in Liangshan; from the "Spanning-three-century Fuzhou" photography exhibition to the Shanghai Expo in 2010 that captured worldwide attention···the photographers have been to famous mountains and rivers across the straits, leaving cultural footprints from folk customs to the development of the modern metropolis, and showing the panorama of Chinese culture. Those photographers who took part in the activities come from different places across the straits, but they have a common vision, that is "recording the reality", spreading Chinese culture and linking the friendship among photographers across the straits. For twelve years, led by Jiao Honghui, cochairman of Fujian Photographers Association, and Tsai Denghuei, ex-director of the Photographic Society of Taipei and Chairman of Cross-Strait Peace Culture and Art Union of Taiwan, the contents keep enriching, the exchanges keep enhancing, and the relations between people across the straits also keep deepening. The photographers from both sides take delight in talking about "Liang Hui Xiang Ying" (Tsai Denghui and Jiao Honghui). This shows people's affirmation and praise for their devotion to the cross-strait cultural exchanges.

Over the past twelve years, the photographers from both sides of the straits have left their footprints around China. What they have captured with their lens has formed many fantastic and touching images. They jointly turned their experiences into series of photography collections. The Haifeng Publishing House has successively published nine photograph albums, including "The Torch Festival in Liangshan", "Ancient Huizhou and New Huangshan Mountain", and "Northwest Fujian Flavor", etc. Those albums are the new chapters of Chinese culture and landscapes jointly written by photographers across the Taiwan Strait.

Over the past twelve years, with their cameras, photographers across the straits have recorded the passing days, traversed the space, enhanced friendship and shared achievements. All these are treasured memories left by photographers across the straits. They are also the historical evidence of the cross-strait photography cultural exchanges. I believe in the years ahead, the exchanges, understanding and integration between photographers across the straits will be furthered. With our compatriots' affections, such exchanges will transcend the cross-strait barriers and advance with the times.

We expect with full confidence that such "12-year-as-one-day" exchanges and cooperation will develop to a higher stage and bear more rich fruits.

Zhang Yu

作者前言

　　"乾隆元年（1736年），台湾四湖乡出现了蔡厝聚落，是由福建泉州蔡姓人士前来垦殖……乾隆五十年（1785年），继蔡厝之后，又有溪底、风沙、溪尾等聚落，其开发者仍为福建泉州人……"短短的《蔡氏族谱》描绘着先人的足迹，刻画着血缘的印记。尽管年代久远，血缘不能改变；纵非生长之地，印记无法抹灭！

　　自幼即常听闻祖先来自大陆福建，讲的是闽南话、吃的是闽南菜、婚丧喜庆、风土民情也都充满着浓浓的闽南味。随着岁月增长，对祖地的憧憬日益加深，总想找个机会来趟寻根之旅。

　　2002年元月，福建省海风出版社首开先河，来台举办《故乡人·故乡情》福建风情摄影展。笔者时任台北市摄影学会理事长，有幸躬逢其盛，应邀出席。近百幅作品中，多彩的民俗风情和深厚的文化底蕴，在在让笔者心生感动、神驰不已！

　　2002年2月，海风出版社社长、福建省摄影家协会副主席焦红辉先生来函邀访。惊喜之余，旋即偕同四位核心干部（按：时任副理事长梅志建先生提前荣退外，郭炳东、连世仁、吕钦宏三位同伴均已先后接任理事长）赴闽采风，终有机会踏上祖先的遗迹，一睹祖地的风采；难能可贵的是，"两岸摄影家·两岸行"系列活动的序幕于焉展开。十余年来，已先后在海峡两岸进行了十余次的"三个共同"——共同拍摄、共同办展、共同出书，诚为两岸艺文交流奠定了坚实的平台，缔造了辉煌的史页。

　　2003年11月，再度幸蒙海风之邀，担任"中华传统节日全国摄影大奖赛"评审委员，同时在焦社长亲自带领下，搭乘了六个多小时的火车直奔闽北，甚且半夜翻墙，捕捉到难得一见的丹山霞海、日升云涌。那幅《武夷胜景》迄今依然高挂中堂，屡令造访宾客为之赞叹！尤其令人振奋的是，《祖地寄情——福建纪实摄影集》的构想，也在回程的火车上获得社长共鸣，慨允全力支持。往后十年，十余趟闽东南西北的旅程中，每每受到海风出版社精心规划、细心安排和贴心照料；尤在2012年辗转获得族谱后，更是专程陪同深入泉州，找到了与生长环境极度神似、已被当地政府列为全国重点文物保护单位的祖先发源地——"蔡氏古民居"，终能聊慰数十年的"寻根之梦"！

　　值此画册付梓之际，谨向"媒人公兼催生婆"——焦红辉社长及全程参与的优质团队——胡国贤副社长、梁希毅主任、张力编辑等良师益友致上十二万分的敬意与谢忱！此外，中国摄影家协会副主席、福建省摄影家协会主席张宇先生亲笔为序；著名书法家、福建省书法家协会主席陈奋武先生，两岸和平文化艺术联盟秘书长、台北市山痴画会理事长李沃源先生墨宝题字，尤为画册增添无限光彩；值得一提的是，《祖地寄情》系小犬铠骏继2002年的《台湾民俗采风——雅美船祭》后，再度运用他的设计专长，为我的画册注入了些许创新元素，尤请大家惠予鞭策、指导和鼓励！

　　最后，祈愿这本"两岸双辉"携手合作的纪实摄影，能为福建片段历史与蓬勃发展留作见证、化为永恒；同时，谨以此书献给86高龄的妈妈、多次"陪寻伴旅"的摄友与兄嫂，同属闽籍的蔡氏宗亲，结缡近四十载，一直陪着"好摄之徒"上山下海、迎月追日的"闲内助"，以及所有翻阅此书的无数读者，敬请不吝批评、指教！

蔡芷隆
12/31
2013

"The first year of reign of Emperor Qianlong (1736 A.D.), the ancestors of Tsai family immigrated from Quanzhou, Fujian province to Sihhu Township, Taiwan, and established the Tsai habitations... In the 50th year of reign of Emperor Qianlong (1785 A.D.), these ancestors also established the Xidi, Fengsha, Xiwei habitations and etc." "The Tsai Family's genealogy" recorded the ancestors' footsteps and marked our lineage. Although it was long time ago, the ties of blood will not be changed. Although Fujian province was not the place where I grew up, the lineage cannot be dismissed.

Since I was a kid, I often heard that my ancestors were from mainland Fujian. I speak Minnan (the southern part of Fujian) dialect and eat Minnan food. The wedding, funeral, rituals, and cultures are all Minnan style. As time goes by, I have been longing to have a root-seeking trip in mainland Fujian.

In January 2002, the Sea Breeze Press from Fujian came to Taiwan to organize a photography exhibition called "Hometown Nostalgia" for the first time. I was the president of Photographic Society of Taipei at that time and was honored to be invited to the event. I was touched and enthralled by the hundreds of photos that feature the local people, lifestyle and culture in Fujian.

In February 2002, Mr. Jiao Hong-Hui --- the president of the Haifeng Publishing House and the vice president of Fujian Photographers Association, invited me to visit Fujian. I was surprised and excited. Four core members (the former vice president, Mr. Mei Zhi-Jian and the former presidents, Mr. Guo Bing-Dong, Mr. Lian Shi-Ren and Mr. Lu Gin-Hong) and I went to Fujian immediately. I finally had the chance to see the beauty of homeland Fujian. More importantly, the series activities of "Photographers between Taiwan and Mainland" got started at the same time. Since then, the activities have been hold together by the photographers in both Taiwan and mainland China over ten times in the past decade. The series activities are firm platforms for the art and cultural exchange between Taiwan and mainland China and have made history.

In December 2003, I was honored to be invited by the Haifeng Publishing House again to be one of the judges of "the Chinese Traditional Festivals: National Photography Award." President Jiao Hong-Hui and I took the train for six hours to Mingbai (the northern part of Fujian). We even climbed a wall at midnight just to catch the great moment of sunrise and morning glow. The spectacular sunrise photo I took now is still hanging on the wall in my house and earning compliments from lots of guests. I was especially excited that President Jiao also supported my idea of this book, "Footprints on the Ancestral Land / A Journey to the Roots — Fujian Documentary Photography." During the past decade, every time I went to Fujian, the Haifeng Publishing House always took good care of me. When I finally got my genealogy in 2012, they even brought me deep into Quanzhou, a city in Fujian, to find my ancestors' homeland --- the ancient Tsai habitation, which is very similar to the place where I grew up. My dream of seeking the root finally came true.

Now while this book is going to publish, I gratefully acknowledge the support from the president Jiao Hong-Hui, the vice president Hu Guo-Xian, the director Liang Xi-Yi, and the editor Zhang Li. I would like to especially thank Mr. Zhang Yu --- the vice president of China Photographers Association and the president of Fujian Photographers Association, for writing the preface of this book. I also would like to thank Mr. Chen Fen-Wu --- the great artist and the president of Fujian Calligrapher's Association, Mr. Lee Wou-Yuan --- the Secretary-general of Peaceful Cross-strait Cultural and Artistic Union and the president of painting Society of Taipei Shan-chih , for his gorgeous calligraphy for the book. Moreover, my son Kai-Jun used his design specialty to add innovative elements to this book. Since the "Folk Culture in Taiwan: Yami Canoe festival" in 2002, this is the second time my son and I cooperated together. Please feel free to give him any comments or suggestions.

To sum up, I truly wish this documentary photography that cooperated between Taiwan and mainland China could record the vigorous development of Fujian and to be a witness to history. This book is dedicated to my 86-year-old mother, my travel companions --- my brother, sister-in-law, and my photographer friends, the Tsai relatives, my wife who is always be there for me around 40.

Tsai , Deng-Huei

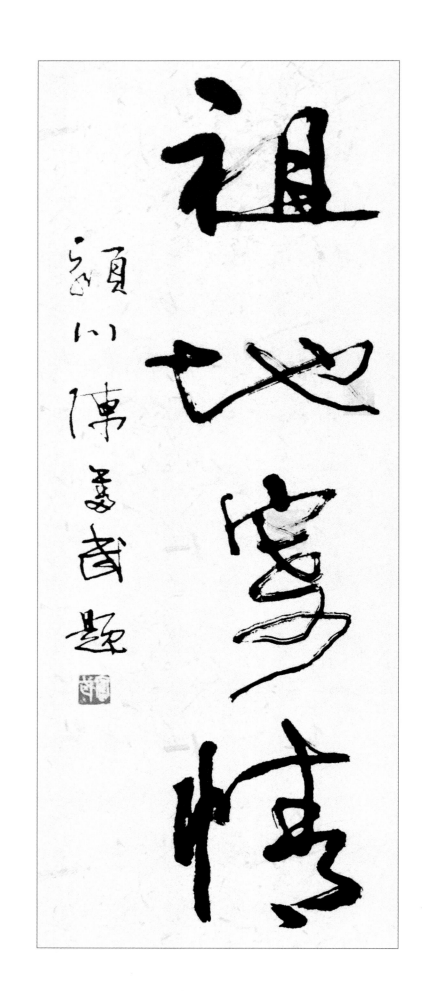

祖地寻情

颍川陈奋武题

Lee Wou-Yuan,
the Secretary-general of Peaceful Cross-Strait Cultural and Artistic Union
and the president of painting Society of Taipei Shan-chih,
inscribed the photography collection.

台湾两岸和平文化艺术联盟秘书长
台北市山痴画会理事长
李沃源为画册题字

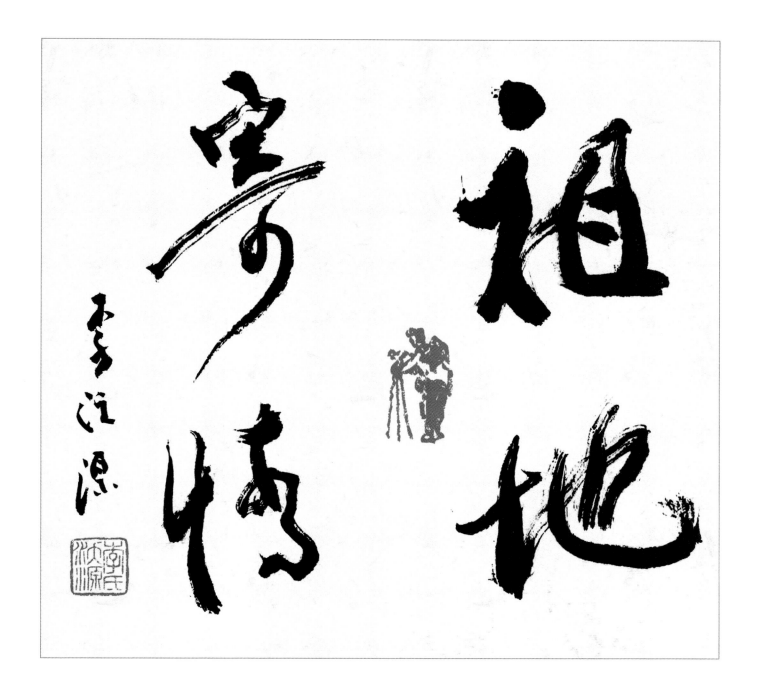

福建

福建，简称"闽"，位于中国东南沿海，东隔台湾海峡与台湾相望。全省大部分属中亚热带，闽东南部分地区属南亚热带。土地总面积 12.4 万平方千米，海域面积 13.6 万平方千米。陆地海岸线长达 3752 千米，位居全国第二位；海岸线曲折率居全省第一位；森林覆盖率居全国首位。

"山海一体，闽台同根，民俗奇异，宗教多元"是福建的特色。

福建境内峰岭耸峙，丘陵连绵，河谷、盆地穿插其间，山地、丘陵占全省总面积的 80% 以上，素有"八山一水一分田"之称。福建水系密布，河流众多，闽江为全省最大河流，全长 577 千米，流域面积 60992 平方公里，约占全省面积的一半。福建陆地海岸线长达 3752 千米，港湾众多，自北向南有沙埕港、三都澳、罗源湾、湄洲湾、厦门港和东山湾等 6 大深水港湾。岛屿星罗棋布，共有岛屿 1500 多个，平潭岛现为全省第一大岛，原有的厦门岛、东山岛等岛屿已筑有海堤与陆地相连而形成半岛。

福建是中国著名的侨乡，旅居世界各地的闽籍华人华侨一千多万人。其中，菲律宾、马来西亚、印尼这三地的闽籍华人华侨最多。福建与台湾源远流长，关系最为密切，台湾同胞中 80% 祖籍福建。

福建历史源远流长，科学文化曾盛极一时。5000 年前，先民们就在此生息繁衍，创造了可与仰韶文化、河姆渡文化相媲美的昙石山文化。福建在历史上是"海上丝绸之路"的起点，是重要的商贸集散地。福州、厦门曾被辟为全国通商口岸。泉州曾是古代世界第一大港口。闽江口的马尾港是中国近代造船工业的先驱和培养科技人才的摇篮。

悠久的历史孕育了闽南文化、客家文化、妈祖文化、闽越文化、朱子文化、海丝文化等六大精品文化，以及茶文化等一批内涵深刻、特色鲜明的地域文化。福建现有世界文化与自然双遗产武夷山、世界文化遗产福建土楼、世界自然遗产与世界地质公园泰宁，世界地质公园宁德白水洋、太姥山、白云山，以及温泉古都福州、海上花园厦门、海上丝路泉州、朝圣妈祖湄洲、滨海火山东山、东海麒麟平潭等独具特色的风景名胜。

福建宗教多元，佛教、道教、伊斯兰教等遗址广为分布，泉州有"世界宗教博物馆"之称，妈祖、陈靖姑、保生大帝、清水祖师等民间信仰在海峡两岸影响很大。闽剧、莆仙戏、梨园戏、高甲戏、芗剧等是福建五大地方剧种。此外还有 20 多种民间小戏分布于全省各地。

福建物产丰富，福州的脱胎漆器、寿山石雕、武夷山的大红袍和安溪铁观音等名茶，惠安的影雕，德化的瓷器，漳州的水仙花、中成药片仔癀等享誉海内外。

Fujian, also called "Min" for short, is located on the southeast coast of China. Separated by the Taiwan Strait, it lies opposite Taiwan to the east. Most part of the province is in middle subtropical area, and part of the southeastern Fujian lies in the south subtropical area. The total land area of Fujian is 124 thousand square meters, and it sea area amounts to 136 thousand square meters. With the most winding coastline in China, its coastline extends 3,752 kilometers, ranking second in China. And Fujian's forest coverage rate ranks top in China.

Fujian is characterized by "the linking between mountains and sea; the same ancestor for the people in Fujian and Taiwan; peculiar folk customs and diversified religions".

In Fujian, mountain ridges stand high and hills stretch continuously, with river valleys and basins among them. Mountains and hills occupy more than 80% of its total area, so Fujian is traditionally described as "eight parts mountains, one part water, and one part farmland". There are many rivers and streams in Fujian. Among them, Minjiang River is the longest one, with a length of 577 meters and a drainage area of 60,992 square meters. About half of Fujian is within its drainage area. Fujian's coastline extends 3,752 kilometers, with many docks and harbors throughout the whole province. From north to south, there are six major deepwater harbors: Shacheng Port, Sandu'ao Port, Luoyuan Gulf, Meizhou Bay, Xiamen Port and Dongshan Bay. There are altogether 1,500 islands in the whole province. They are scattered along the coastline like stars in the sky. Among them, Pingtan Island is the largest. Sea walls were built to connect the Xiamen Island and the Dongshan Island with lands, which makes these two islands become present peninsulas.

Fujian is a well-known hometown of overseas Chinese. Around the world, there are more than 10 million overseas Chinese from Fujian. And most of them presently live in the Philippines, Malaysia and Indonesia. The relationship between Fujian and Taiwan is very close and goes back to ancient times. For 80% of the Taiwan compatriots, their ancestral home is Fujian.

Fujian has a long history and science and culture ever flourished in its history. 5,000 years ago, ancestors lived and multiplied here and created the Tanshishan culture, which is comparable to the Yangshao culture and the Hemudu culture. In history, Fujian was the starting point of "the Maritime Silk Road", and an important trading center. Fuzhou and Xiamen were ever opened up as the ports for trade in history. Quanzhou was ever the largest port in ancient China. Mawei Port, which is the pioneer for Chinese modern shipbuilding industry and the cradle for cultivating technological talents, is situated near the estuary of the Minjiang River.

The long history of Fujian breeds six types of boutique culture: Minnan culture, Hakka culture, Matsu culture, Minyue culture, Zhu Zi culture and Maritime-Silk-Road culture. Some regional cultures with deep connotation and distinct characteristics, such as the tea culture, are also bred in this land. There are many unique scenic spots in Fujian: Wuyi Mountain, the site of World Cultural Heritage and World Natural Heritage; Fujian Tulou, the World Cultural Heritage site; Taining county, the site of World Cultural Heritage and World Geopark; Baishuiyang, Taimu Mountain and Baiyun Mountain, sites of World Geopark; Fuzhou, the ancient capital with rich hot springs; sea garden Xiamen; the Maritime Silk Road Quanzhou; Meizhou Island, the birthplace of the sea goddess Matsu; Dongshan Island, the volcano by the sea, etc.

The religious culture of Fujian is diversified. Historical sites of Buddhism, Taoism and Islamism can be found around the province. Quanzhou is famous as "the Museum of World Religions". The folk beliefs, including Matsu, Lord Bao Sheng the Great and Qingshui Founder, are popular across the straits. Min Opera, Puxian Opera, Liyuan Opera, Gaojia Opera and Xiang Opera are five major types of Fujian's traditional operas. In addition, there are more than 20 kinds of folk plays in different parts of Fujian.

Fujian is rich in natural resources. The bodiless lacquer ware and the Shoushan stone carving of Fuzhou, the Da Hong Pao Tea and the Anxi Tieguanyin Tea of Wuyi Mountain, the Huian shadow sculpture, the Dehua ceramics, the Zhangzhou daffodils, and the Chinese proprietary medicine Pianzaihuang all enjoy great reputation home and abroad.

Fujian Province

Footprints on the Ancestral Land

Directory 目录

Footprints on the Ancestral Land

闽 East Fujian

广义的闽东意指福建东部地区，包括福州、宁德两市，依山傍海，景色秀丽；农渔特产与旅游资源尤其丰富多彩，独具特色。

闽东历史悠久，早在新石器时代，古越族先民就在这里劳动生息。历代名人朱熹、陆游、戚继光、唐伯虎、冯梦龙等均曾在闽东留下足迹和珍贵文物，还有保存完好的建筑群、石雕等古迹。

In a broad sense, Mindong refers to the eastern part of Fujian, mainly including Fuzhou City and Ningde City. This region is nestled between hills and sea and has beautiful scenery. And it is unique in its rich agricultural and fishery products and colorful tourism resources.

East Fujian has a long history. Early in the Neolithic Age, the Guyue tribe lived and worked here. Celebrities of successive dynasties, including Zhu Xi, Lu You, Qi Jiguang, Tang Bohu and Feng Menglong, all came to East Fujian and left some treasured cultural relics. Up to now, there are still well-preserved archaeological relics here.

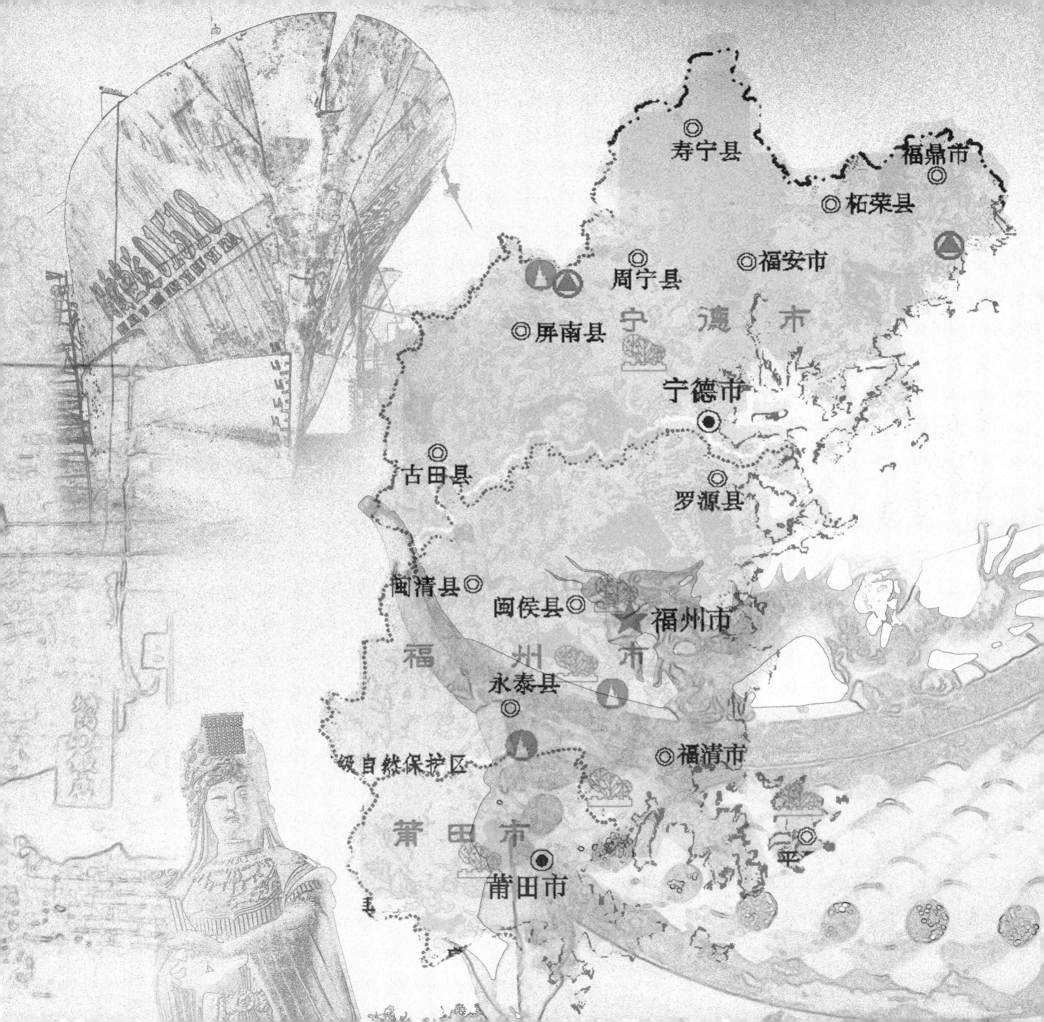

寿宁县

福鼎市

柘荣县

福安市

周宁县

屏南县

宁　德　市

宁德市

古田县

罗源县

闽清县

闽侯县

福州市

福　州　市

永泰县

级自然保护区

福清市

莆　田　市

莆田市

平

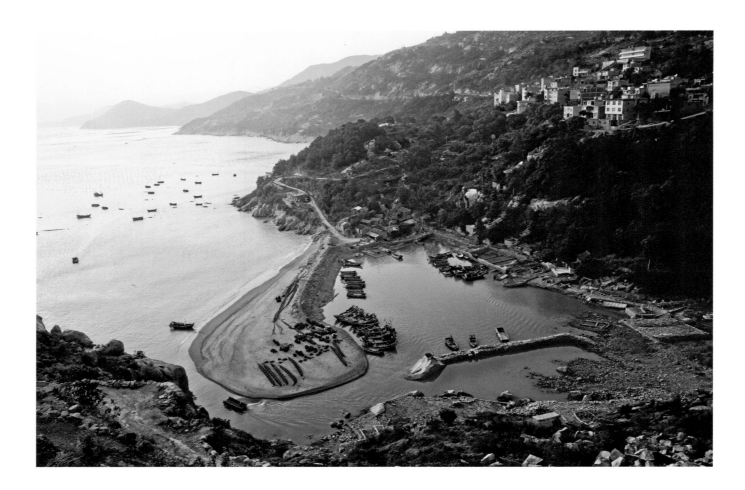

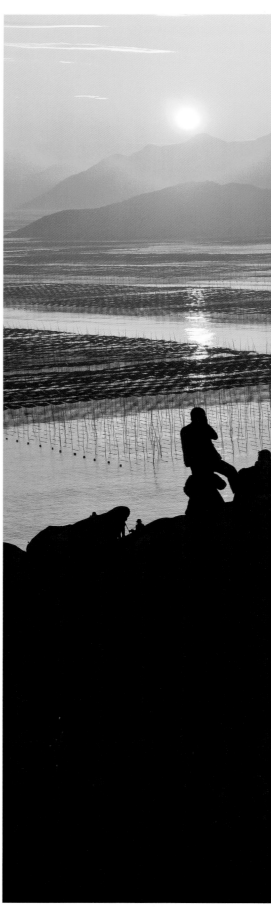

东壁村
Dongbi Village

霞浦三沙镇一个面海的小渔村，依山傍海、视野宽阔、极为壮观。特别是紫菜季节，诡竿谲影、船只穿梭，在落日余晖照射下呈现出不同色调，为多彩的沙滩增添无限生趣。

The village is a small fishing village in Sansha Town, Xiapu County. It is nestled between hills and sea, and has a broad vision and spectacular scenery. During the seaweed-harvesting season, the bamboo poles, fishing boats and the setting sun form sceneries of different colors, adding vividness to the beach.

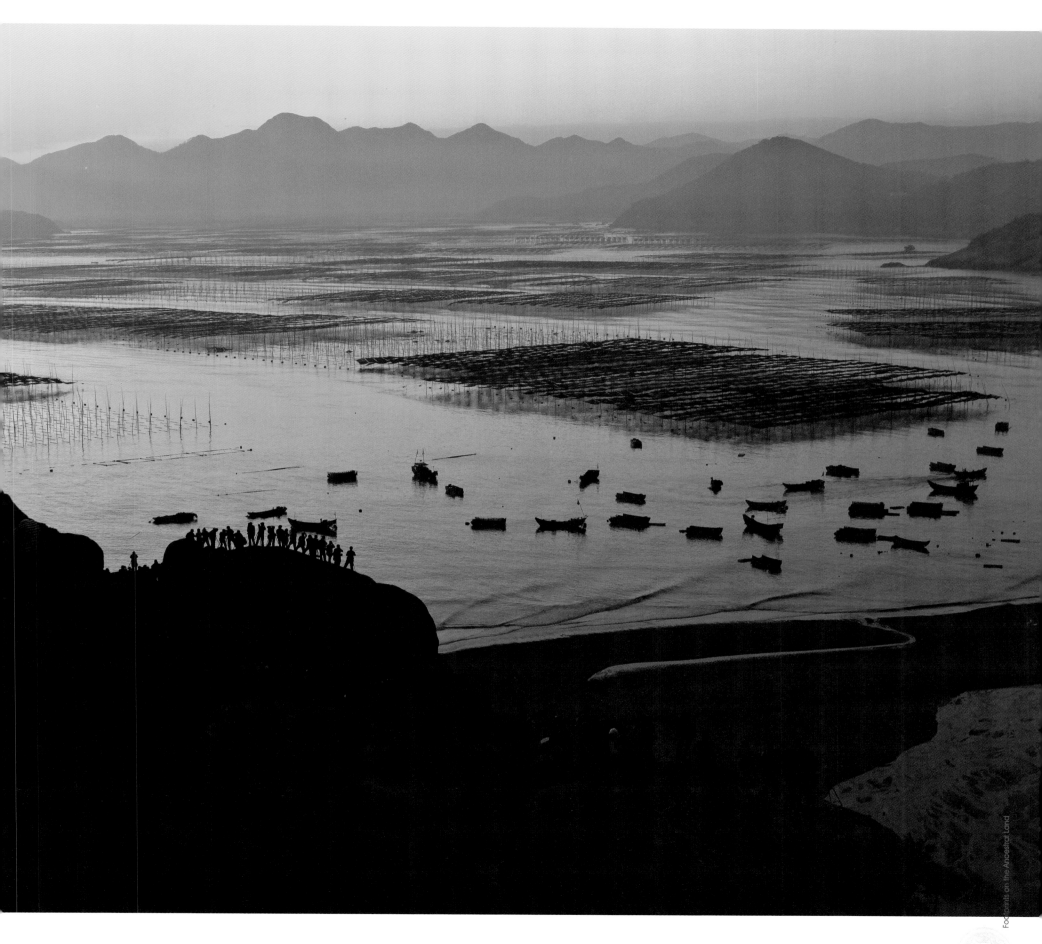

沙江镇
Shajiang Town

位于福建省霞浦县西南部，南临东吾洋，曾被喻为"福建大念山海经的缩影"。东吾洋内有竹江岛屹立中流，风景优美、山色鲜明、水光潋滟。

The town is located in the southwestern part of the Xiapu County, Fujian province, with the bay "Dongwu Yang" to the south. It was ever described as "the epitome of Fujian's mountains and seas". The Zhujiang Island is in the middle of the Dongwu Yang. Here, people can enjoy the beautiful scenery of waters and hills.

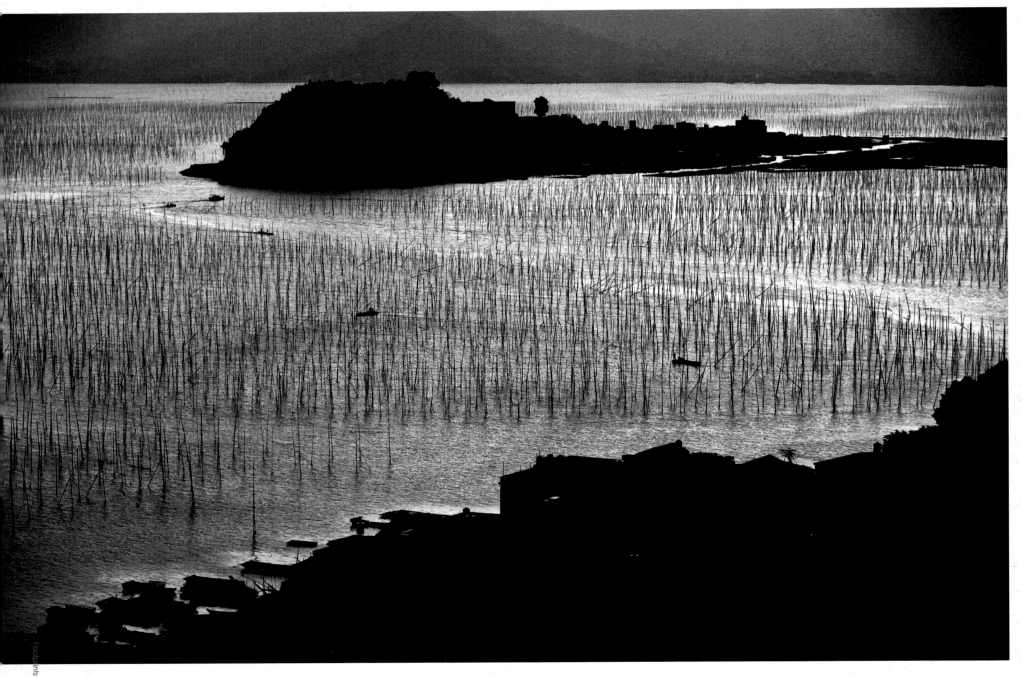

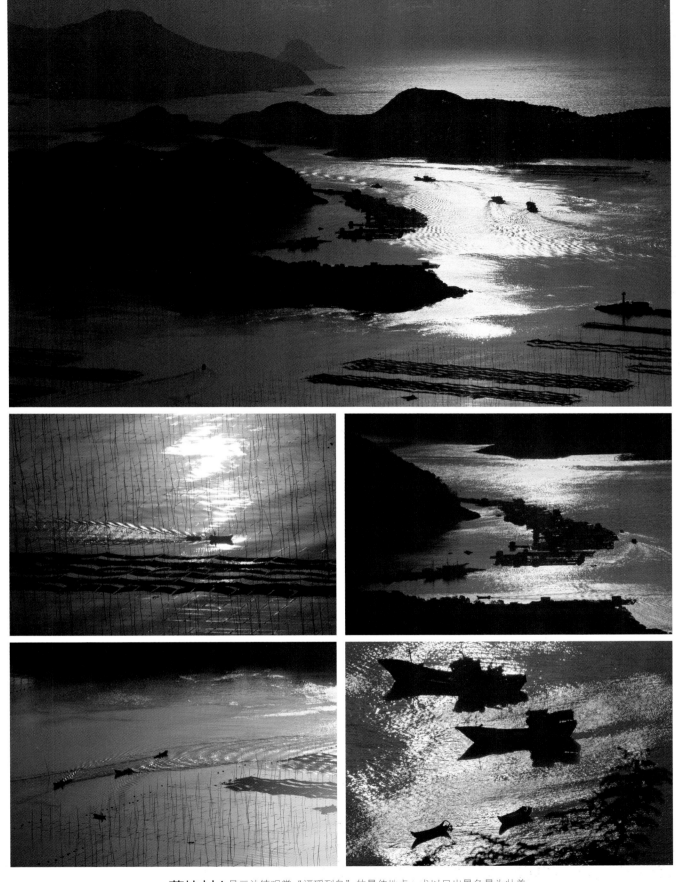

花竹村
Huazhu Village 是三沙镇观赏"福瑶列岛"的最佳地点，尤以日出景色最为壮美。

The village is the best place to enjoy the scenery of the Fuyao Islands, especially the stunning sunrise.

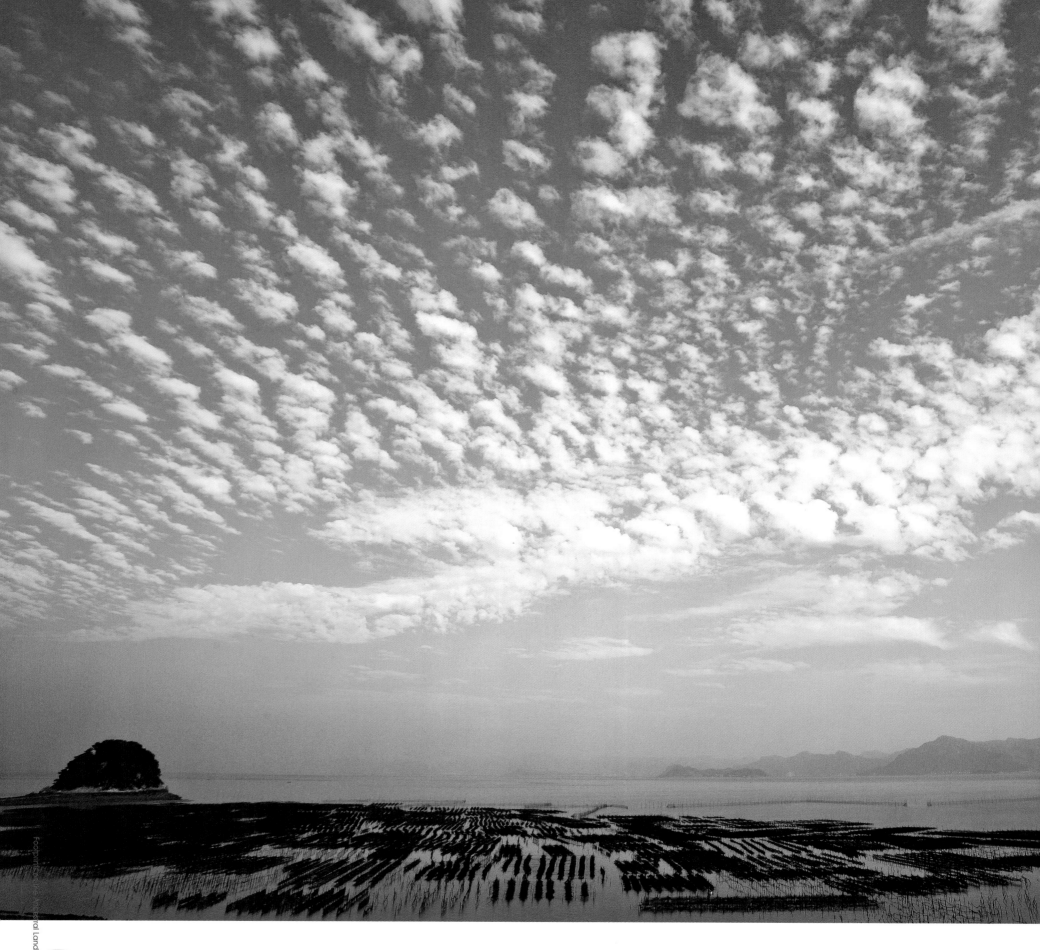

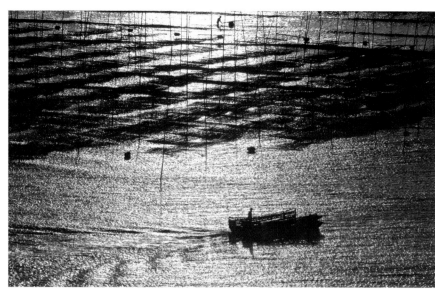

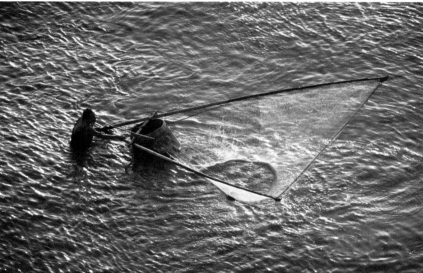

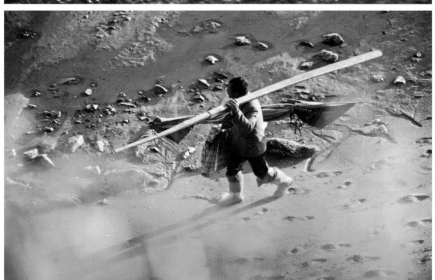

北岐村 Beiqi Village

是霞浦沿海的一个小渔村，有渔港、肥沃的滩涂和壮阔的海面。除了有名的紫菜养殖场外，也是海内外摄影人士的热门景点。

It is a small fishing village on the coast of the Xiapu County. There are fishing ports, fertile mudflats and vast sea. In addition to the famous seaweed farms, there are other favorite scenic spots for photographers home and abroad.

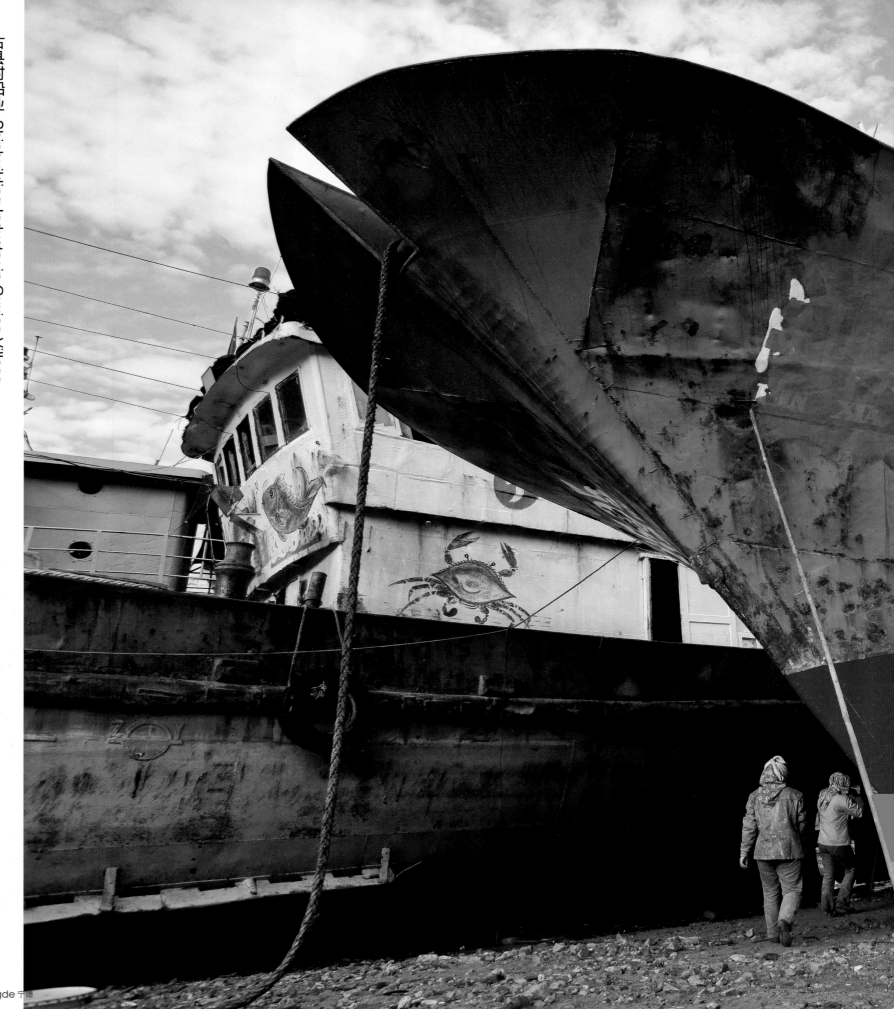

古县村船业 Shipbuilding Industry in Guxian Village

历史记载，建衡元年（公元 269 年）孙吴在霞浦县葛洪山脚下的古县村一带建立温麻船屯，建造大量海船，为发展吴国航海事业和壮大水军力量奠定了坚实的基础。迄今，邻近渔船仍视此为重要维修基地。

In recorded history, in 269 A.D. the Kingdom of Wu built a shipyard, called "Wenma Chuan Tun" in Chinese, around the Guxian Village, Xiapu County to build ships in large scale, which laid a solid foundation for developing the Kindom Wu's marine industry and strengthening its sea power. Up to now, it is still an important maintenance base for fishing boats nearby.

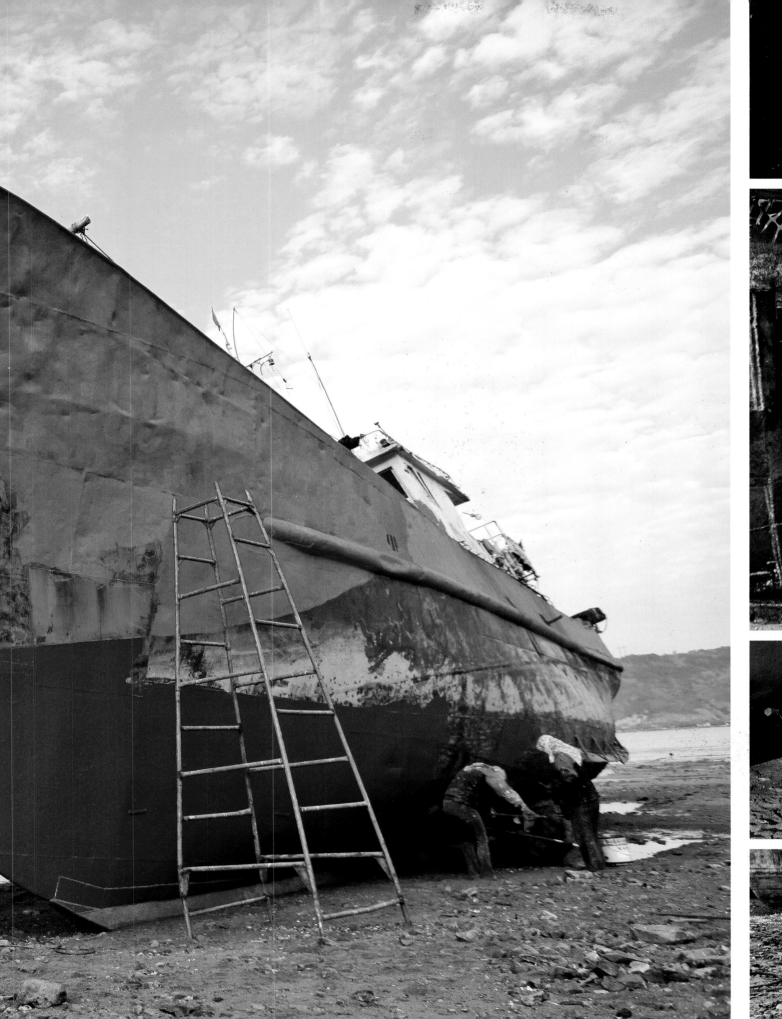

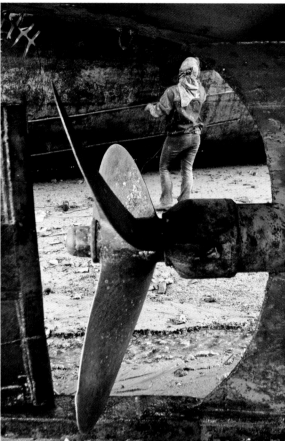
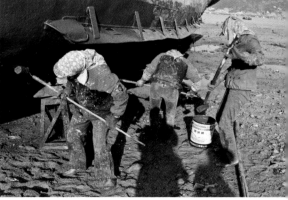
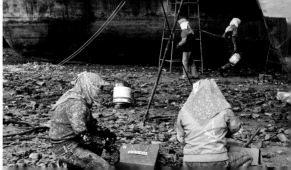

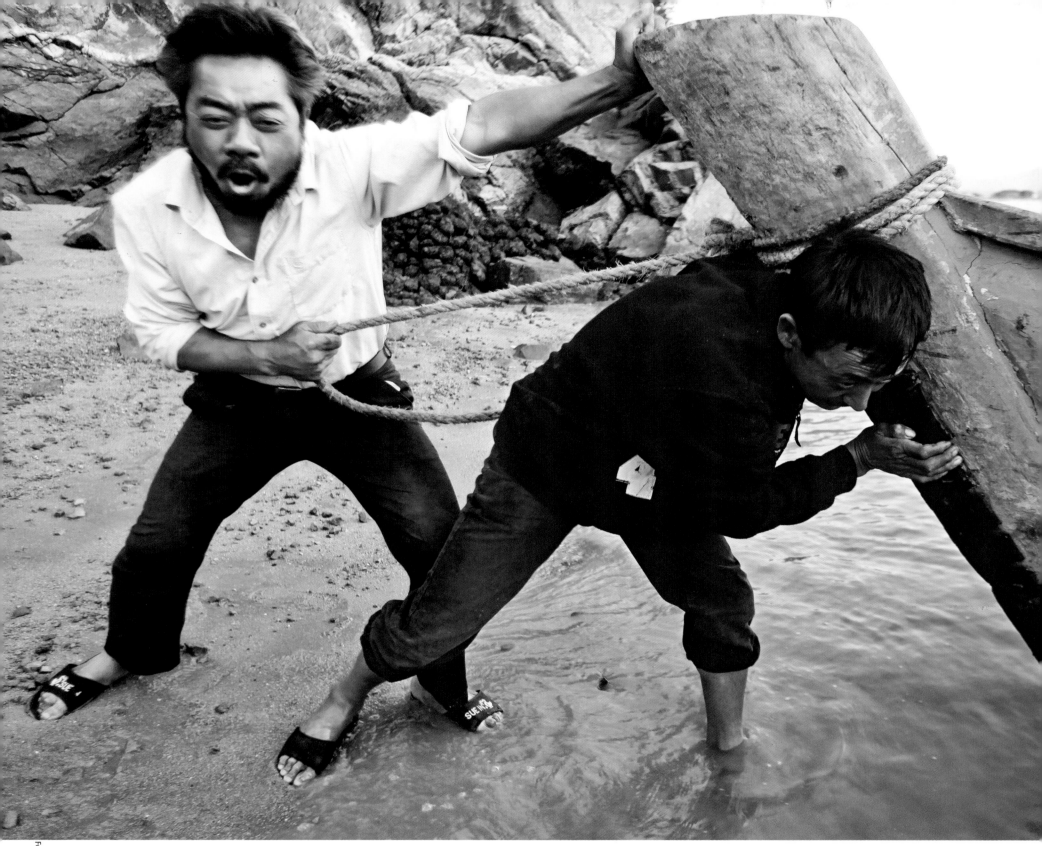

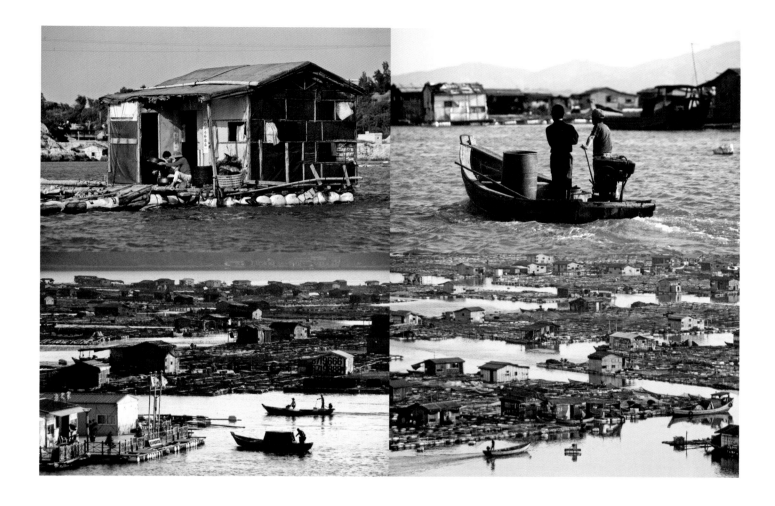

东安岛
Dong'an Island | 位于著名的官井洋、东吾洋交界处的福建霞浦溪南镇，是霞浦县的第二大岛，素有"海上威尼斯"美誉。在东安岛有一大片的海上小屋，世代在这里生活的人们被称作"海上吉普赛人"。碧水，滩涂，彩色的小屋和远处的青山随着光线的不同组成了一幅幅水墨丹青一样的画卷。东安岛已成为摄影同好们心驰神往的创作基地。

Located in Xinan Town of the Xiapu county, the island is at the junction of the two well-known bays: Guanjing Yang and Dongwu Yang. It is the second largest island of the Xiapu County, known as "Venice on the sea". There are hundreds of floating wooden houses on the sea, and people living here are called "the gypsies on the sea". With different light, blue water, mud flats, colored cottages and faraway hills form many scenes as beautiful as Chinese ink paintings. The Dong'an Island has become a famous place photographers long for.

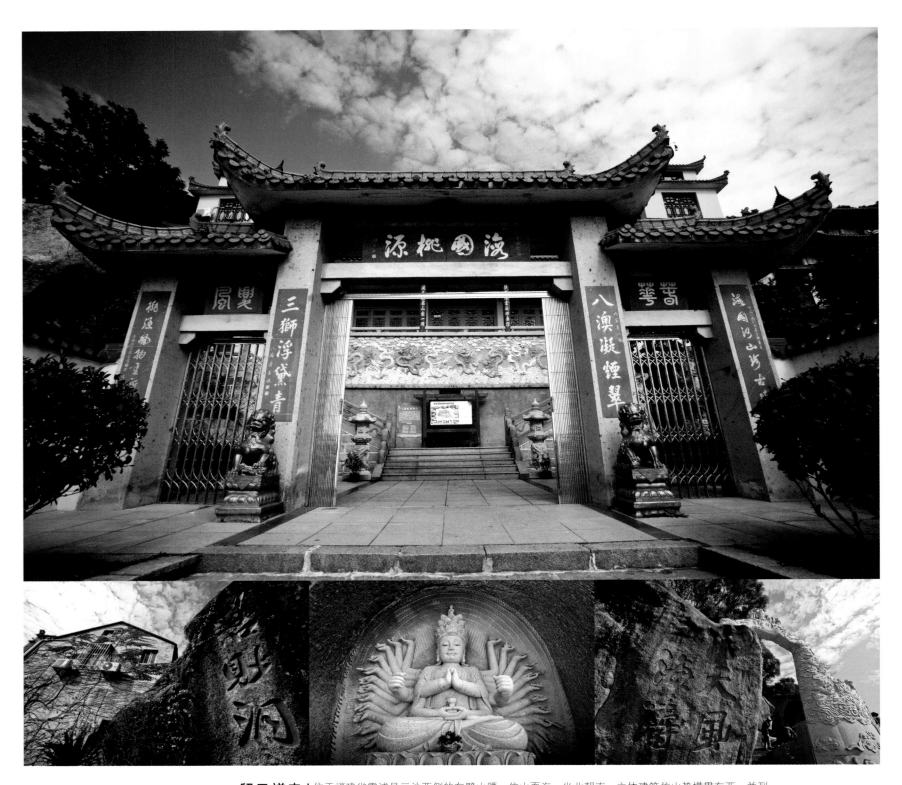

留云禅寺
Liuyun Buddha Temple

位于福建省霞浦县三沙西侧的东壁山腰，依山面海，坐北朝南，主体建筑依山势横贯东西、并列四座，风光极为秀丽，有"闽东小普陀"之称。

The temple is on the half way to Dongbi Hill, which is in the west side of the Sansha Town, Xiapu County. With hills behind and the sea in front, the temple has windows and doors facing the south. Its main structure runs from east to west along the hill.
And the temple is well known as "Small Putuo in East Fujian" for its beautiful scenery.

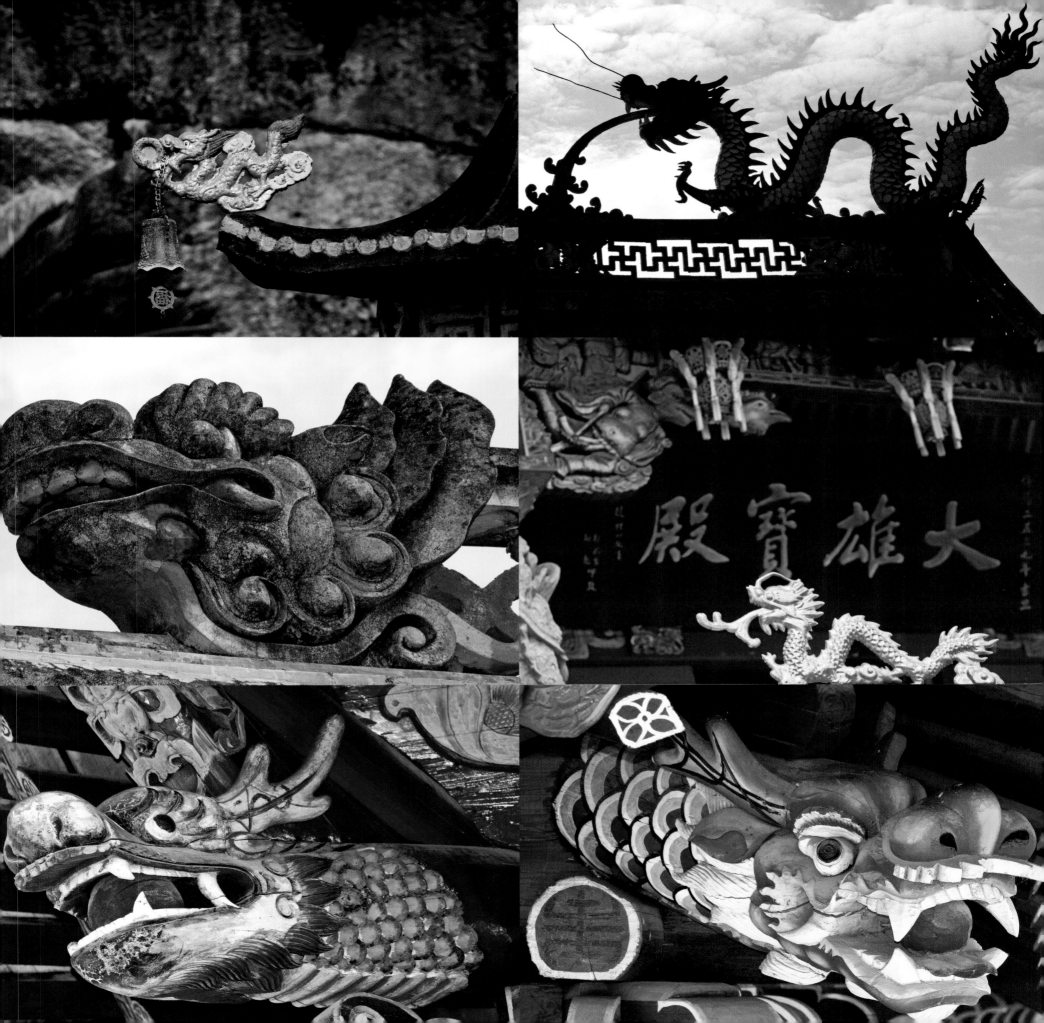

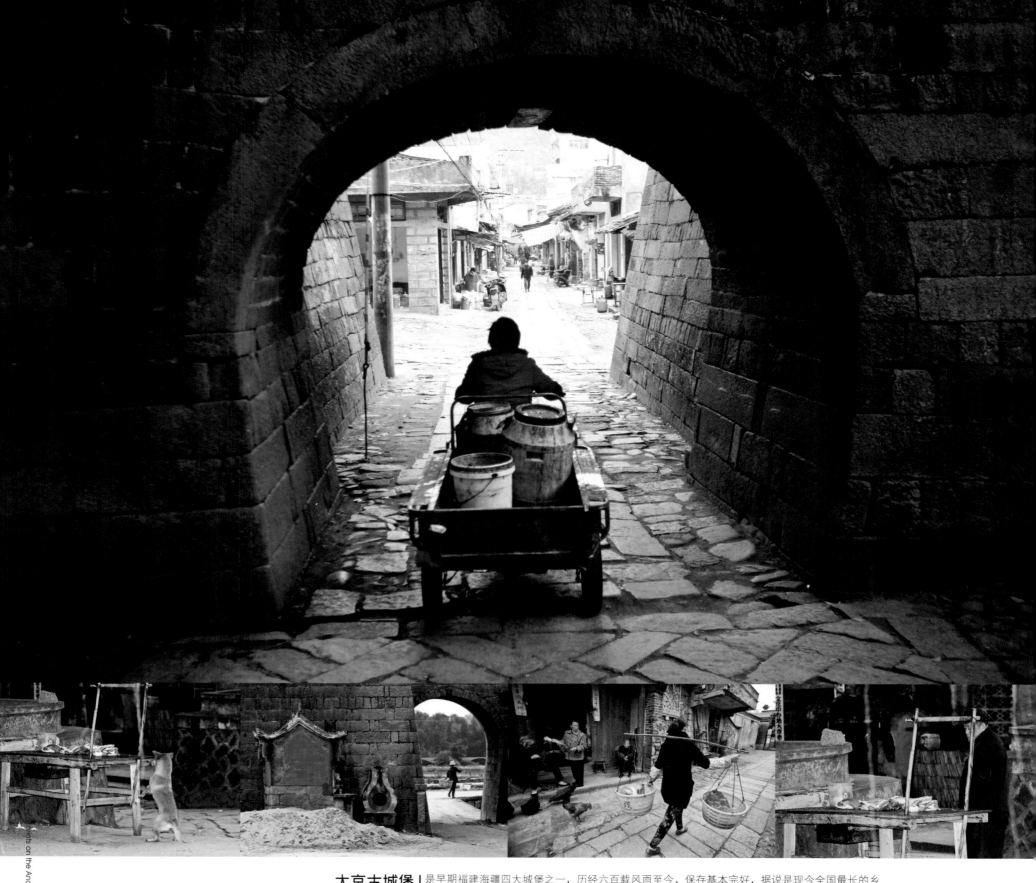

28

大京古城堡
Dajing Ancient Castle | 是早期福建海疆四大城堡之一，历经六百载风雨至今，保存基本完好，据说是现今全国最长的乡村古城堡，1991 年被列为福建省重点文物保护单位。

In the early days of Fujian, it was one of the four major castles by the sea. After six hundred years of wind and rain, it is still well preserved. It is said that it is the oldest castle in China. In 1991, the castle is listed as key cultural units in Fujian Province.

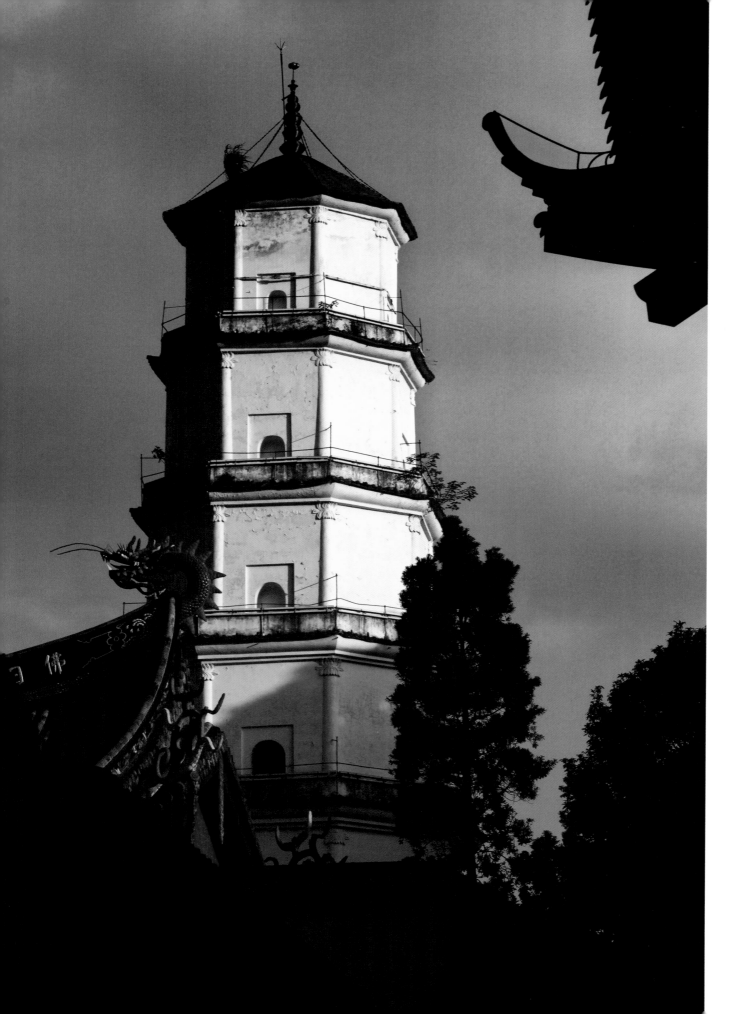

福州白塔
Fuzhou White Pagoda

又名定光塔，矗立在于山西麓，与乌山乌塔遥遥相对。初建于唐天元年（公元 904 年），是闽王王审知为报父兄教养之恩而建。塔南有白塔寺，为宫殿式建筑。相传开塔基时发现一颗宝珠，故名"定光多宝塔"。因其塔高 41 米，外敷白灰，故又名白塔，是福州规模较大的一座古塔。

The White Pagoda is also called "Ding Guang Ta" (Pagoda of Eternal Brightness). It stands on the western slope of the Yu Hill and faces the Black Pagoda at a distance. It was originally built in 904 A.D. by the Wang Shengzhi, the king of Min Kingdom, in paying a debt of gratitude to his parents. To the south of the pagoda, there is the White Pagoda Temple, a palace-style building. According to legend, a pearl was found when the foundation of the pagoda was dug. So it is named "Ding Guang Duo Bao Ta". As it is 41 meters in height and covered with white lime, the pagoda is also called "White Pagoda". It is the largest pagoda in Fuzhou.

陈宝琛故居
Former Residence of Chen Baochen

又名陈氏五楼，位于福州市苍山区螺洲镇，乃清末太师陈宝琛所建。"五楼"依次为赐诗楼、还读楼、沧趣楼、北望楼和曦楼。用以收藏皇帝御赐图书，民间善本、珍本，与古玩、金石、字画等，是福州地区最大的私人图书馆和博物馆。

The Former Residence of Chen Baochen is also called "Five Houses of the Chen Family". It is located in Luozhou County of the Cangshan District of the Fuzhou city. The residence was built by Chen Baochen, who served as tutor of the last emperor in the late Qing dynasty. The "Five Houses" respectively are Cishu Lou, Huandu Lou, Cangqu Lou, Beiwang Lou and Xi Lou. The residence is used for storing up the books granted by the emperor, antiques and paintings, etc.. And it is the largest personal library and museum in Fuzhou area.

闽江
Minjiang
River

是福建省最大河流，以沙溪为正源，全长 577 公里。发源于闽赣、闽浙交界的杉岭、武夷山、仙霞岭等山脉。建溪、富屯溪、沙溪三大主要支流在南平市附近汇合后被称为闽江。

With the Shaxi Stream as its source, Minjiang River is the longest river in Fujian. It is 577 kilometers long, and originates from the mountains at the junction of three provinces: Fujian, Jianxi and Zhejiang. After its main three tributaries, which are Jianxi Stream, Shaxi Stream and Tunxi Stream, join near the Nanping City, the river is called "Minjiang River".

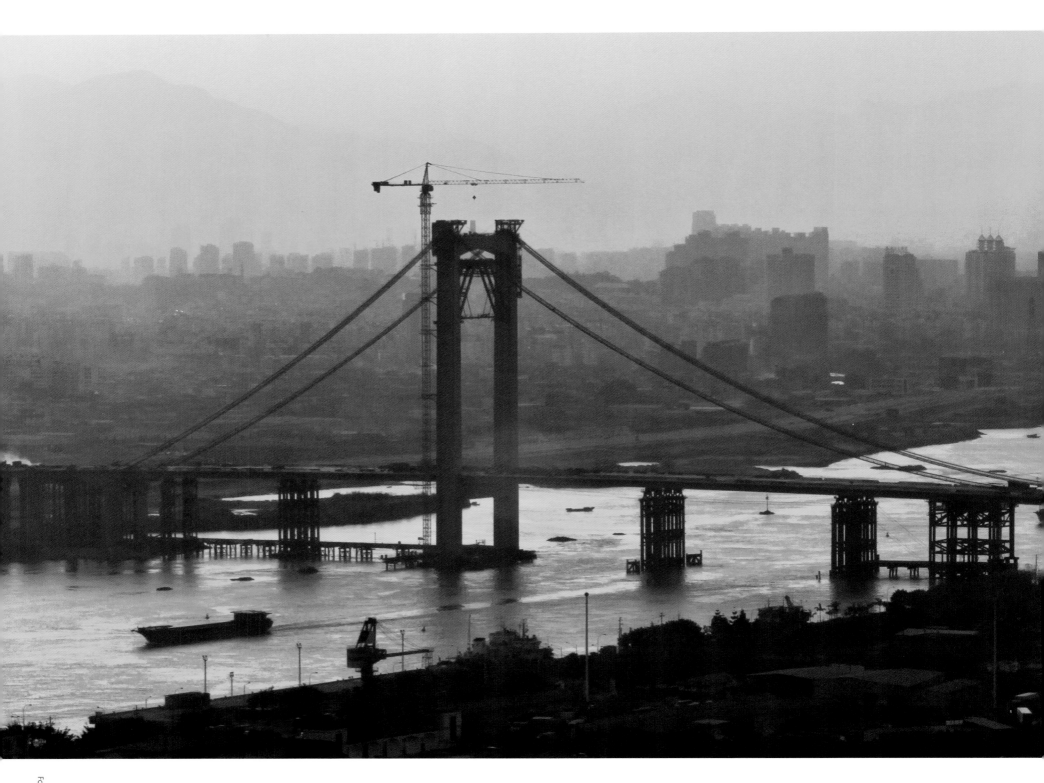

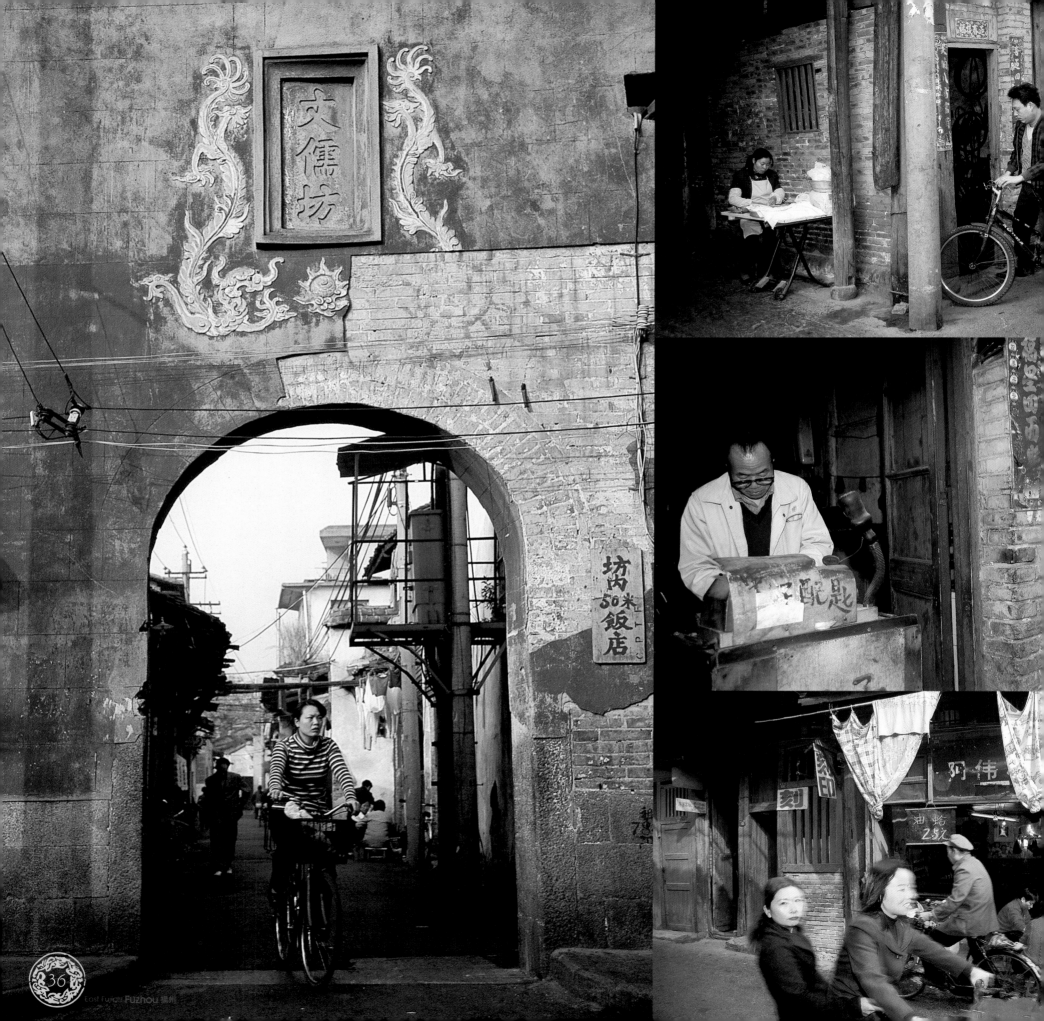

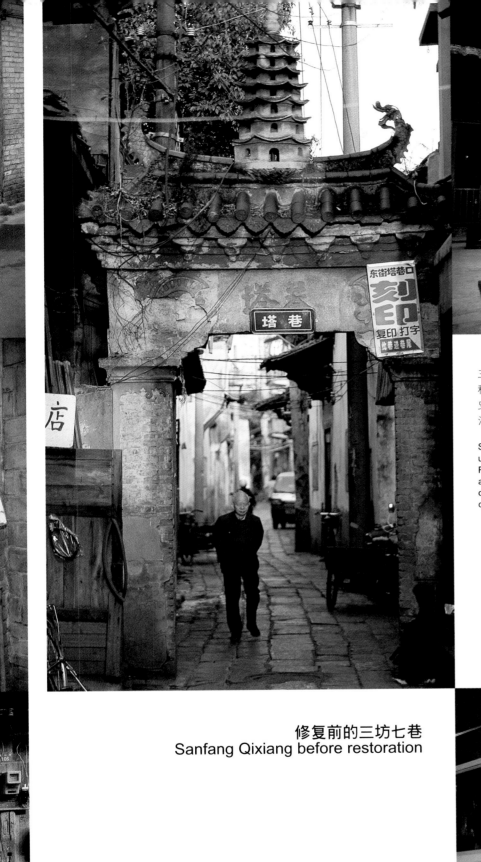

三坊七巷是福州市南后街两旁从北到南依次排列的十条坊巷的简称。向西三片称"坊"，向东七条称"巷"。此街区是中国十大历史文化名街之一，被誉为"明清建筑博物馆"、"城市里坊制度的活化石"。

Sanfang Qixiang is the abbreviation for the ten lanes and alleys lining up one by one from north to south on both sides of the Nanhou Street in Fuzhou. The three lanes to the west of the Nanhou Street are called "Fang", and the seven alleys to the east are called "Xiang". Known as "the museum of the architecture of the Ming and Qing dynasties", the ancient block is one of the ten famous historical cultural streets in China.

修复前的三坊七巷
Sanfang Qixiang before restoration

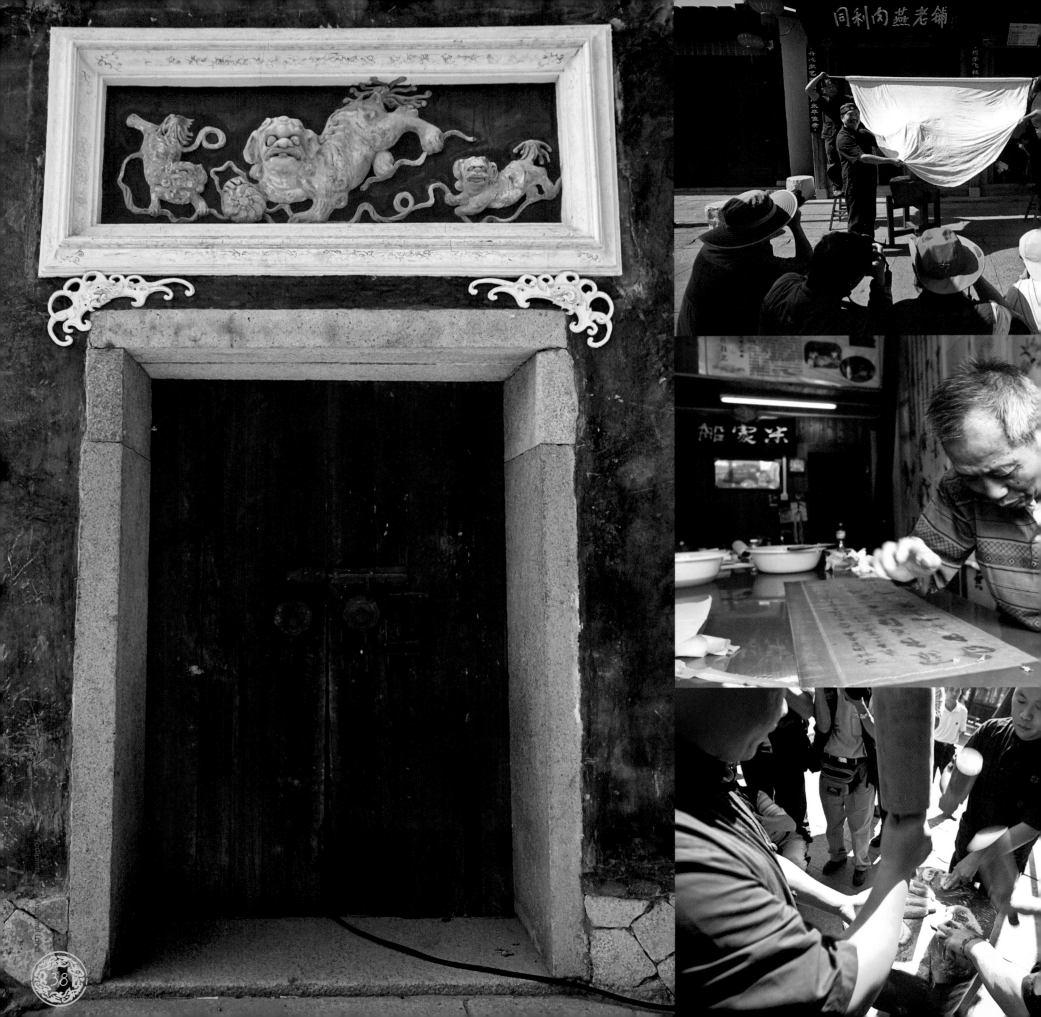

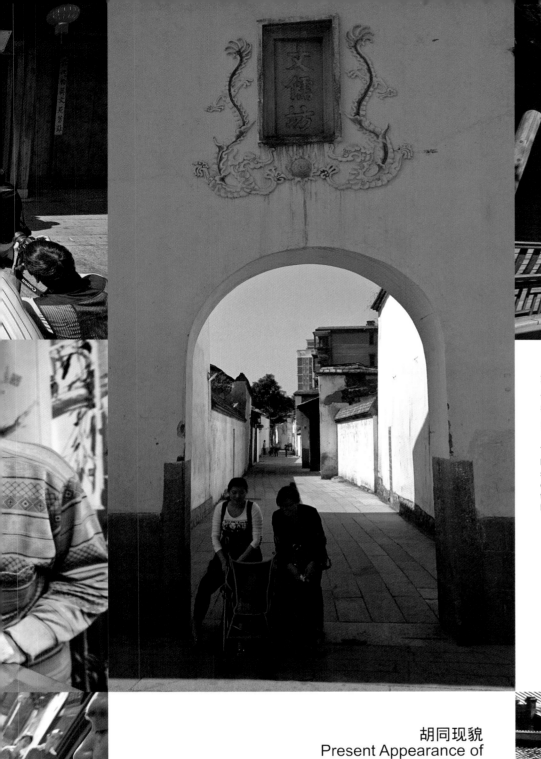

经过修复的三坊七巷维持鱼骨状的传统格局。中轴为南后街，现已辟为福州市传统手工艺、名小吃和海峡两岸特色商品市场一条街，每日游人如织。而街两边的三坊和七巷大多闹中取静，依然保持着幽巷深宅的风貌。

The refurnished Sanfang Qixiang still maintains the traditional fish-bone layout. The axis is the Nanhou Street, which has become a commercial street for traditional handicrafts, famous snacks and cross-strait special commodities. Every day, the street is packed with visitors. Whereas, the three lanes and seven alleys on both sides of the street still keep quiet in a hustling surrounding.

胡同现貌
Present Appearance of
Lanes and Alleys

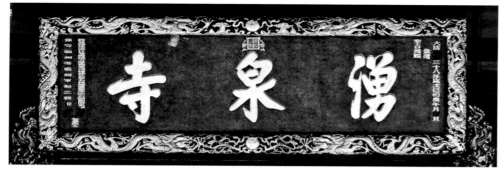

涌泉寺
Yongquan Temple

为"闽刹之冠",又是全国重点寺庙之一。相传它的旧址为"华严寺",建在海拔455米的鼓山山腰,前为香炉峰,后倚白云峰,有"进山不见寺,进寺不见山"的奇特建筑格局。

Known as "the best Buddhist temple in Fujian", the Yongquan Temple is one of the national key temples. According to legend, the temple was originally named "Huayan Temple". It is located on the half way to Gushan Mountain, 455 meters above sea level. With the Xianglu Peak in its front and the Baiyun Peak at its back, the temple's layout is unique for people's "not seeing the temple in the mountain and not seeing the mountain in the temple".

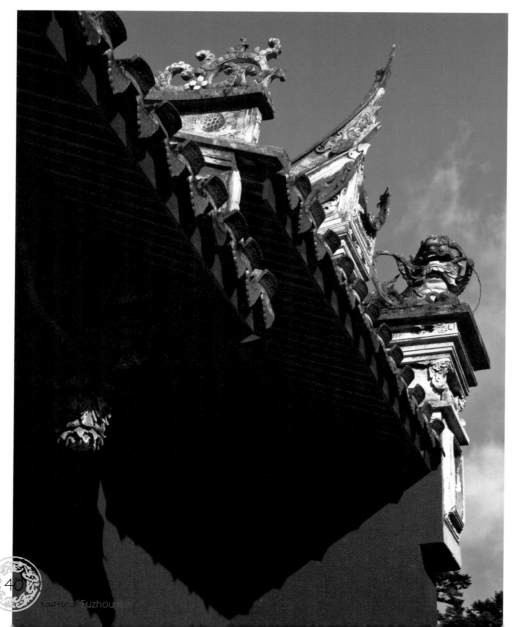

天王殿
Tianwang Hall

始建于唐咸通八年（公元867年），现有建筑为清光绪十四年（公元1888年）住持唯妙禅师重建，1980年起又作修建。殿中所奉有弥勒菩萨、四大天王与韦驮菩萨等神像，是佛教寺院内的第一重殿。

The hall was originally built in the 8th year of Xiantong reign in Tang Dynasty (867 A.D). The present hall was reconstructed by the temple abbot Weimiao Mater in 1888 A.D. It was reconstructed again in 1980. The statues of gods enshrined in the hall include Maitreya Bodhisattva, the four guardians of Buddha and Wei Tuo Bodhisattva, etc. It ranks first among the key halls in the Buddhist temple.

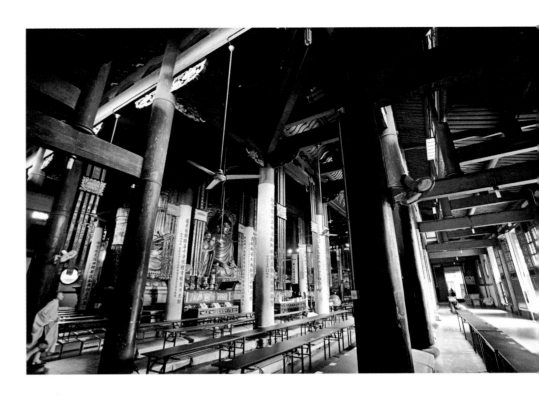

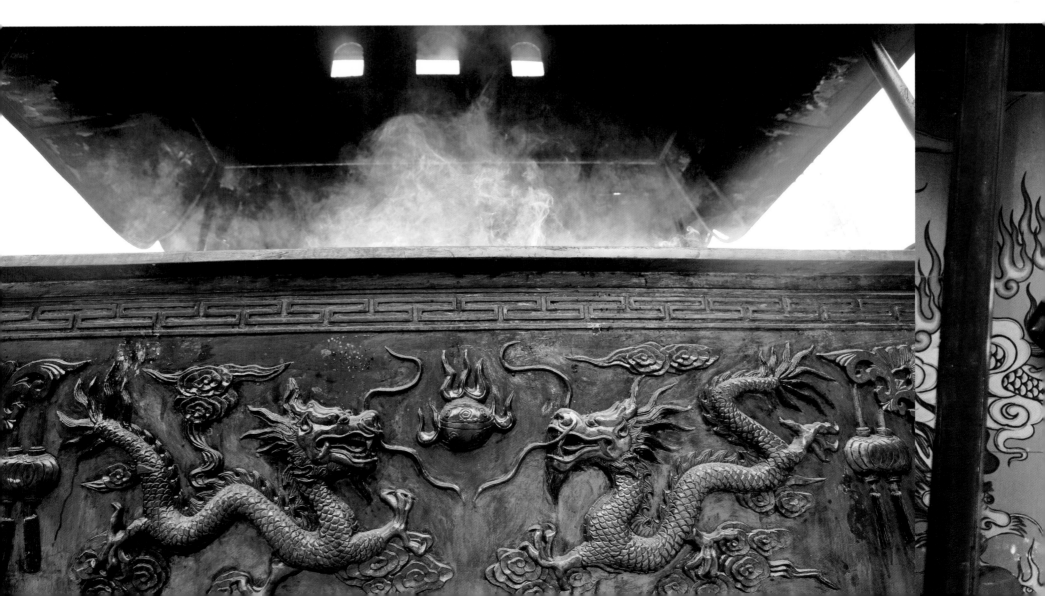

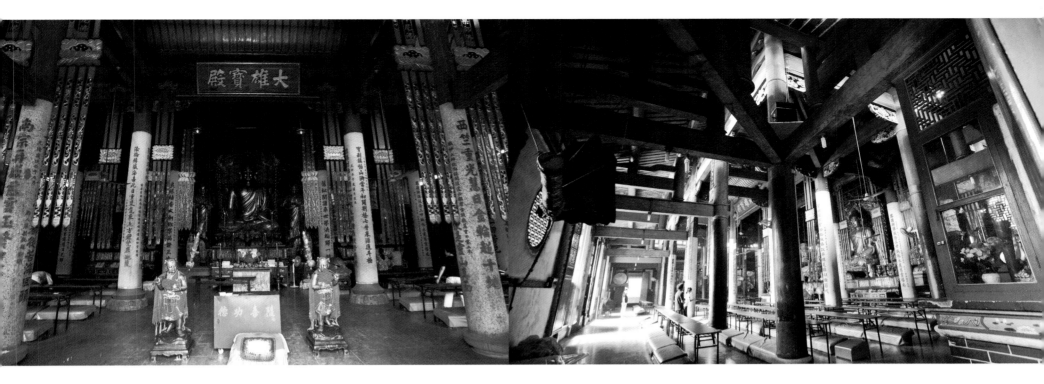

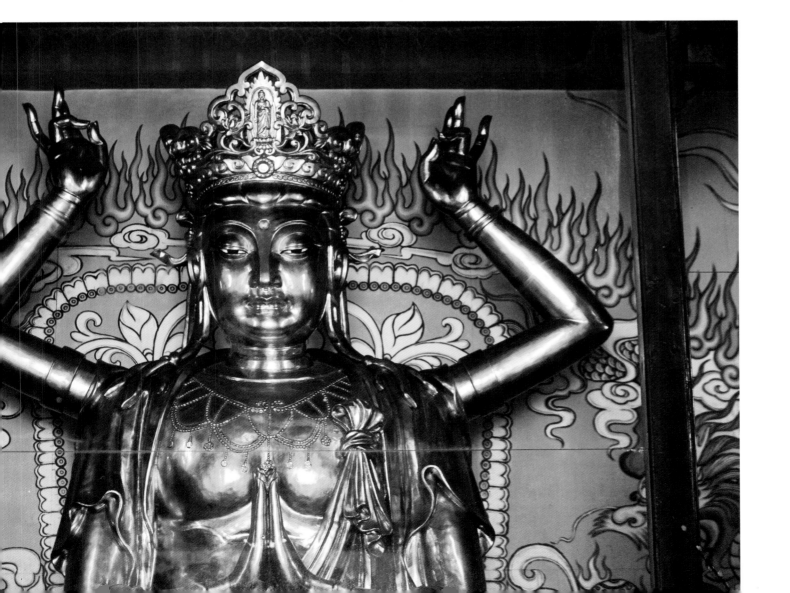

镇海楼
Zhenhai Tower

位于屏山之巅，为中国九大名楼之一。明洪武四年（公元 1371 年）始建，原是作为各城门楼的样楼，后更名为镇海楼，是福州古城的最高楼，为城正北的标志，并作为海船昏夜入城的标志，"样楼观海"曾是福州西湖外八景之一。

Situated on top of Pingshan Mountain, the Zhenhai Tower is one of the nine most famous buildings in China. Established in the fourth year of Hongwu reign of the Ming Dynasty (1371A.D.), it is originally set as draft tower for other fortress towers. Later it was renamed as Zhenhai Tower, being the tallest building in ancient Fuzhou, and the landmark of the north part of the city. Besides, it is the lighthouse for guiding fleets to enter the city. The scenery of "viewing sea sight from the draft tower" was once one of the eight unique sceneries outside of Fuzhou West Lake.

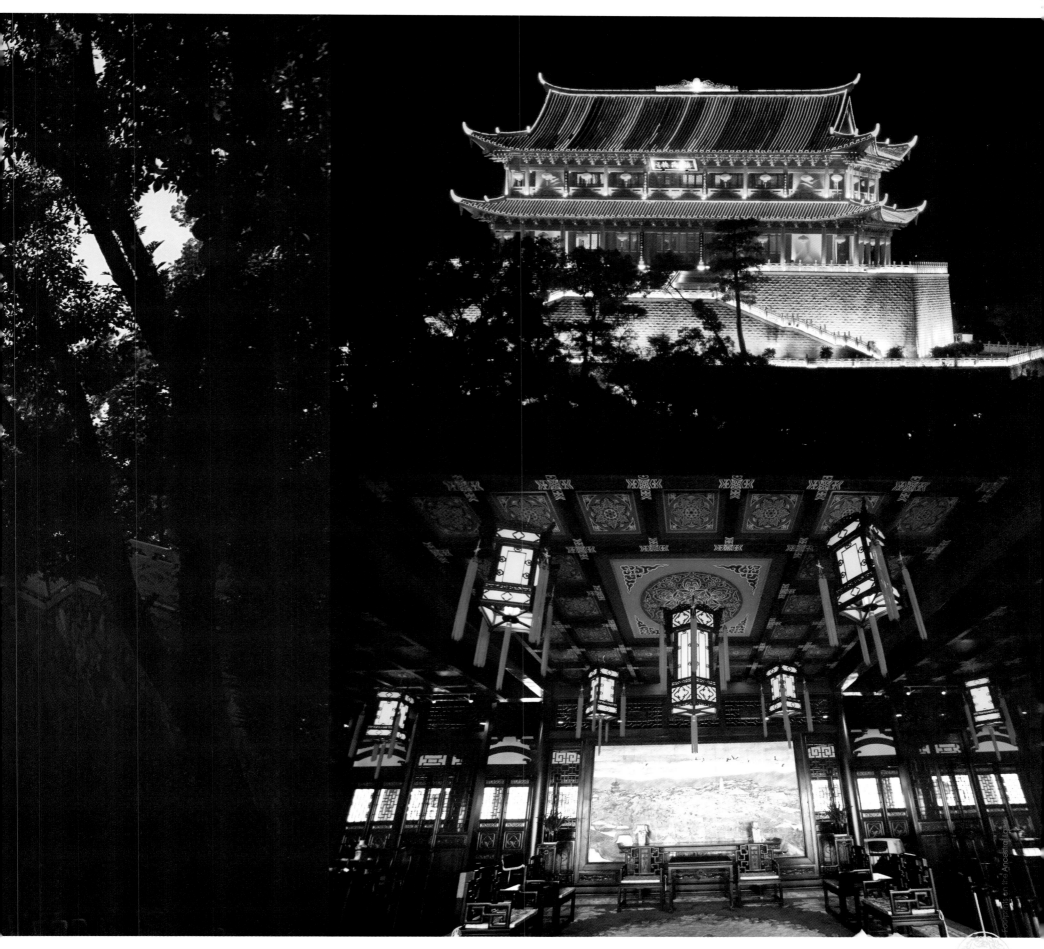

45

East Fujian Fuzhou 福州

枯木庵
Deadwood Nunnery

位于福建省闽侯县大湖乡，由五代闽王王审知于唐天佑二年（公元905年）建造，庵内有一枯木，高3.32米，围7.13米，树腹中空，中开一窦如洞门，内可容纳十余人，相传为义存大师初入山时栖止之所。

It is located in the village of Dahu, Minhou County, Fujian Province, and was built by a local celebrity Wang Shenzhi in the year of AD 905 in Tang Dynasty. Inside the nunnery, there is a dead tree, with a height of 3.32 meters and a perimeter of 7.13 meters. The interior of the tree is hollow, spacious for more than 10 people. It is allegedly to be the residence of Monk Yi Cun the famous monk in the mount.

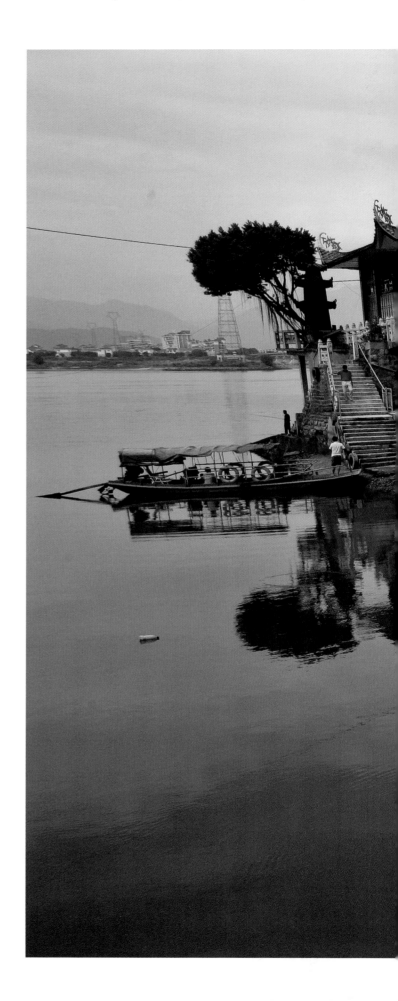

金山寺
Jinshan Temple

位于福州市西郊洪塘村附近乌龙江上，建于宋代，是福州唯一的水中寺。金山寺原是江心的小石埠，因为它的形状像石印浮于水面，早在宋代当地人就在这石埠上建了一座寺庙，因为很像镇江的金山寺，故取名小金山寺，是历代著名的旅游胜地。

Located alongside the Wulong River in the Hongtang Village on the western outskirts of Fuzhou City, the Jinshan Temple was built in the Song dynasty, being the only temple in water in Fuzhou. Jinshan Temple was originally a small stone pier at the heart of the lake, with its outline resembling a stone stamp floating on water. Local people in Song Dynasty built a temple on the stone pier, in resemblance of the Jinshan Temple in Zhenjiang. So it is named small Jinshan Temple and has been a famous tourist resort since ancient times.

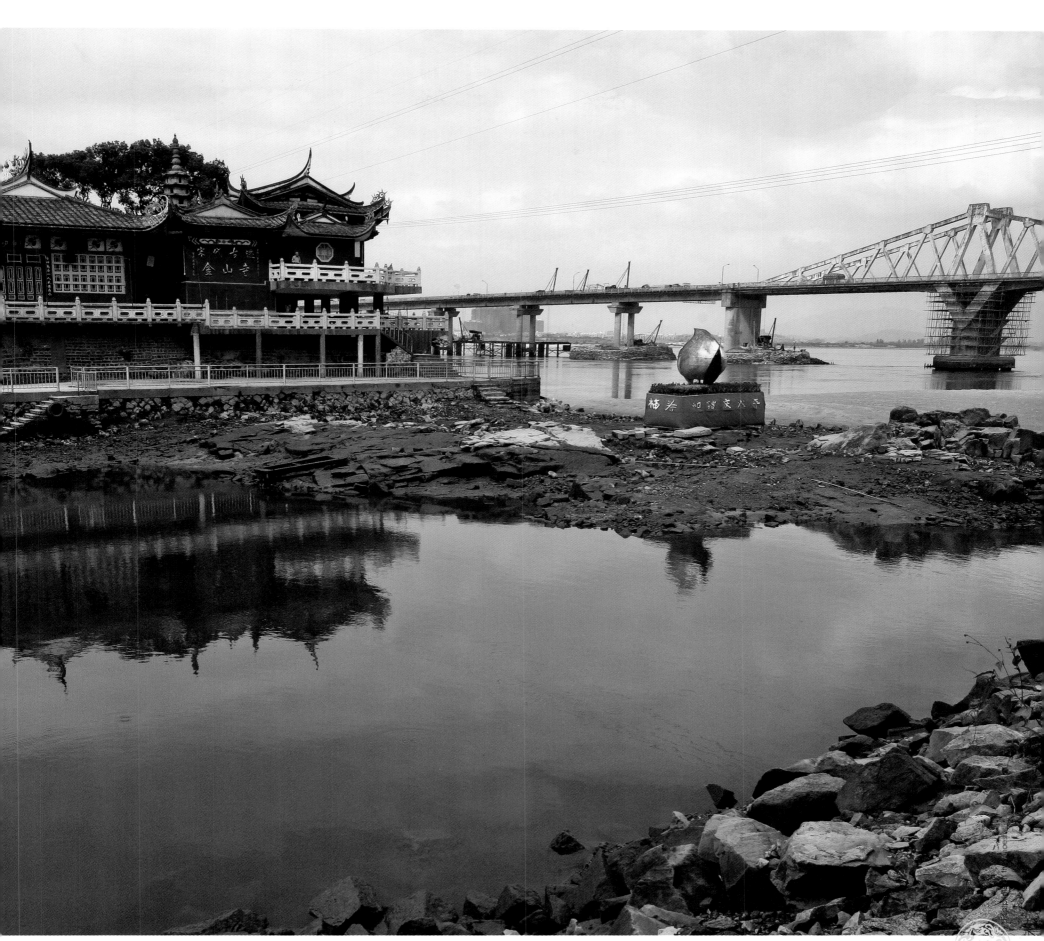

螺江陈氏宗祠
Ancestral Hall of the Chen Family in Luojiang

位于福州市郊螺洲镇店前村，建于明代，原为家庙。清康熙十六年（公元 1677 年）改建宗祠，现为福建省文物保护单位。

It is located in the Dianqian village in Luozhou County in the suburbs of Fuzhou, and was built in the Ming Dynasty, formerly as a family temple. In the 16th year of Kangxi (1677A.D.) in the Qing dynasty, it was altered to be an ancestral hall and has then been a unit of cultural relics protection.

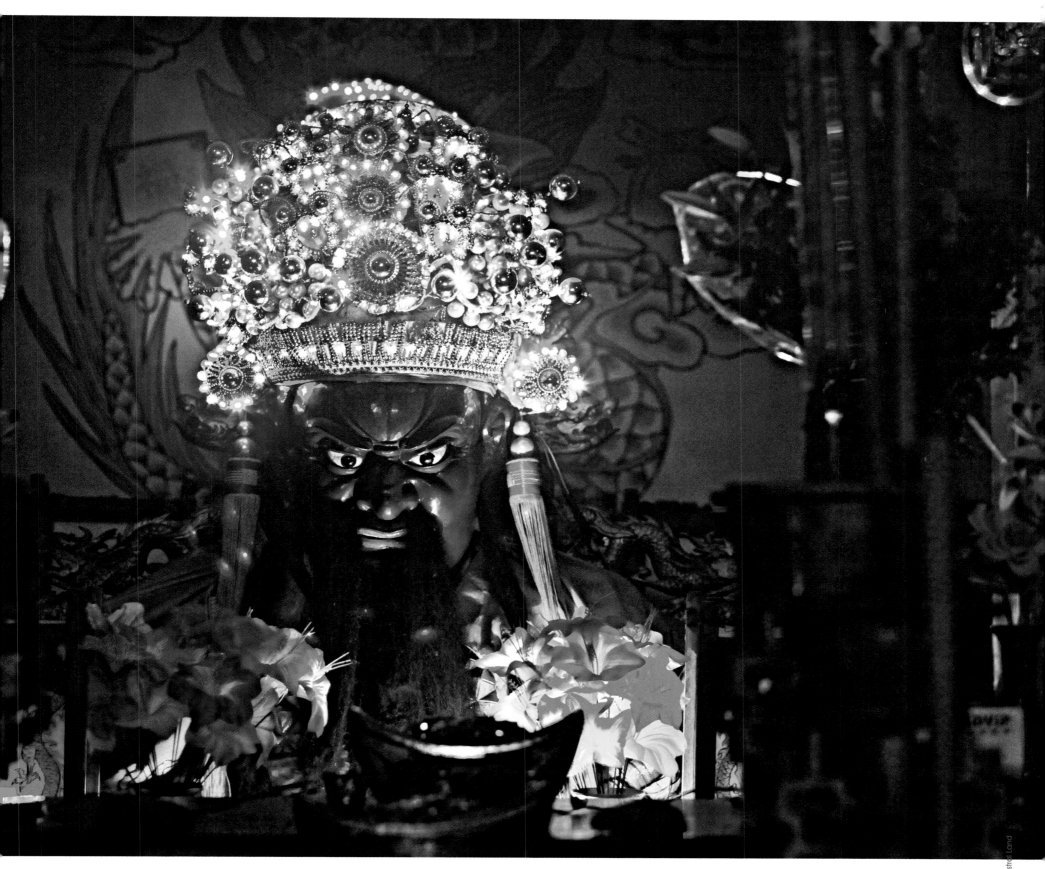

泰山宫
Mount Tai
Palace

是福建省级文物保护单位，位于福州市仓山区城门镇濂江村，原为平山阁，因南宋益王赵昰曾驻跸于此，后改称泰山宫。

As a unit of cultural relics protection in Fujian province, the Mount Tai Palace is located in Lianjiang village, Chengmen County, Cangshan District, Fuzhou city. Since South Dynasty Emperor Zhao Shi once resided here, it was originally called Pingshan pavilion, and later was renamed as Mount Tai Palace.

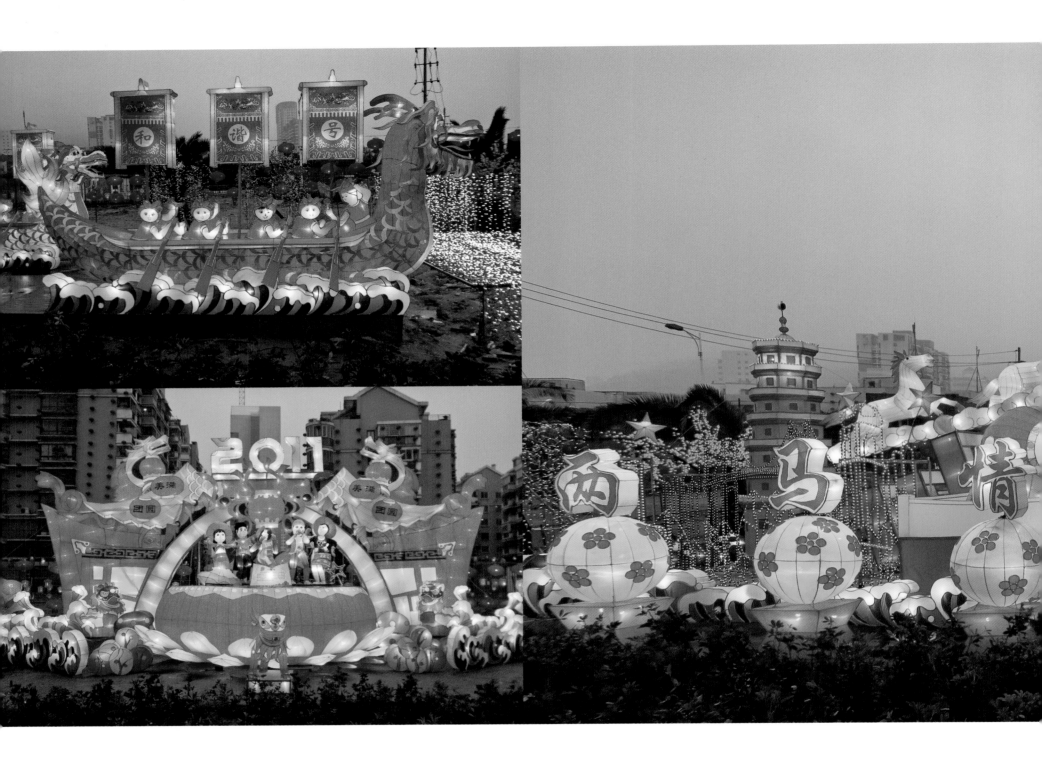

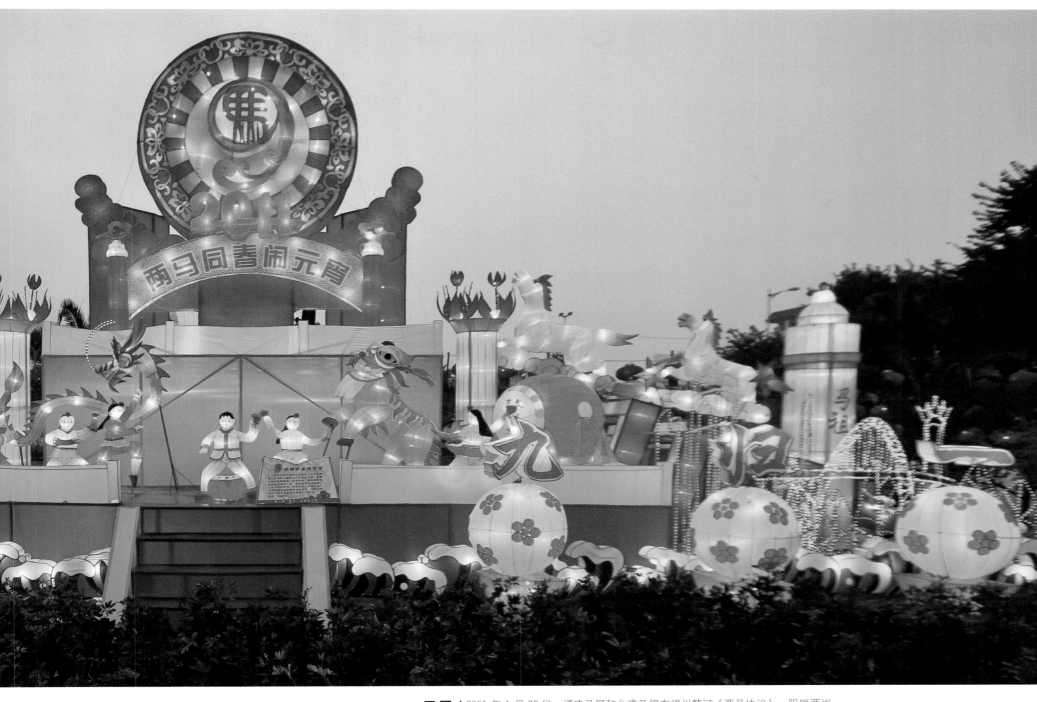

马尾
两马同春闹元宵
Two Horses Lantern Festival
Celebration in Mawei

2001 年 1 月 28 日，福建马尾和台湾马祖在福州签订《两马协议》，阻隔两岸 52 年的坚冰终于开始融化。2003 年元宵节，马尾、马祖乡亲自发互送花灯，并在马尾罗星塔公园集中展示，这是首届"两马同春闹元宵"的发端。从此两马交流有了新的平台，规模一届比一届大，内容一年比一年丰富。

On the 28th of Jan., 2001, Mawei of Fujian and Matsu of Taiwan signed Two Horses Agreement in Fuzhou, breaking the ice which has hindered the cooperation across the straits for 52 years. During the Lantern Festival of 2003, local people from Mawei and Matsu spontaneously bestowed each other with lanterns and held an exhibition in the Luoxing Tower Park in Mawei, which is the origin of the first "Two Horses Lantern Festival Celebration". From then on, the mutual communication has stepped into a new chapter with the size growing and coverage expanding.

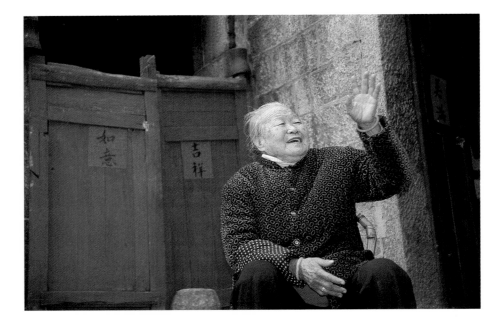

平潭 | 是大陆距离台湾最近的县，面积392.92平方千米，由126
Pingtan | 个岛屿和近千个岩礁组成，主岛海坛岛为中国第五大岛，
福建第一大岛。2009年7月成立的平潭综合实验区成为
探索两岸交流合作先行先试的示范区和海峡西岸经济区科
学发展的先行区。平潭海峡大桥已于2010年11月建成
通车，福州至平潭的铁路也将于2015年建成。

As the nearest county to Taiwan, Pingtan covers an area
392.92 square kilometers. It is composed of 126 islands
and hundreds of ledges, with the main island Haitan Island
as the fifth largest in China and the biggest one in Fujian.
Pingtan Comprehensive Pilot Zone, which was established
in July 2009, is a representative area to explore mutual
communications across the straits and a pioneer zone for
scientific development of the western economic zone. The
Pingtan Haixia Bridge was completed and opened to traffic
in Nov.2010. The railway from Fuzhou to Pingtan also will be
completed in 2015.

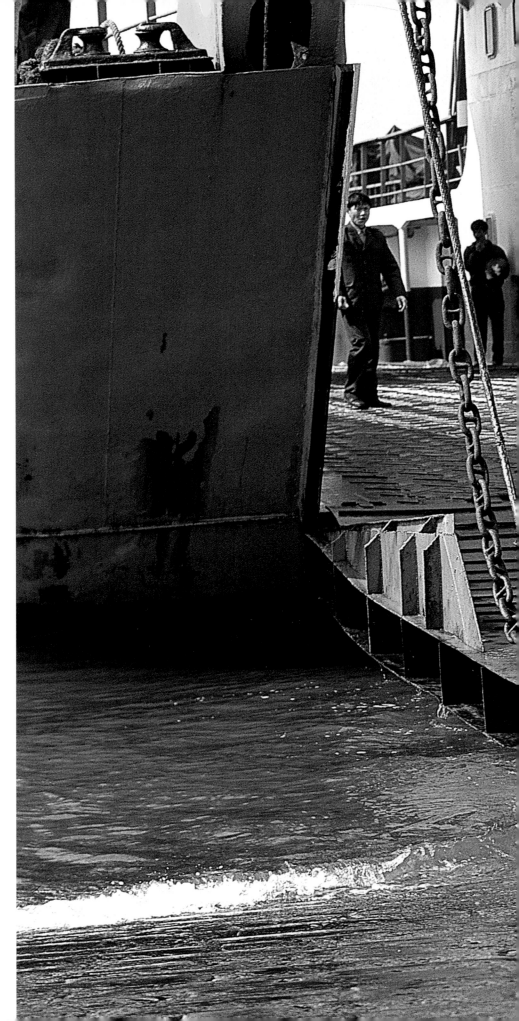

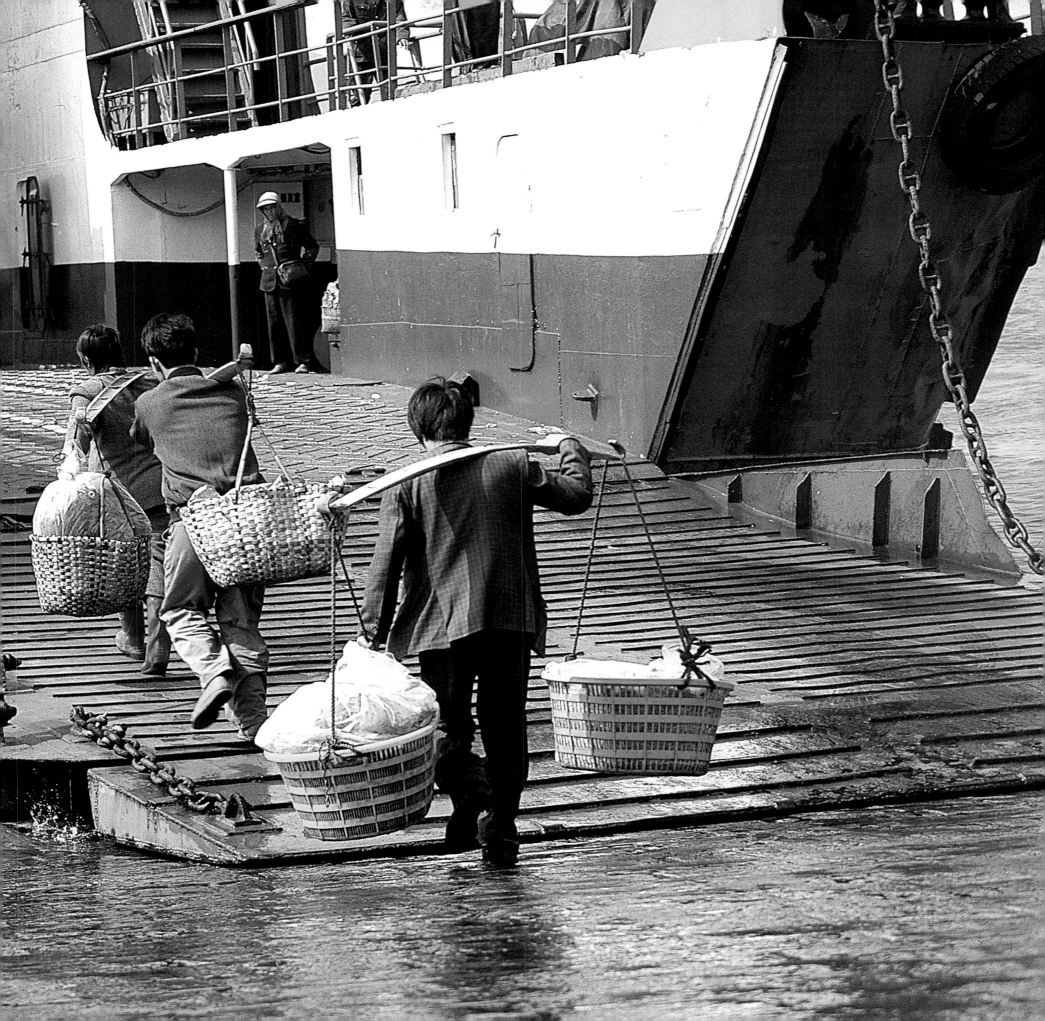

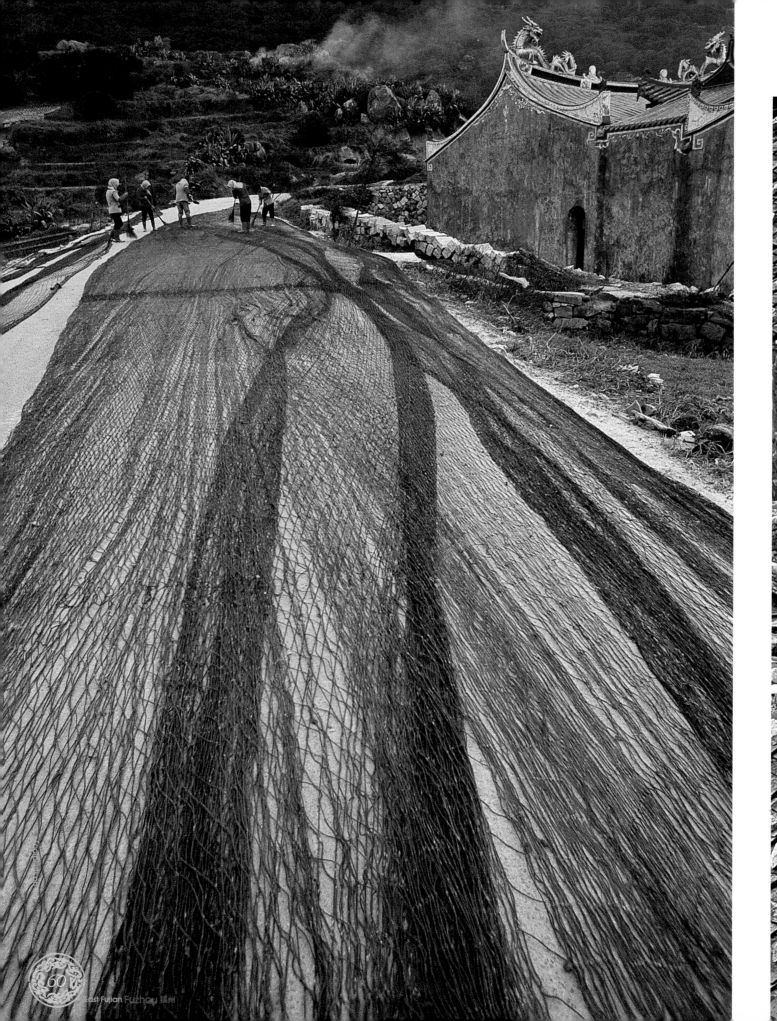

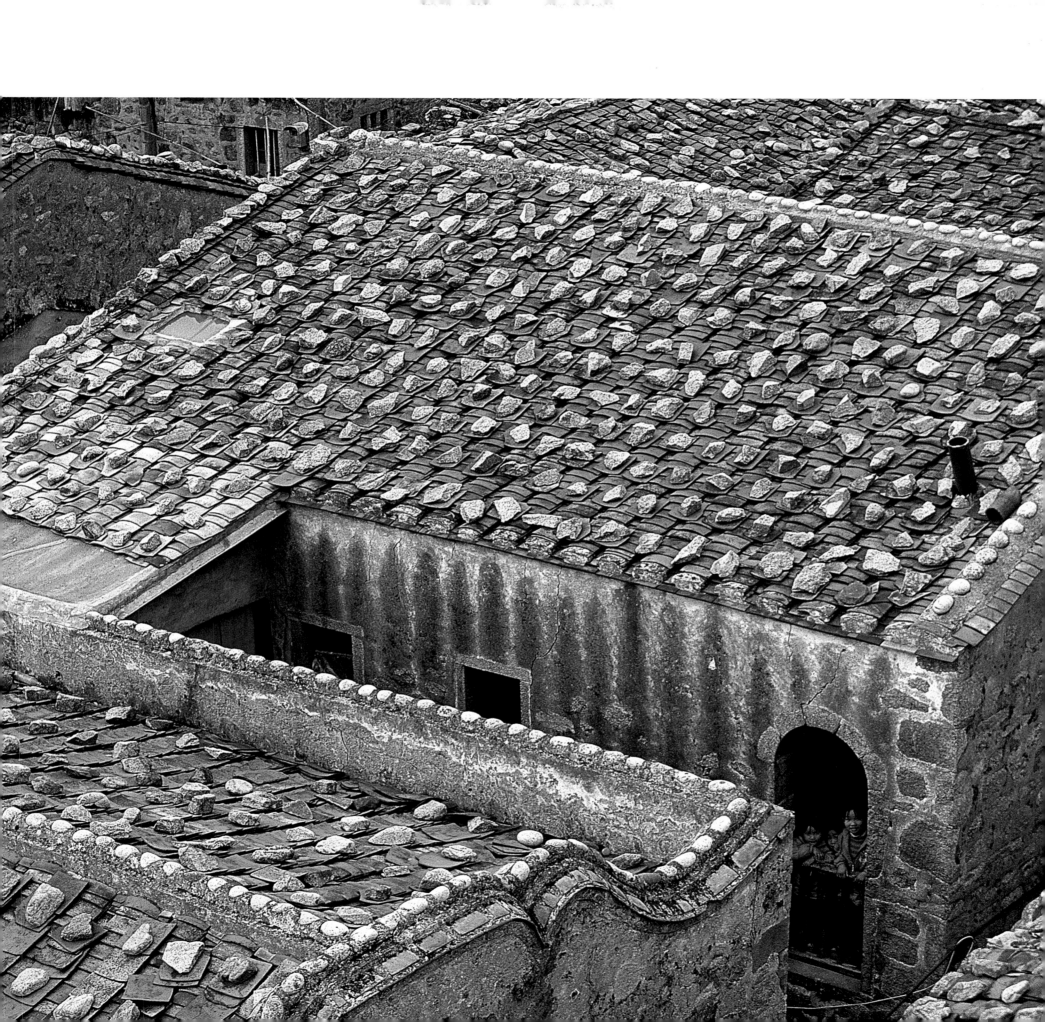

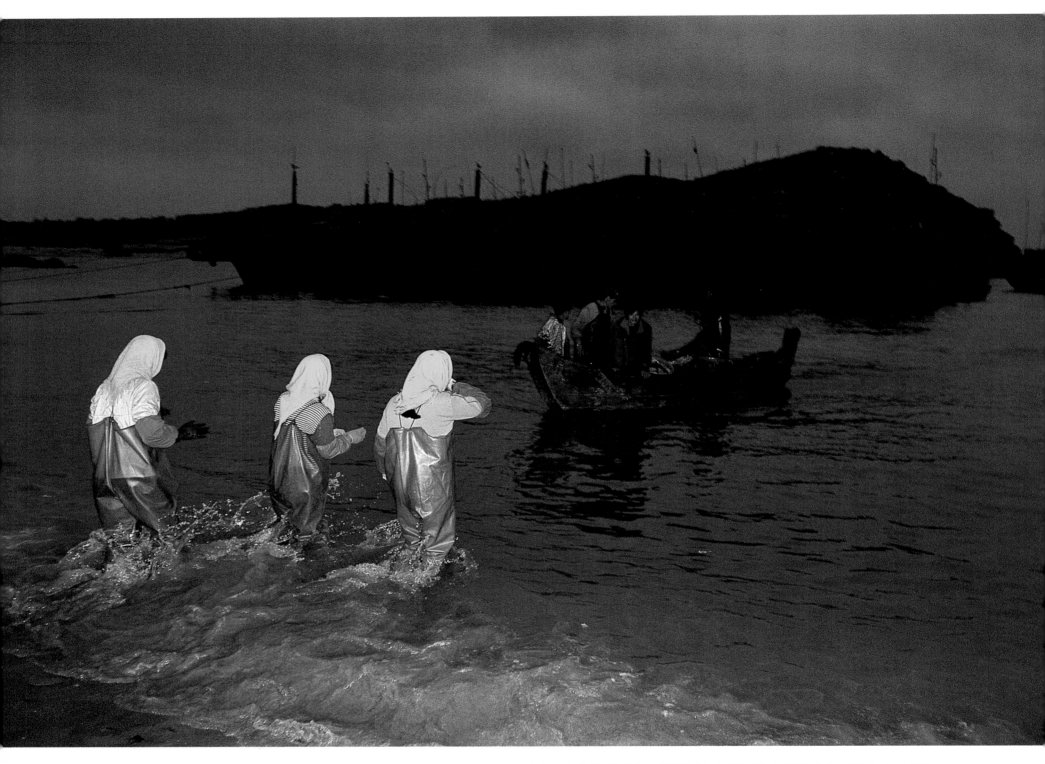

平潭渔作
Pingtan Fishing

每年的夏秋季节，"涨潮布网，退潮拉网"是平潭最传统的捕鱼方式，也是当地渔民的主要生活来源之一。天色灰蒙，便见十几个渔民奋力将船抬到岸边，而渔妇们则将网具和绳子抬到船上准备出海布网。待渔船归航后，渔妇们再将满载的鱼虾分类装筐，卖给守候在场的鱼贩子。

During each summer and autumn, casting nets when flooding and retrieving nets with the ebb tides can be seen as the most traditional way of fishing in Pingtan and also main income resources for local fishers. With the dusks, we can see fishers struggling to move the boats to the shore and their wives loading fishing gears and ropes on the boats to set nets. After the fishing boats return, the wives will resort fishes and shrimps into different baskets and then sell to the fish monger on site.

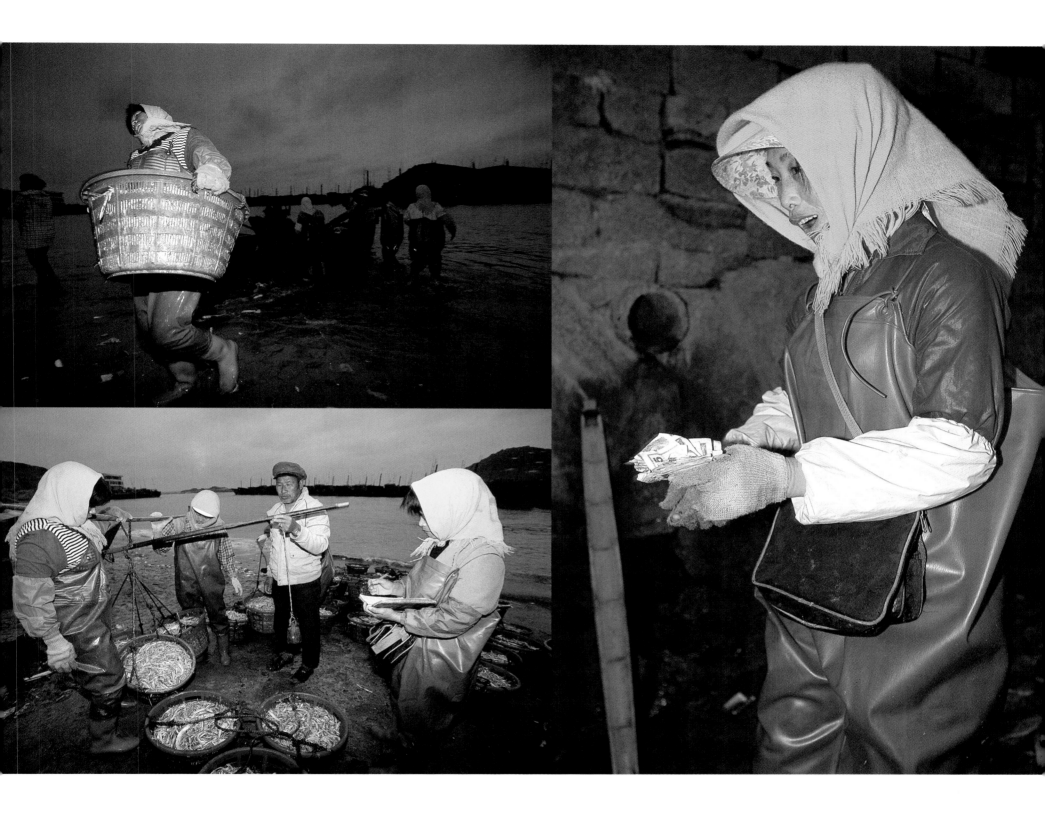

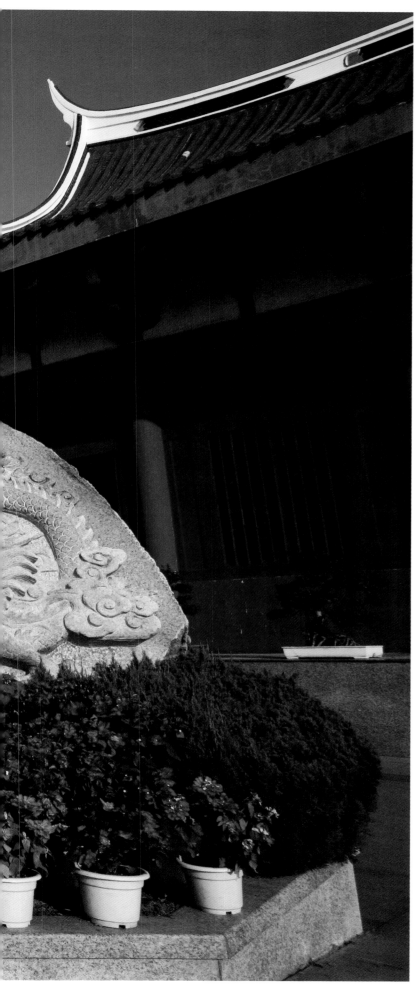

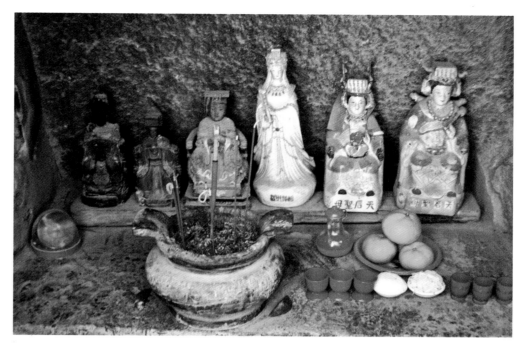

湄洲妈祖祖庙
Matsu Temple in Meizhou

位于素有"海上明珠"美誉、形如秀眉的湄洲岛北端。初建于宋代雍熙四年（公元 987 年），是为纪念妈祖而设立。一千多年来，妈祖的信仰远播海内外，分灵庙宇遍布世界各地，于是尊此为"祖庙"。

It is located to the north of Meizhou Island, reputed as the "Pearl on th Sea". Originally it was built in the 4th year of Yongxi (987 AD) of the Song dynasty to commemorate Matsu. Over one thousand years, the belief of Matsu has been spread overseas with branch temples scattered all over the world, so this place is called the ancestor temple.

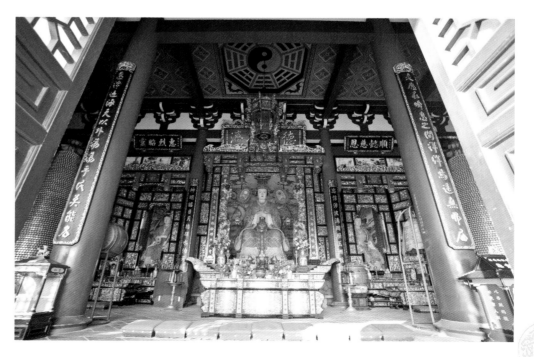

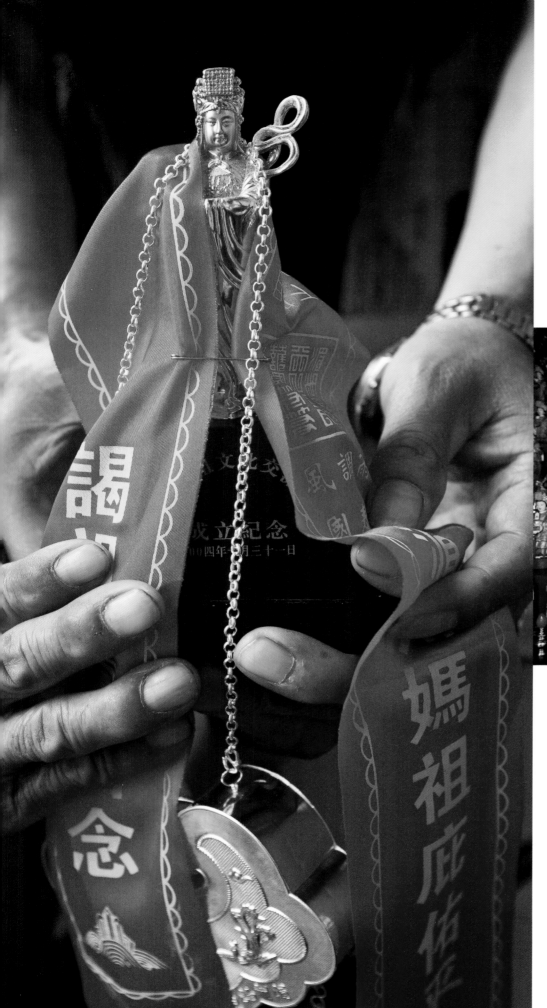

妈祖文化祭
Matsu Cultural Fete

妈祖信仰起源于北宋初期，至今已跨越一千多年的历史。民间对妈祖女神的大祭日期选在每年农历三月廿三的妈祖诞辰和九月初九的妈祖升天之日，这与历代朝廷御定的春秋二祭不谋而合，异曲同工。2008 年秋，作者恭逢"天下妈祖回娘家"的感人盛况。

The belief of Matsu can date back to the beginning of North Song dynasty, which has a span of period for more than one thousand years. Every year, on the lunar 23rd of March, Matsu's birthday, and on the 9th of September, the day on which Matsu died, the fete was held. In the autumn of 2008, the author witnessed the grand scenery of Matsu's return to hometown.

Footprints on the Ancestral Land

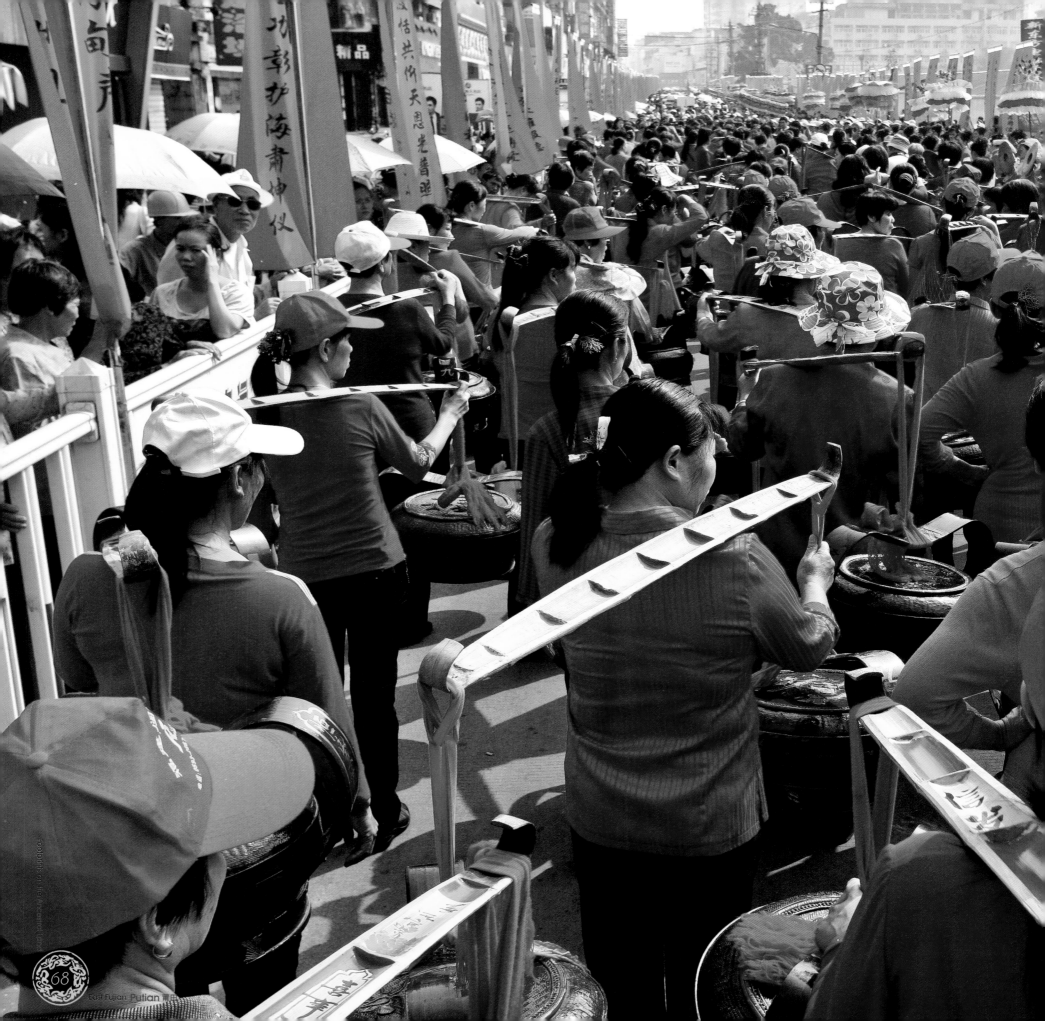

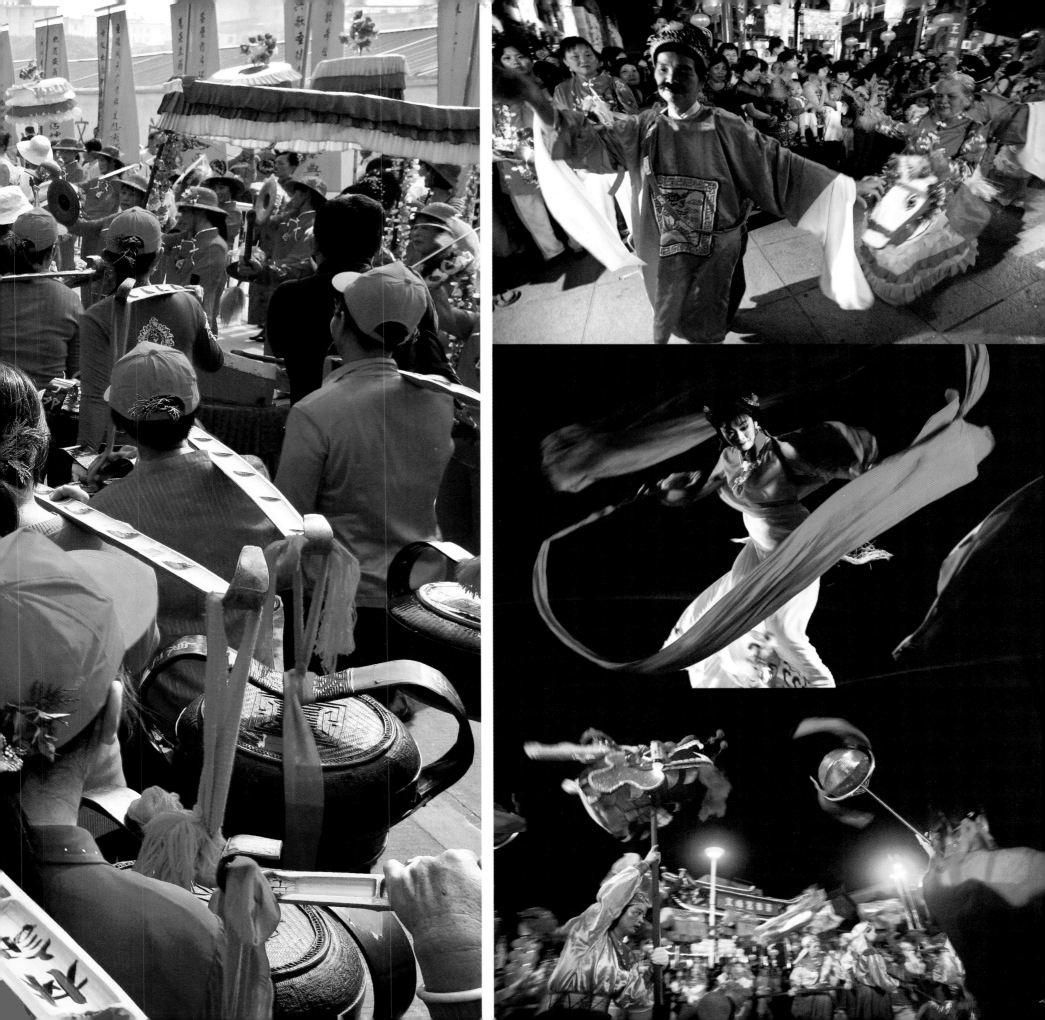

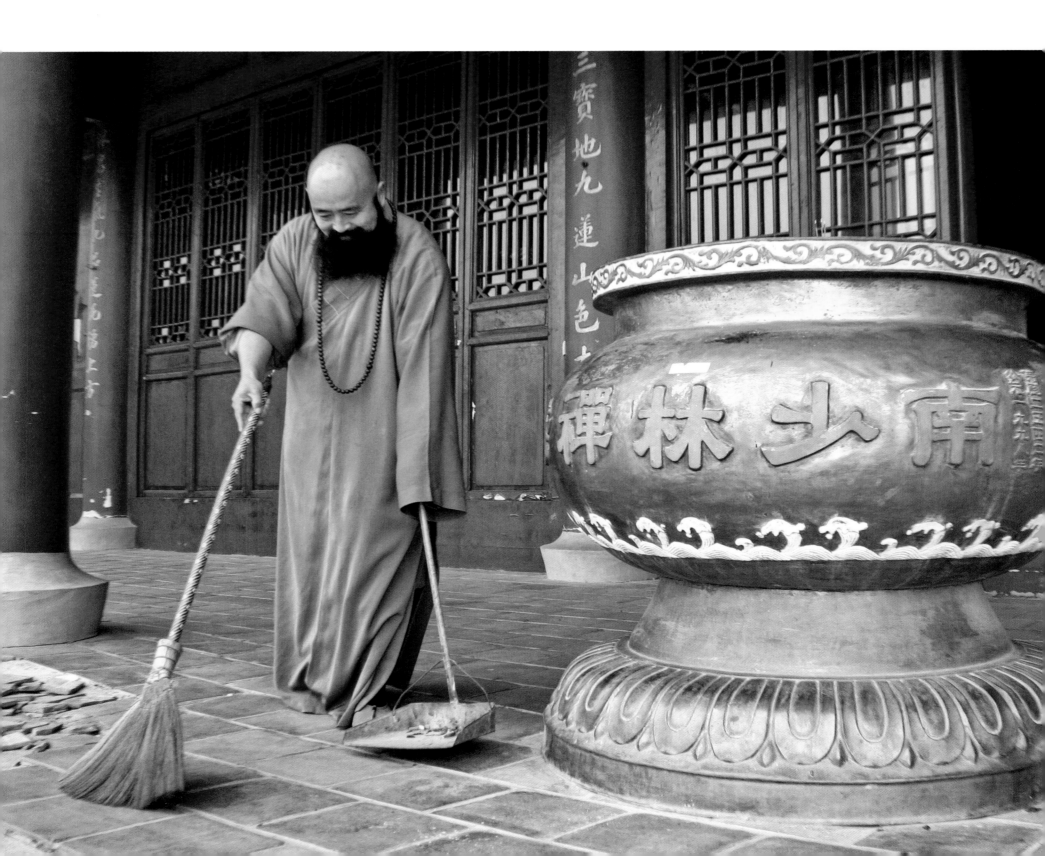

南少林寺
South Shaolin Temple

位于莆田市荔城区西天尾镇九华山，不但是南派拳种的重要发祥地、弘扬少林文化的圣地，也是习武健身的最佳学堂。

Located in the Qiuhua Mountain in Xitianwei Town, Licheng District of Putian City, the South Shaolin Temple is not only the originating place for South Schools of Chinese boxing and holy place for promoting Shaolin culture, but also provides the best classes for martial exercises.

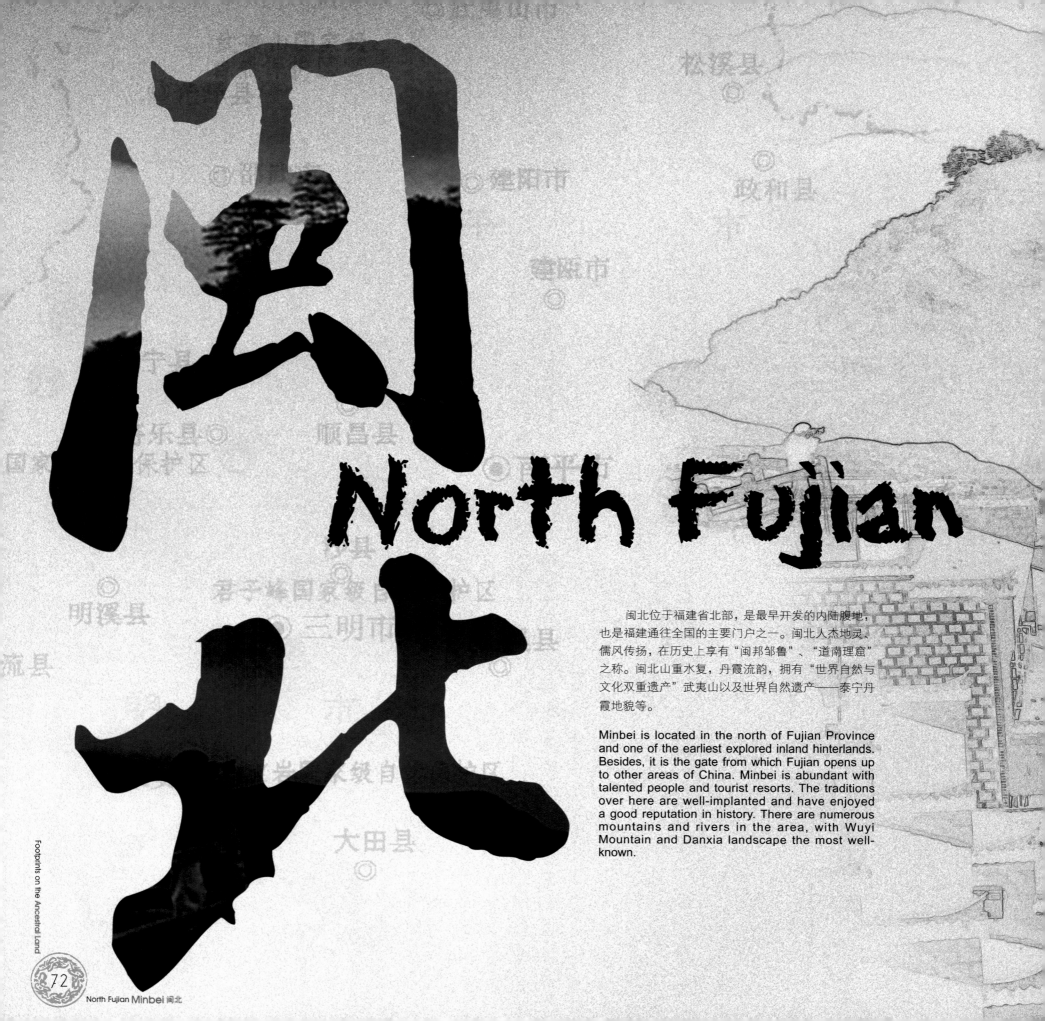

闽北 North Fujian

闽北位于福建省北部，是最早开发的内陆腹地，也是福建通往全国的主要门户之一。闽北人杰地灵、儒风传扬，在历史上享有"闽邦邹鲁"、"道南理窟"之称。闽北山重水复，丹霞流韵，拥有"世界自然与文化双重遗产"武夷山以及世界自然遗产——泰宁丹霞地貌等。

Minbei is located in the north of Fujian Province and one of the earliest explored inland hinterlands. Besides, it is the gate from which Fujian opens up to other areas of China. Minbei is abundant with talented people and tourist resorts. The traditions over here are well-implanted and have enjoyed a good reputation in history. There are numerous mountains and rivers in the area, with Wuyi Mountain and Danxia landscape the most well-known.

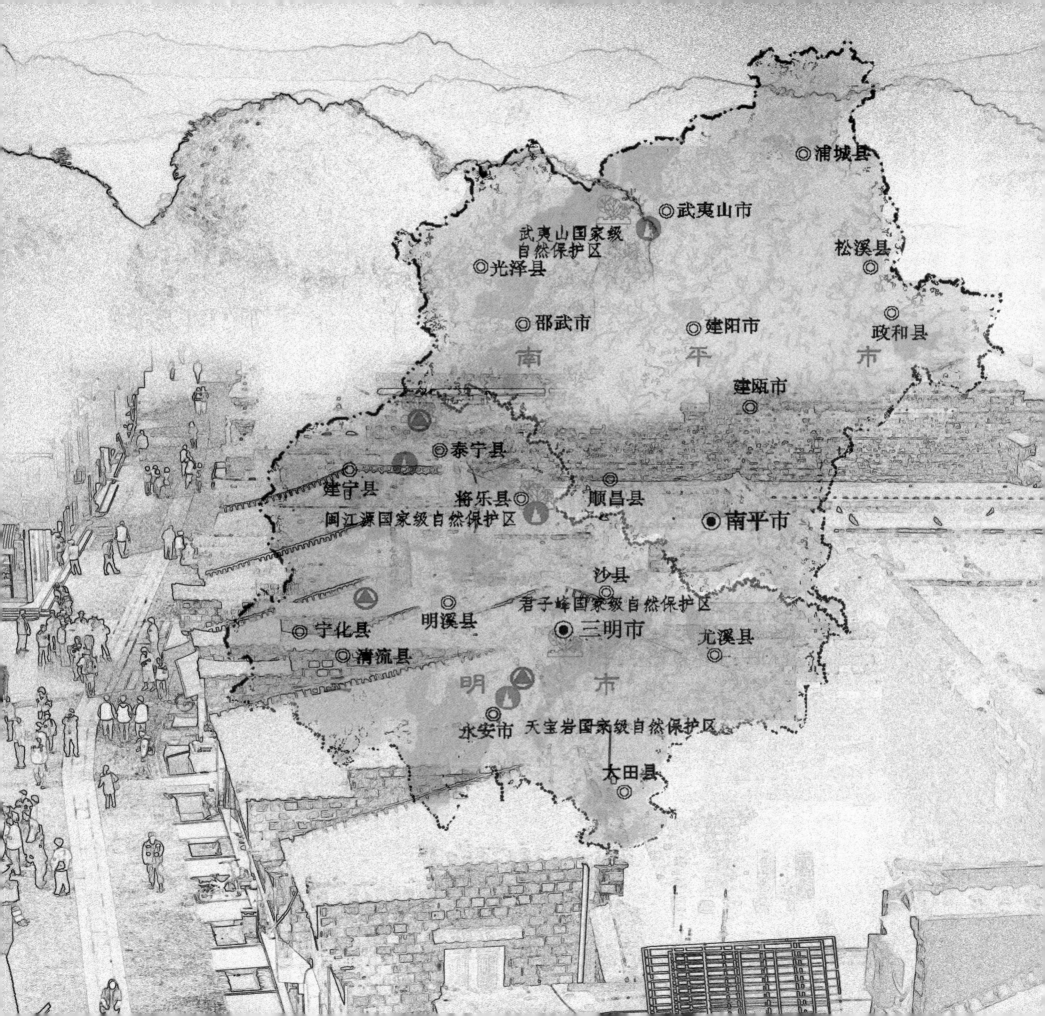

◎浦城县

◎武夷山市

松溪县
◎

武夷山国家级
自然保护区

◎光泽县

政和县
◎

◎邵武市

◎建阳市

南　　　　平　　　　市

建瓯市
◎

◎泰宁县

建宁县

将乐县◎

顺昌县

◎南平市

闽江源国家级自然保护区

沙县
◎

君子峰国家级自然保护区

◎宁化县

明溪县

◎三明市

尤溪县
◎

◎清流县

三　　　　明　　　　市

永安市　天宝岩国家级自然保护区

大田县
◎

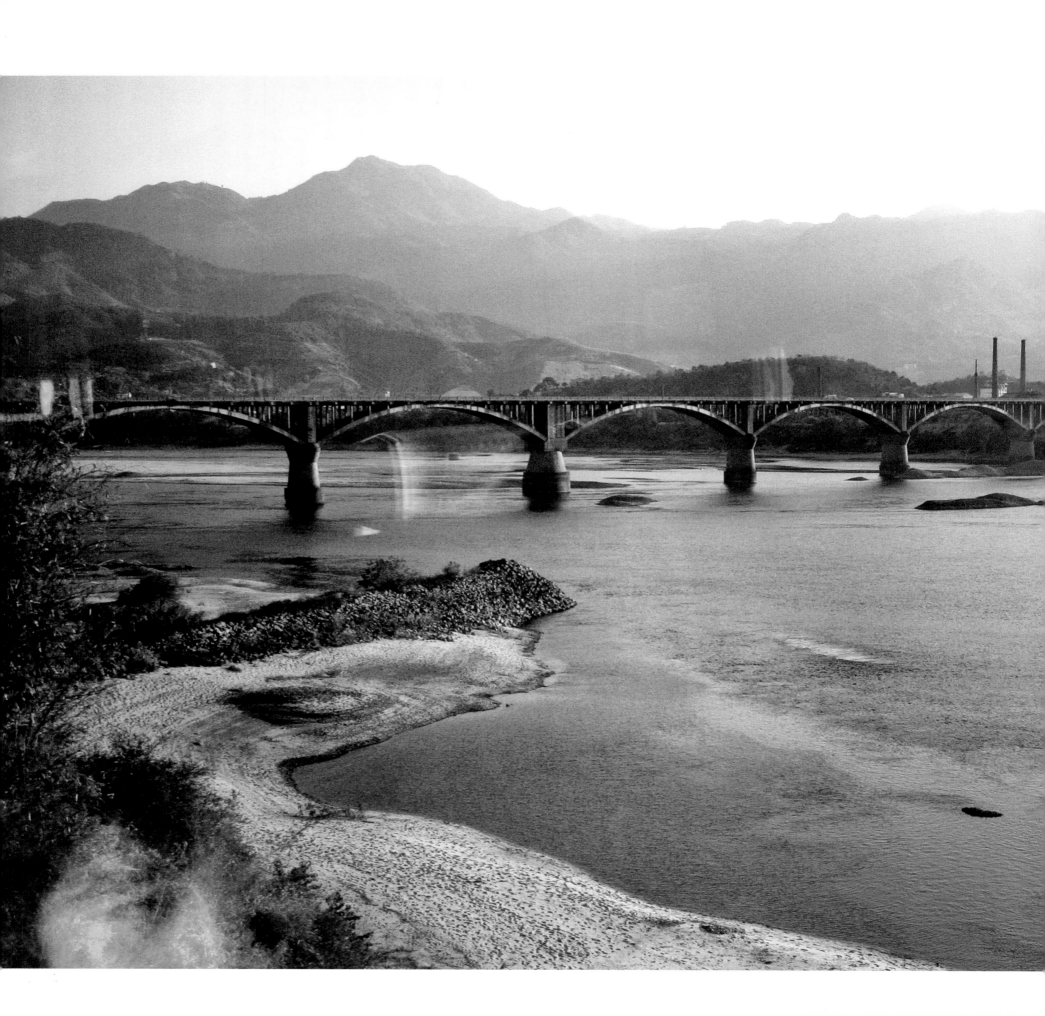

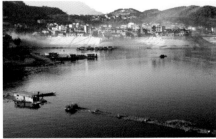
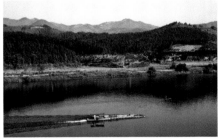

福州 ←→ 武夷山
Fuzhou
to
Wuyi Mountain

武夷山交通非常便利，从福州到武夷山飞机、铁路、公路皆可到达，沿途风光明媚，美不胜收。附图为作者 2003 年 11 月从行进的火车上偶拾的山水美景。

Thanks to the convenient transportation in Wuyi Mountain, we can go to Wuyi Mountain from Fuzhou by plane, railway, bus or car. Along the way, there are lots of spectacular sceneries. Attached are the pictures taken by the author in November, 2003 on the way to Wuyi Mountain.

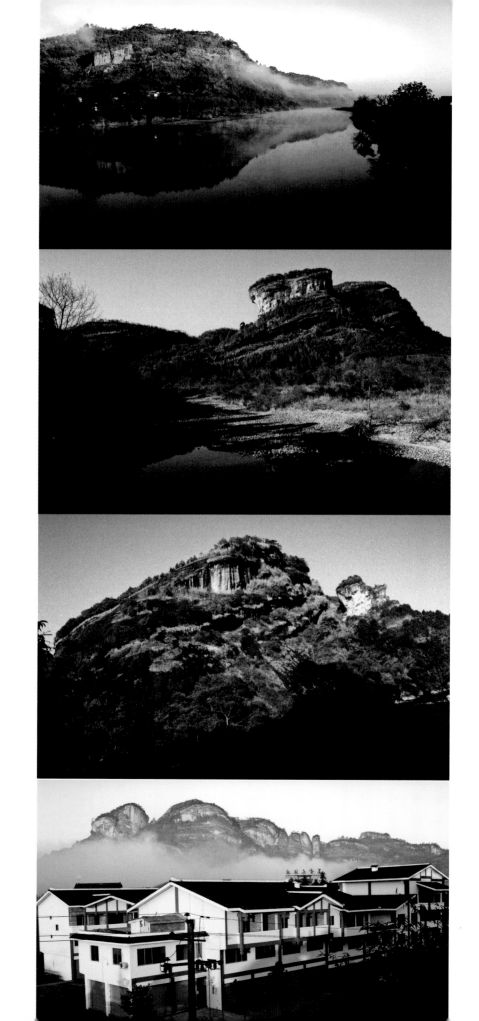

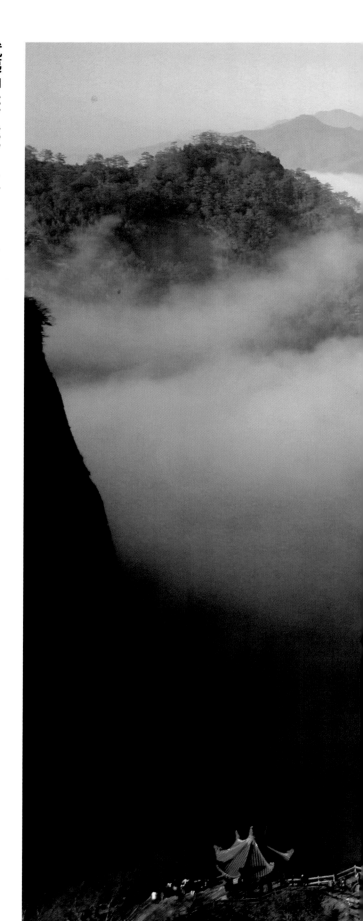

武夷山 Wuyi Mountain

位于武夷山脉中部、福建省武夷山市境内，方圆 60 平方公里，属典型的丹霞地貌，素有『碧水丹山』、『奇秀甲东南』之美誉，是首批国家级重点风景名胜之一，于 1999 年 12 月被联合国教科文组织列入《世界遗产名录》，成为『世界自然与文化双遗产』。

Wuyi Mountain lies in the middle ridge of Wuyi Mountain range and in the city of Wuyishan, covering an area of 60 square kilometers. It belongs to the typical Danxia landform, characterized by blue waters and red mountains, enjoying the reputation of most unique scenery of Southeast China. As one of the first important tourist resorts of national level, it was listed in the world heritage site catalog by UNICEF in Dec. of 1999 and became the World natural and cultural heritage.

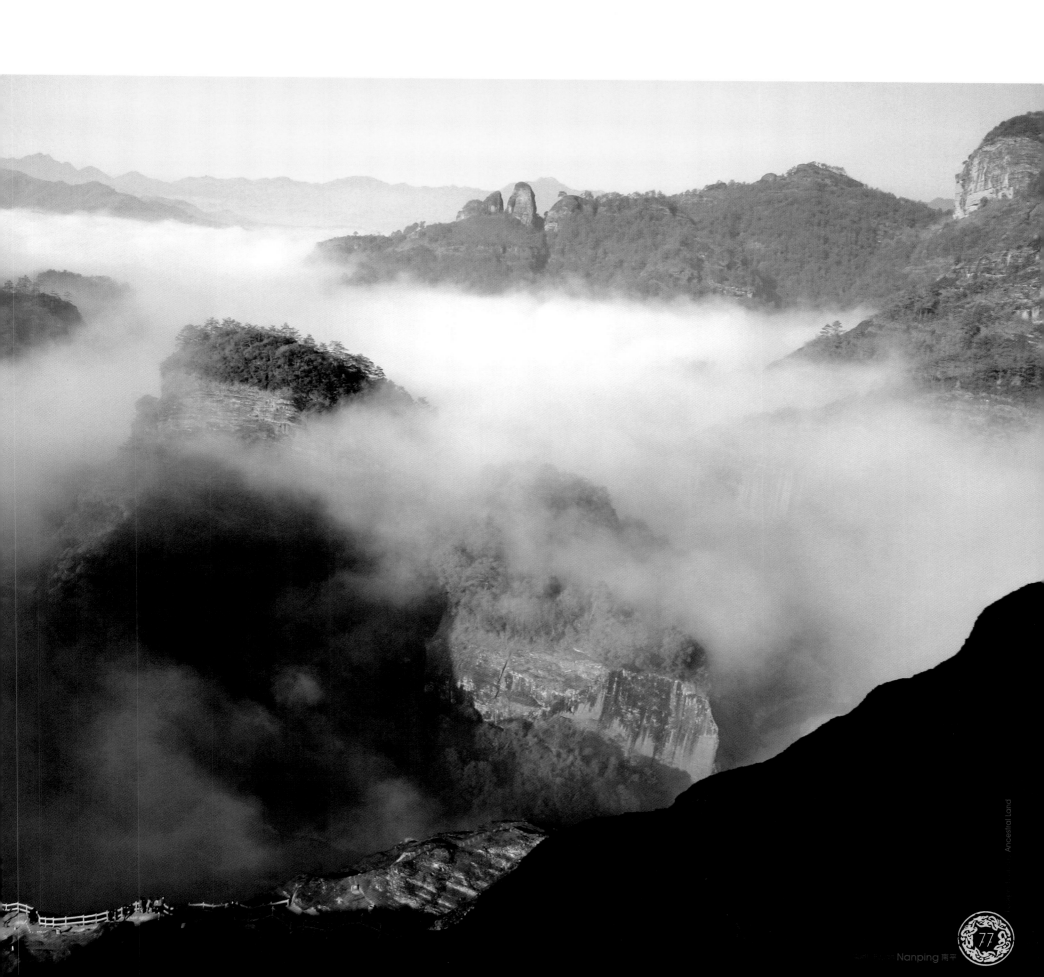

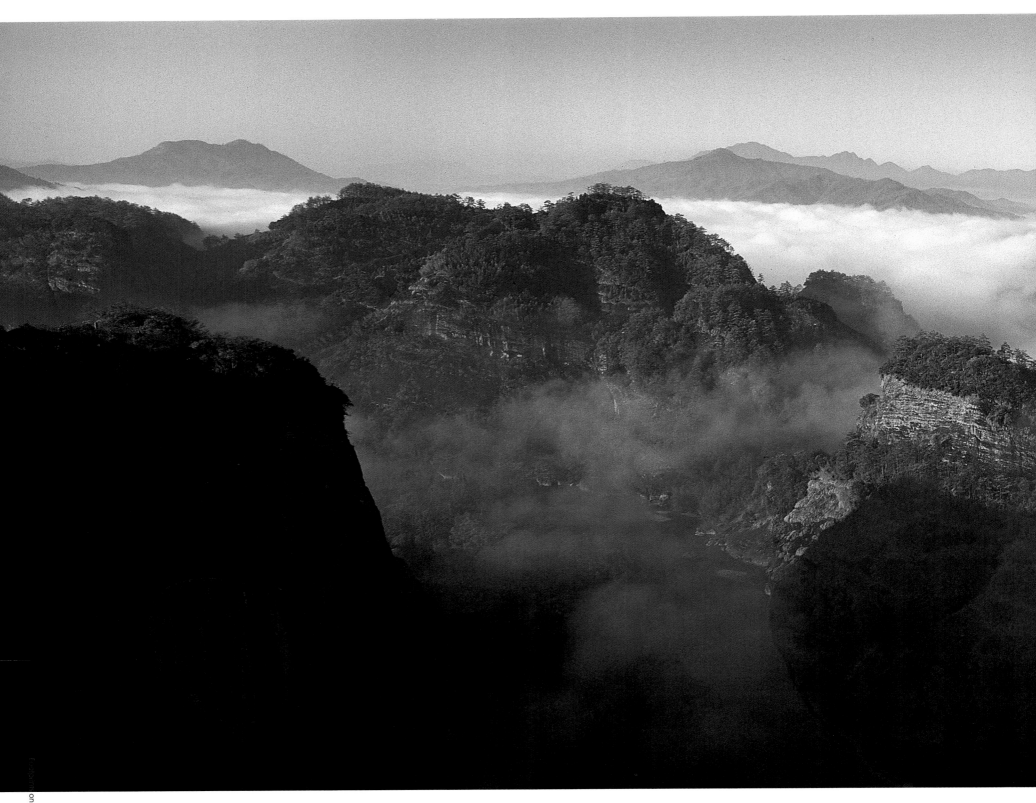

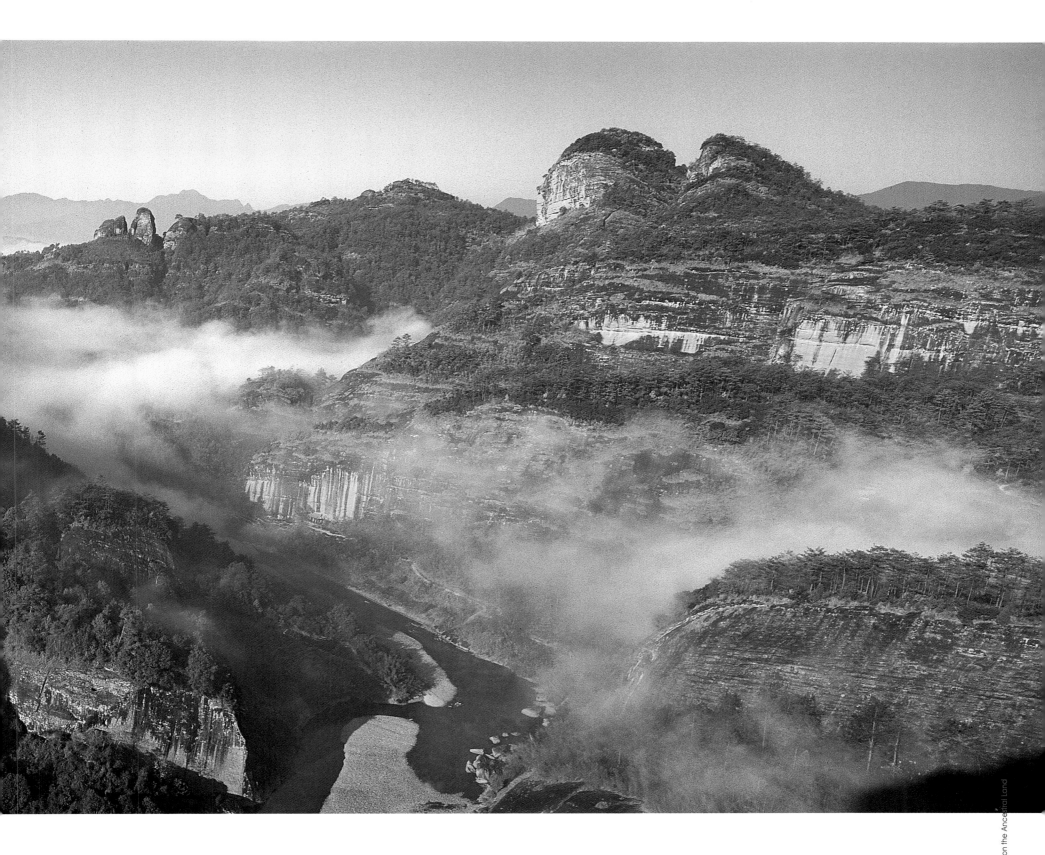

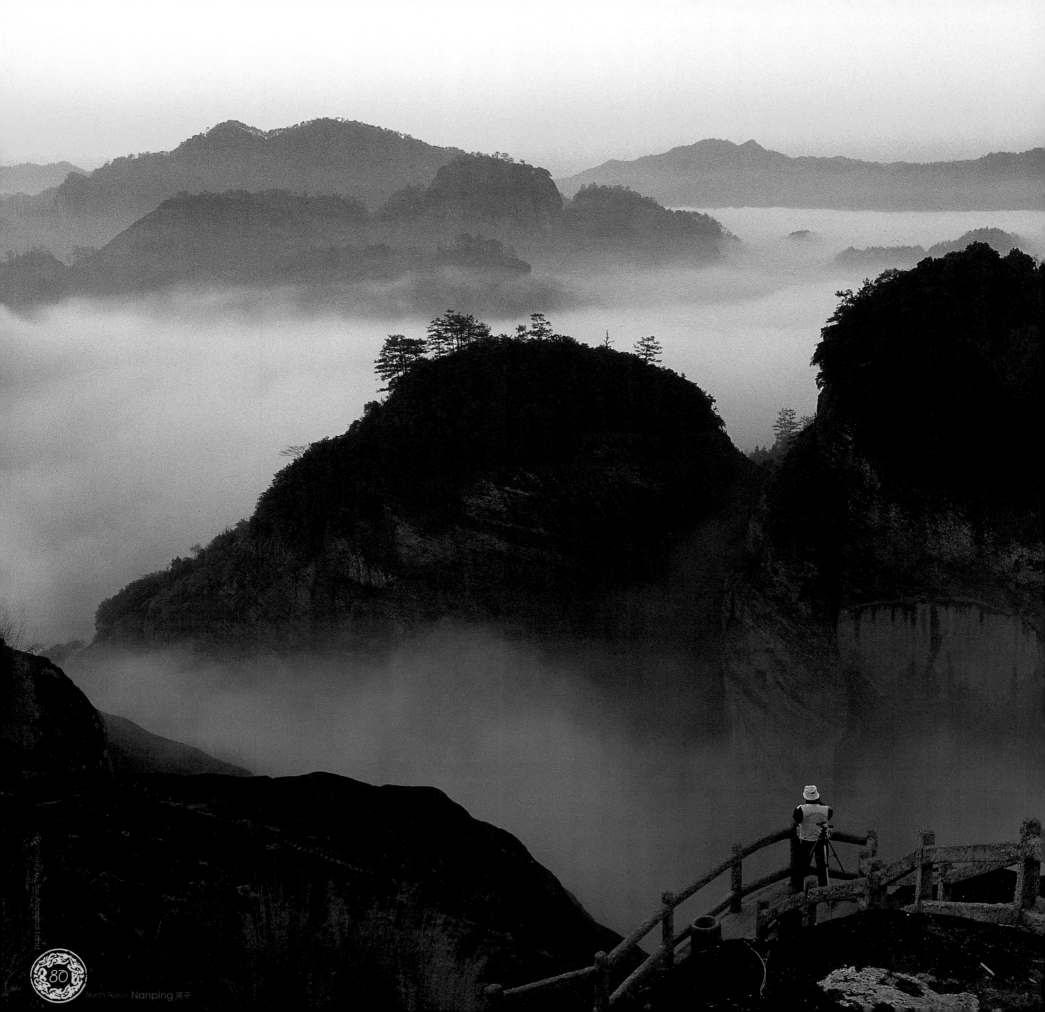

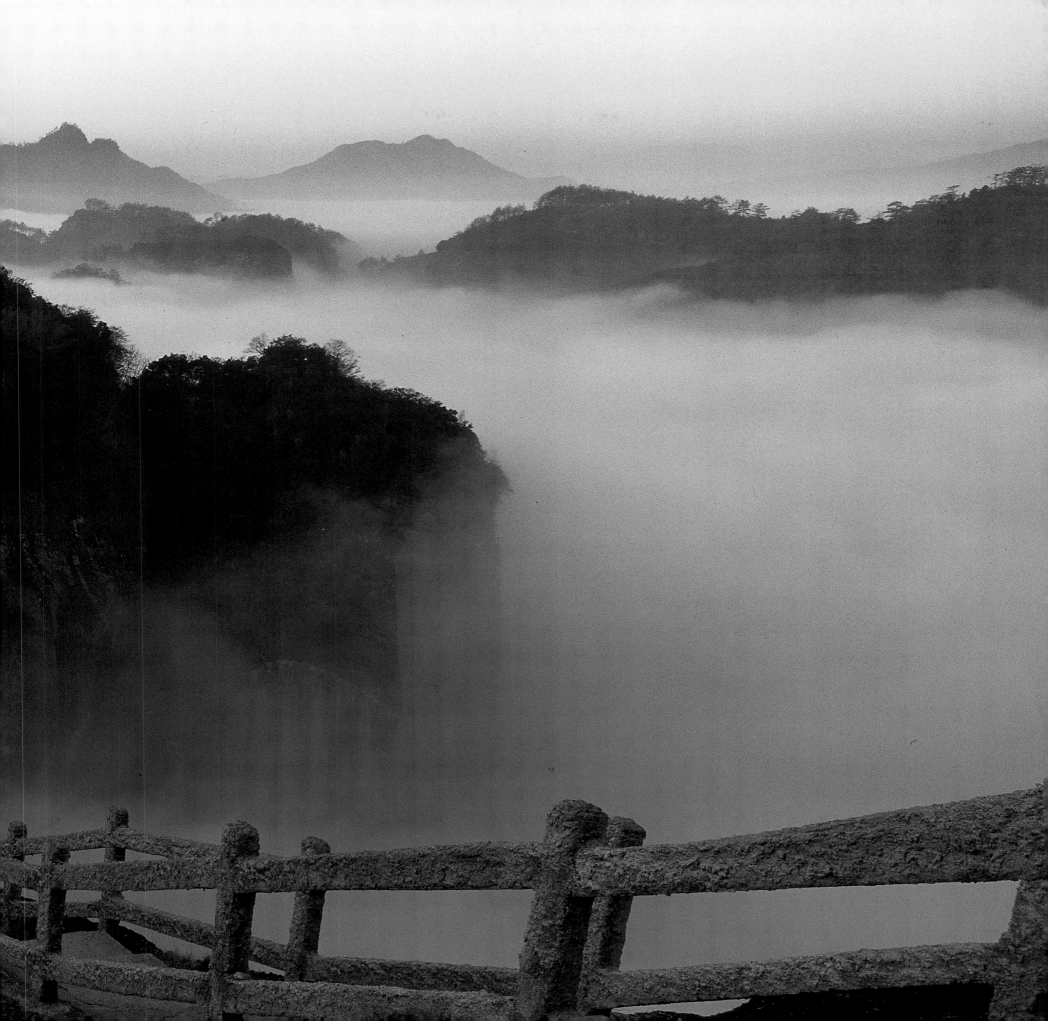

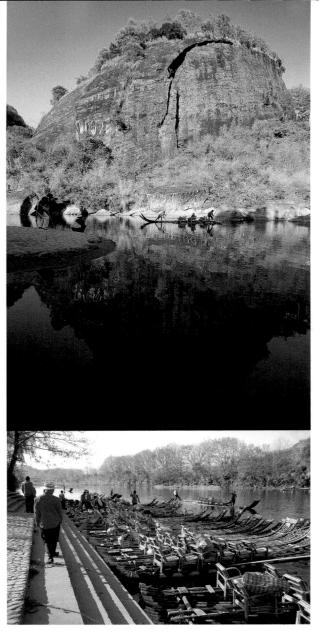

九曲溪
Jiuqu Stream

武夷山有三十六峰、九十九岩,峰岩交错、溪流纵横。九曲溪贯穿其中,蜿蜒十五华里,山挟水转、水绕山行,每一曲都有不同景致的山水画意;诗云"溪流九曲泻云液,山光倒浸清涟漪"正是它的最佳写照。

Wuyi Mountain has 36 peaks, 99 rocks, with the summits overlapped with rocks and all streams surrounding the mountains. Jiuqu stream runs through and winds for 15 Chinese miles. Hills and rives are surrounded by each other and every twist has a unique scenery.

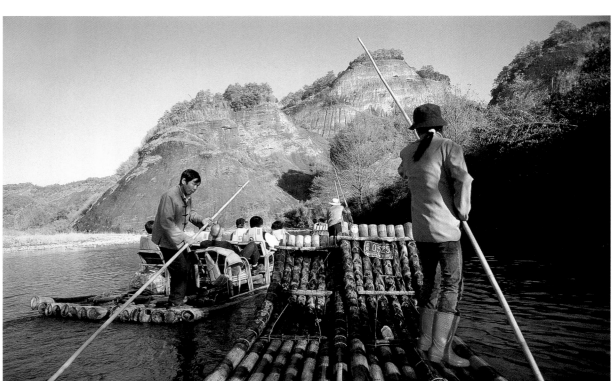

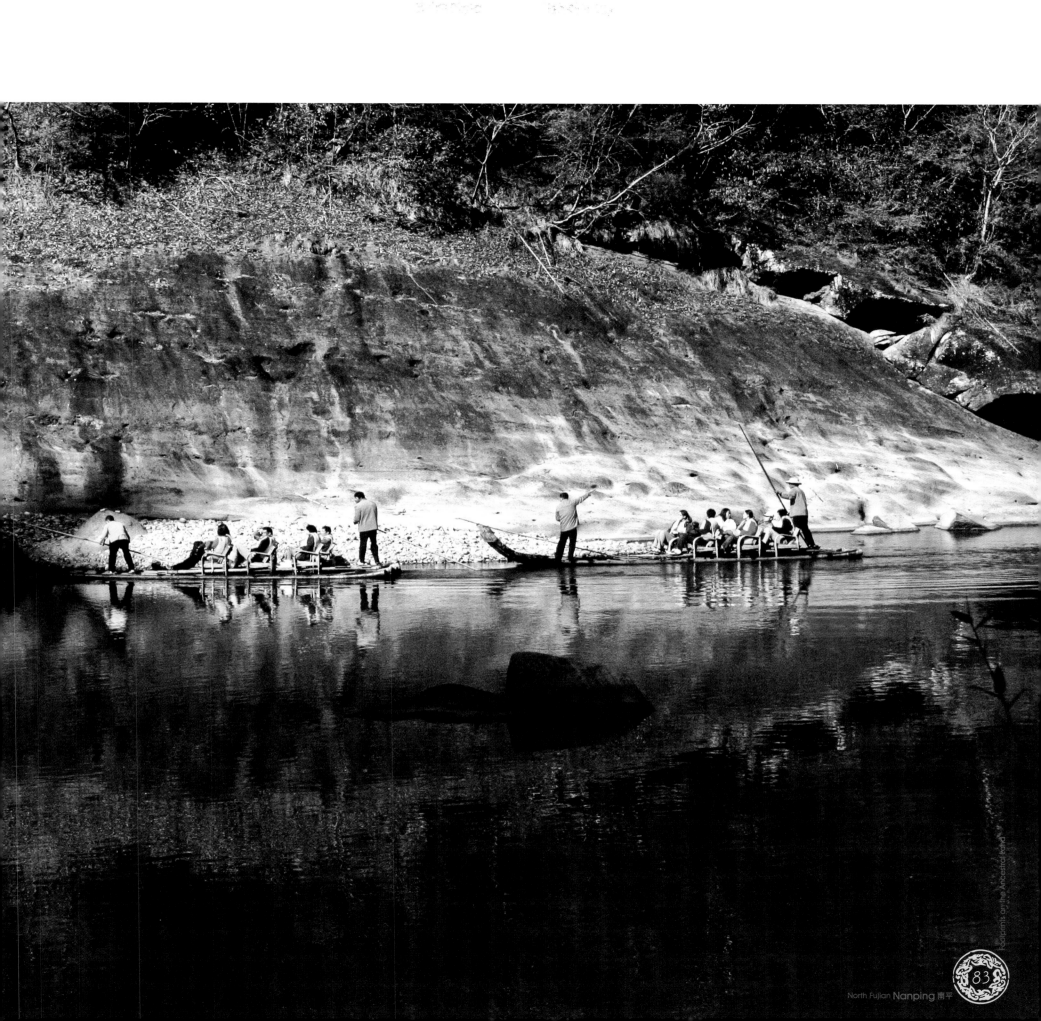

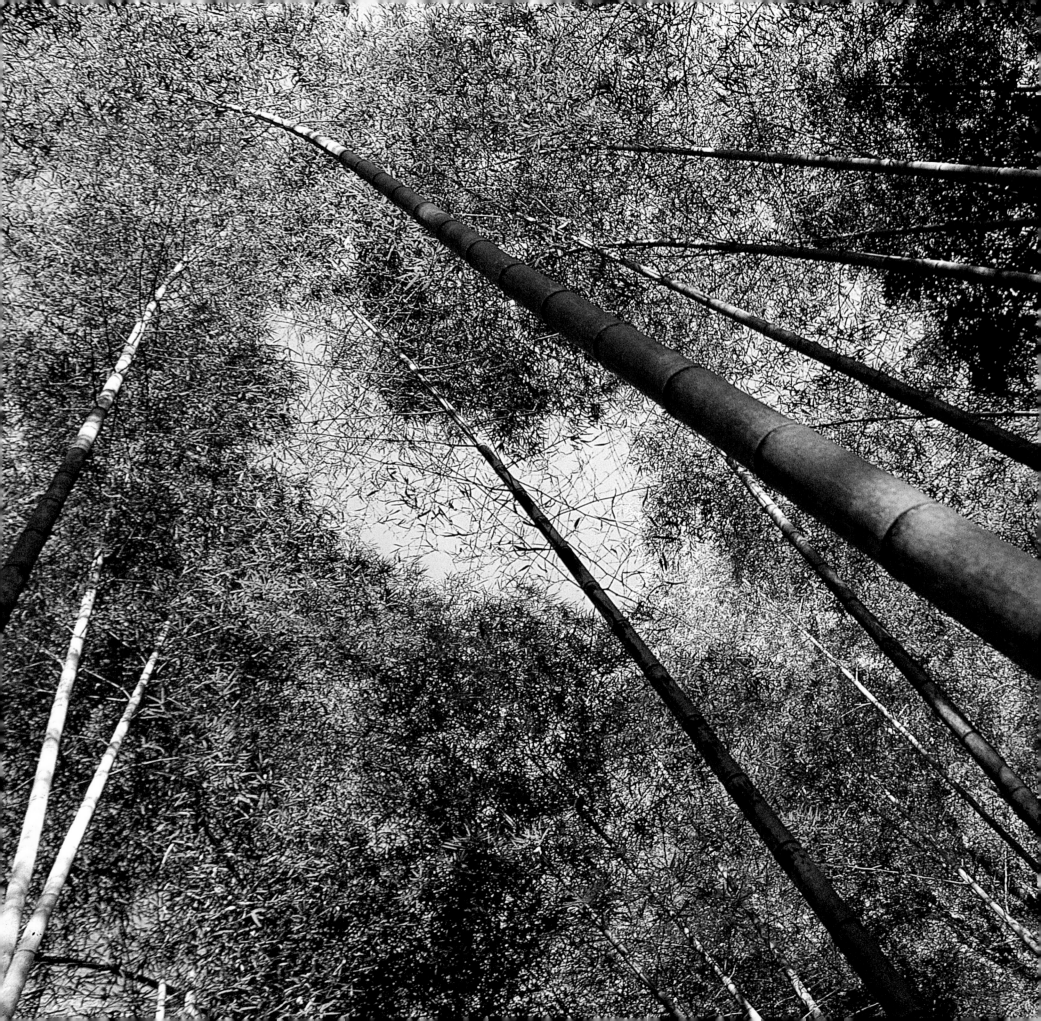

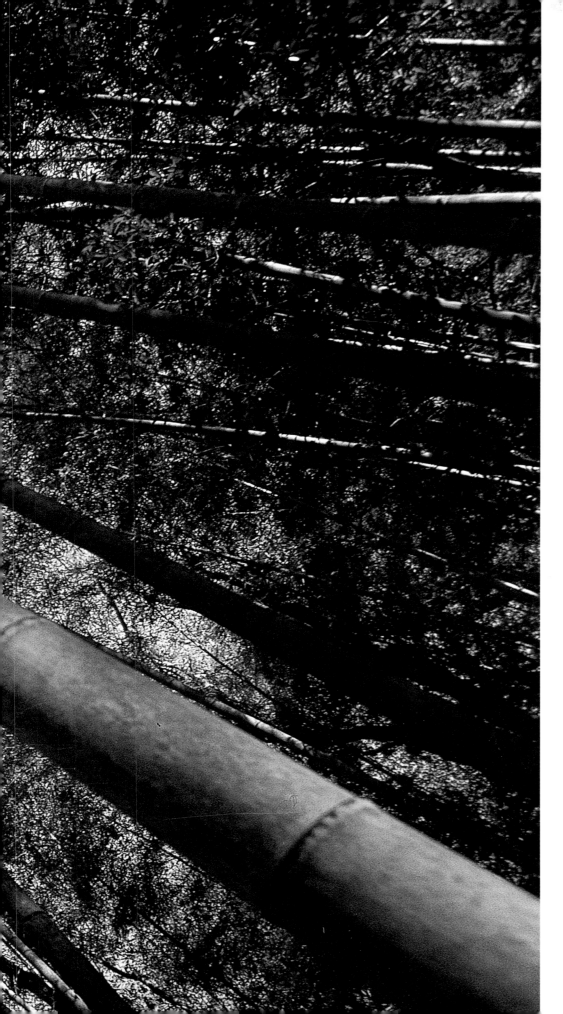

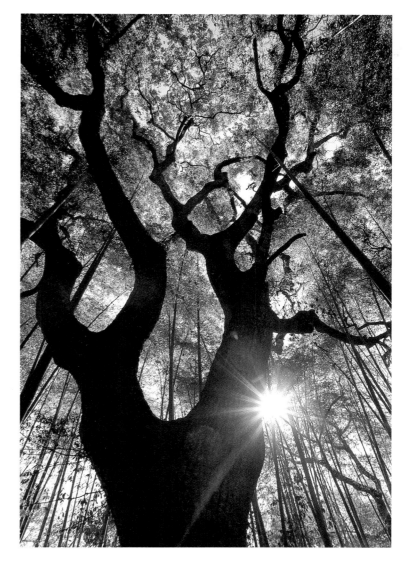

毛竹林 |
Bamboo Forest

南平是中国南方的重要林区，林地面积高达 2,946 万亩，森林覆盖率 74.7%，绿化程度 93.1%，其中拥有毛竹林 535 万亩。因此享有 "南方林海" 、 "中国竹乡" 之美誉。

Nanping is a big wood origin in South China, with a coverage of up to 29460 thousand acres and a forest coverage ratio of 74.7 percent, and greening ratio of 93.1 percent. Among them bamboo forest accounts for 5350 thousand acres. It is thus called wood sea in the south and bamboo hometown in China.

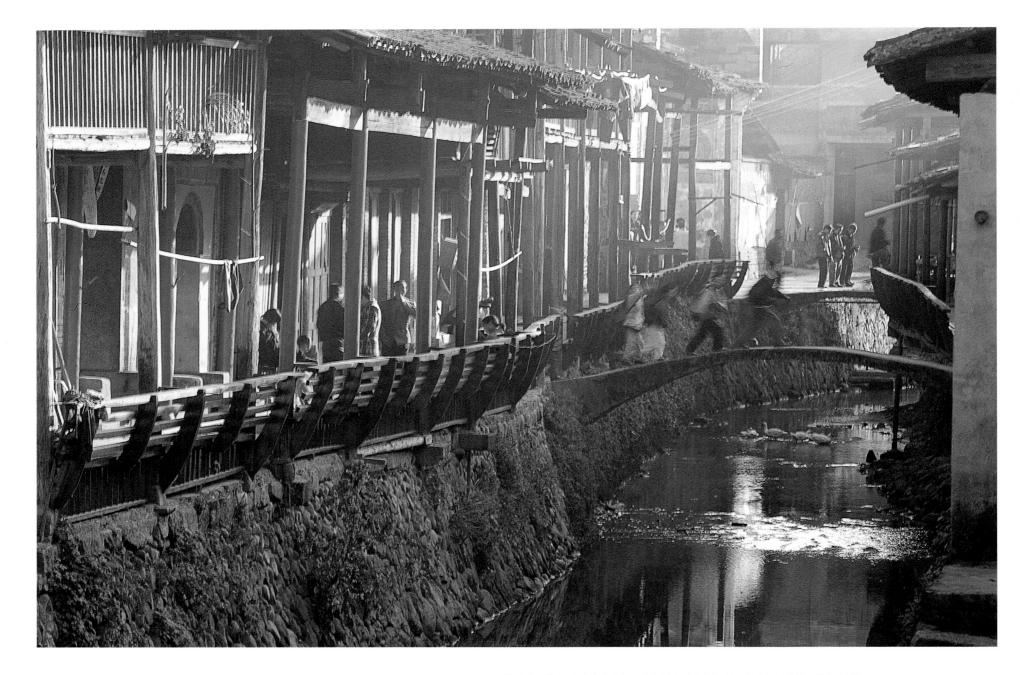

下梅村
Xiamei Village

位于武夷山市东部，由于该村在梅溪下游，故名。清康熙、乾隆年间，下梅村曾是武夷山的茶市，兴盛一时，现仍保留具有清代建筑特色的古民居 30 多幢。这些集砖雕、石雕、木雕艺术于一体的古民居建筑群，是武夷山文化遗产的一部分。

It is located in the eastern part of Wuyishan city. It lies at the downstream of the Mei Stream and got the name as such. Back in the Qing dynasty, it was a very popular tea market. Up to now there still remain more than 30 buildings of the architectural style in the Qing dynasty. These ancient inhabitant buildings incorporate brick carving, stone carving and wood carving and are an integral part of Wuyishan cultural heritage.

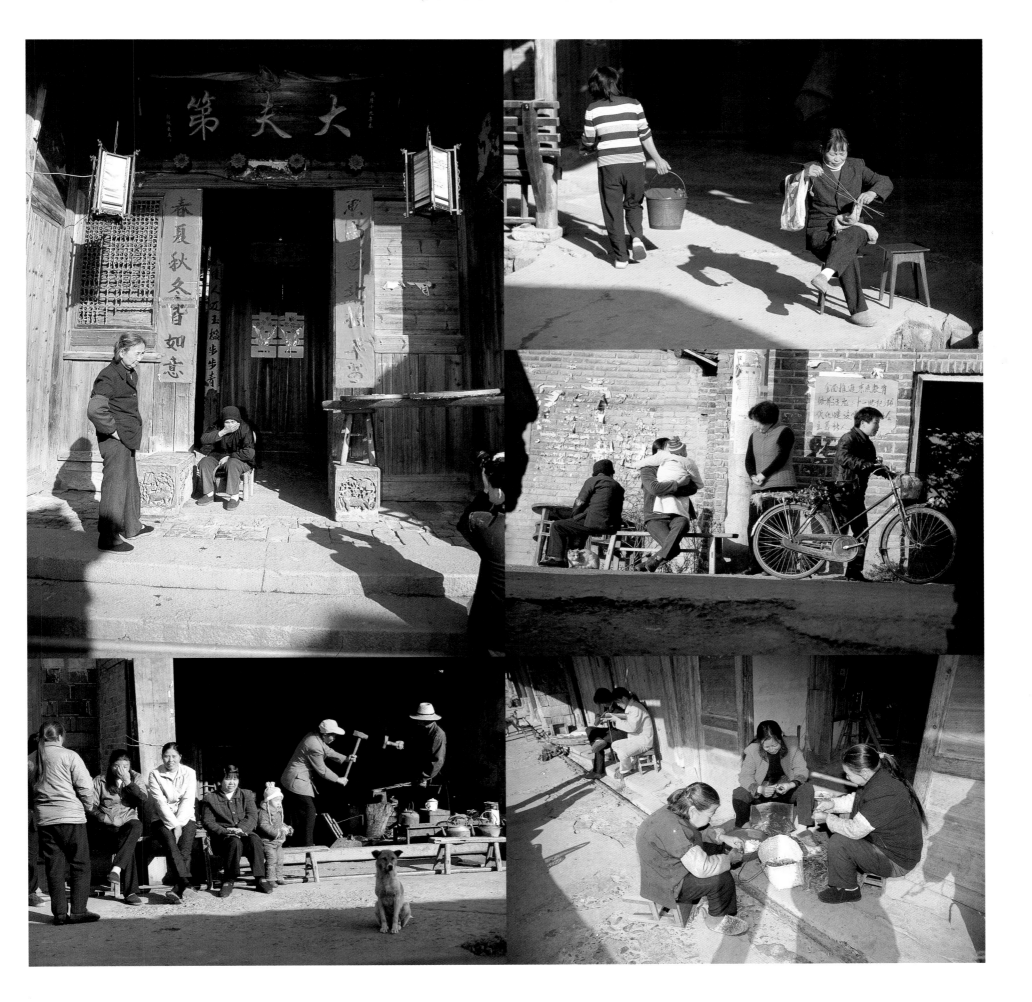

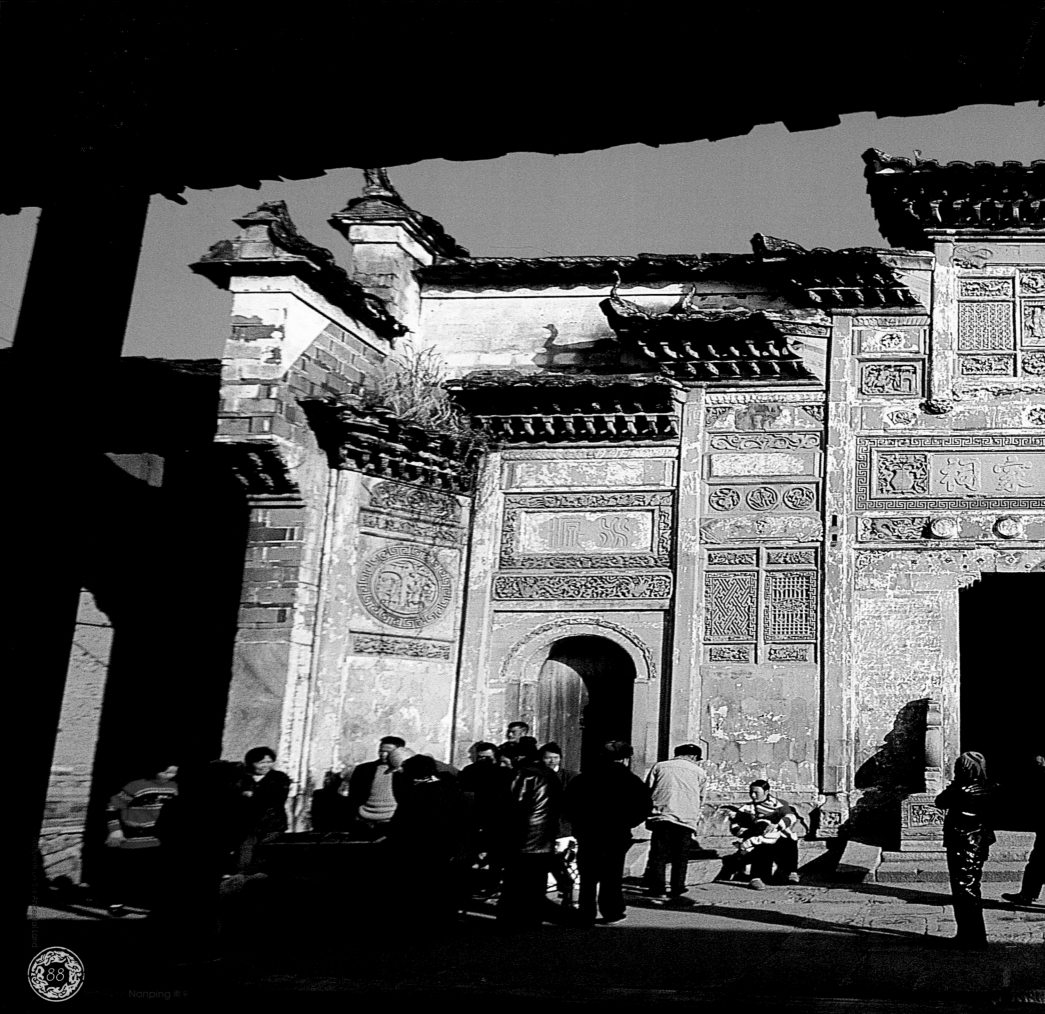

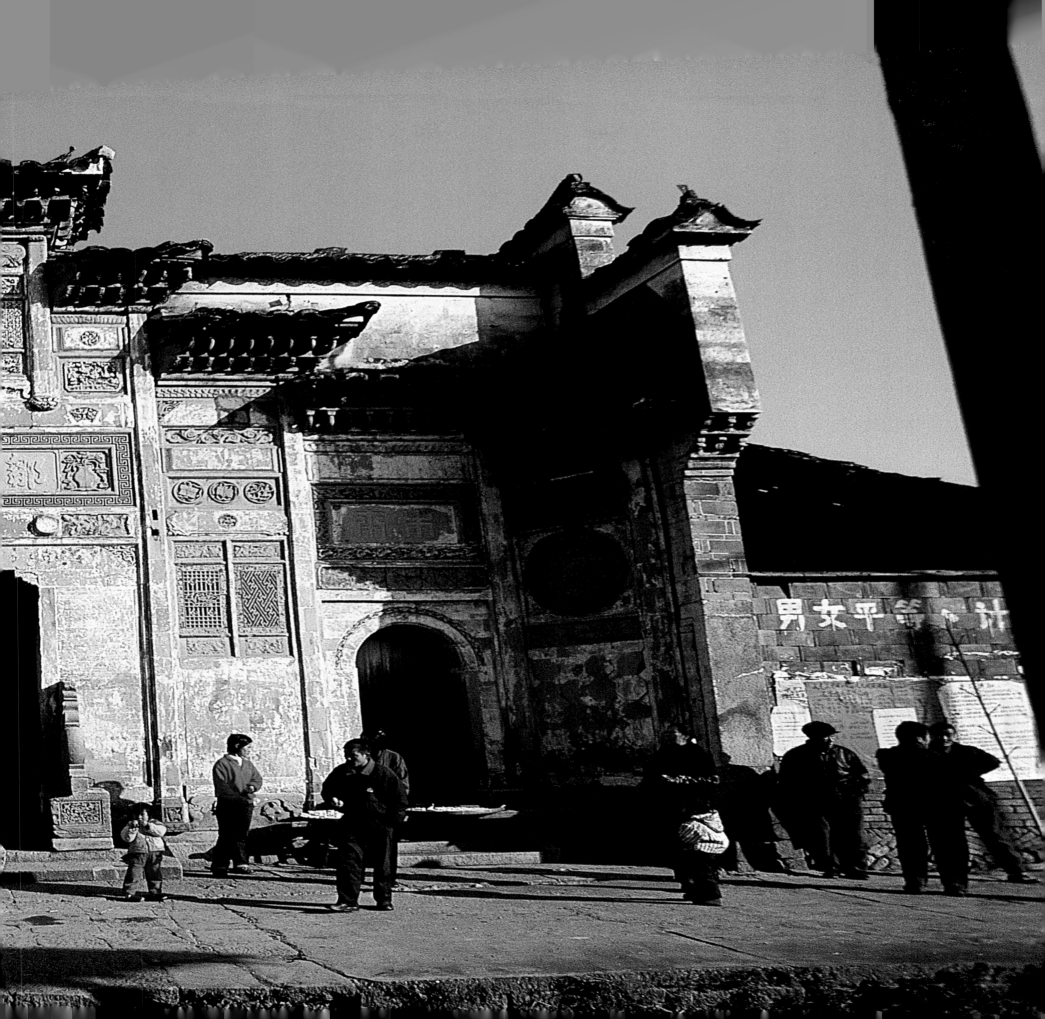

武夷山斗牛
Wuyi Mountain Bull-fighting

武夷山斗牛是"牛与牛斗"，不同于西班牙的人与牛斗，被誉为"东方文明斗牛"。获得胜场最多的牛主，将会牵着披红挂彩的斗牛绕场一周，接受观众的喝彩。

It is actually the fights between bulls, which differs from the Spanish-style bullfighting. It is reputed as oriental cultural bullfighting. The owner of the bull that wins the most rounds will lead the fighting bull for one round of the arena and embrace the audience's applauses.

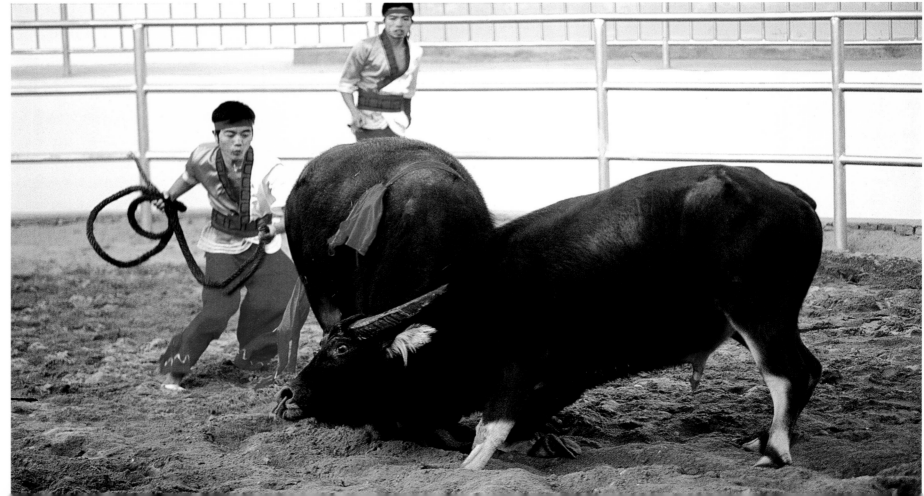

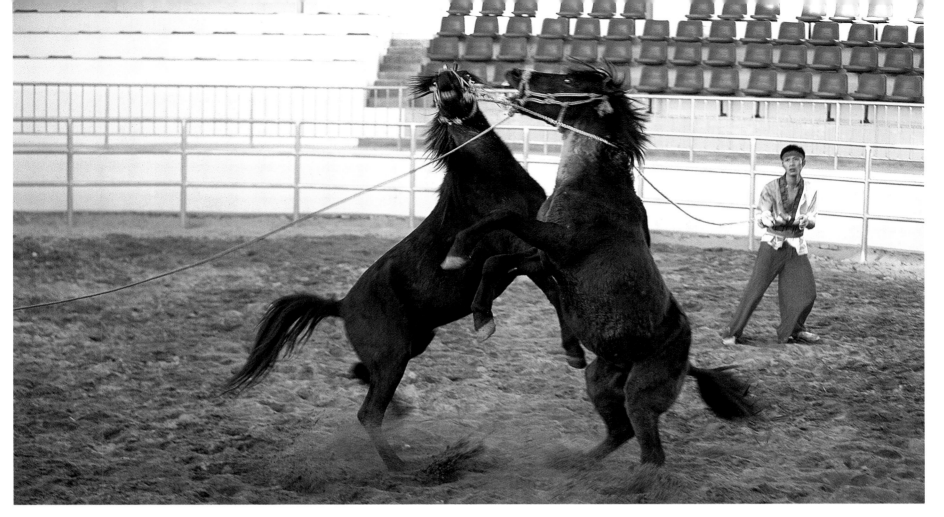

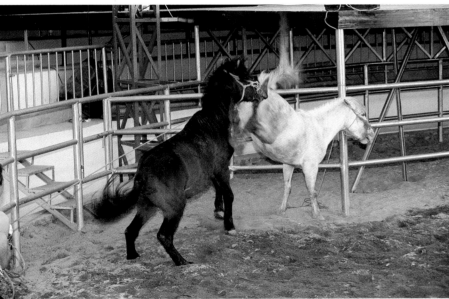

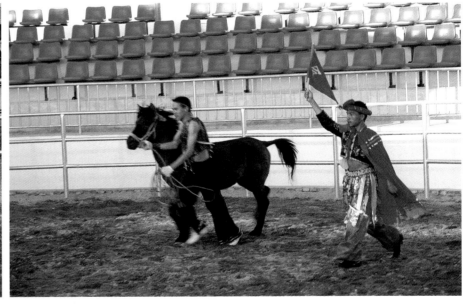

武夷山斗马
Wuyi Mountain
Horse-fighting

斗马场分有歇马场和决斗场，由两个马主把各自的公马从歇马场牵进
决斗场踢斗，其场面之刺激、逗趣，令人赞赏。

The horse fighting fields include the rest fields and fighting fields. During the
game, owners of two horses will lead the horses from the rest fields to the
fighting fields for kicking fights. The scene is very exciting and funny.

民族舞蹈 |
Ethical Dances

除了斗牛、斗马外，武夷山景区内尚有精彩的民族舞蹈与君同乐。穿戴少数民族传统服饰的男女舞者，随着嘹亮的歌声翩然起舞，色彩缤纷、赏心悦目。

Apart from bullfighting and horse fighting, Wuyishan area also has unique and wonderful ethical dances. Male and female dancers wear traditional minority dresses and dance to the loud and clear songs. You can see colors dazzle and feel the joy inside.

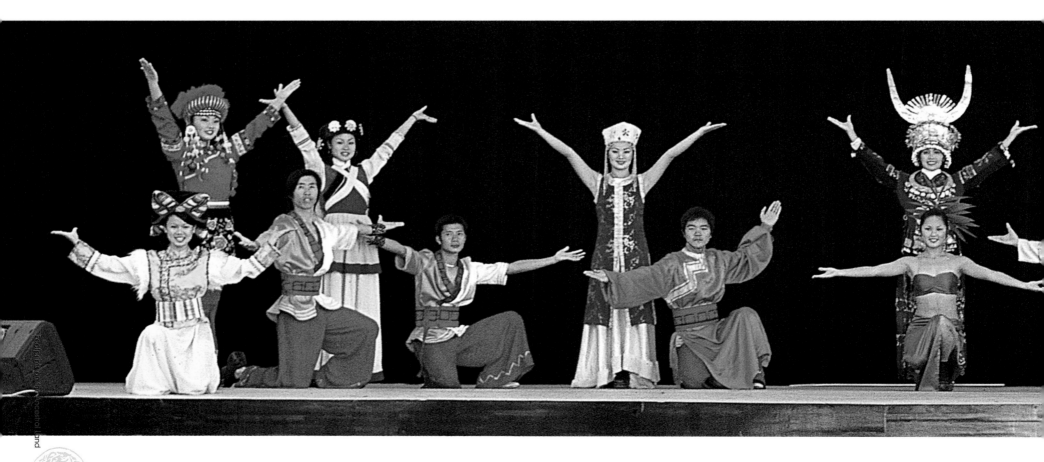

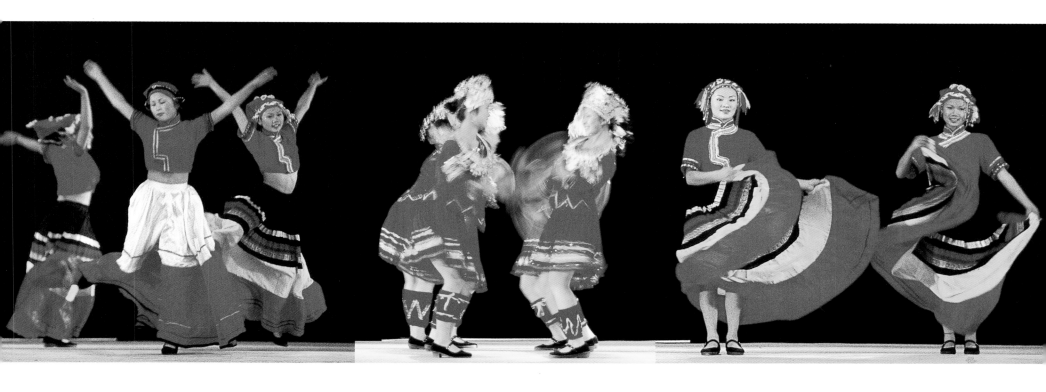

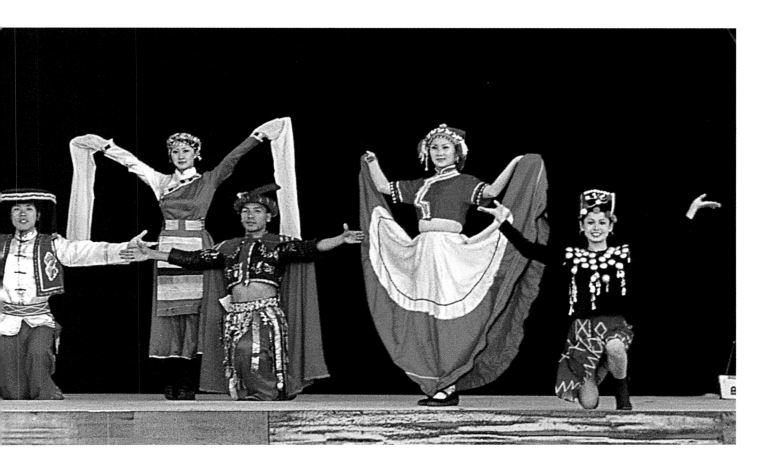

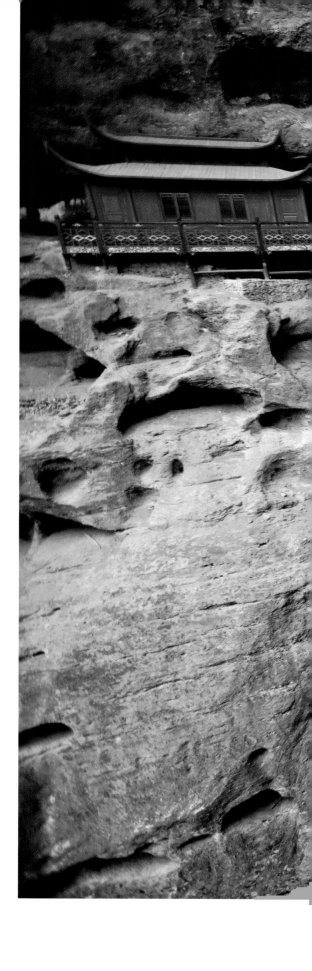

泰宁甘露寺 Ganlu Temple In Taining

始建于南宋（公元 1146 年）的甘露寺位于泰宁金湖之畔的天然洞穴中。「一柱插地，不假片瓦」是其鲜明的建筑特色。甘露寺曲径幽幽、古木苍天、景致优美，以「甘露晚钟」、「甘露报晖」、「甘露右寺」、「啸天雄狮」四景闻名。

Built in 1146A.D. of the Nansong dynasty, the Ganlu Temple lies in a natural cave alongside the Jinhu Lake in Taining, with a unique architectural style of "one pillar standing upright, no bricks and tiles inside". There are numerous twists and turns in the temple, as well as many tall ancient trees, leading to beautiful scenery. The most famous attractions in the temple are "Nightfall Bell", "Day Break", "Ganlu Rock Temple" and "Ganlu Lion Sculpture".

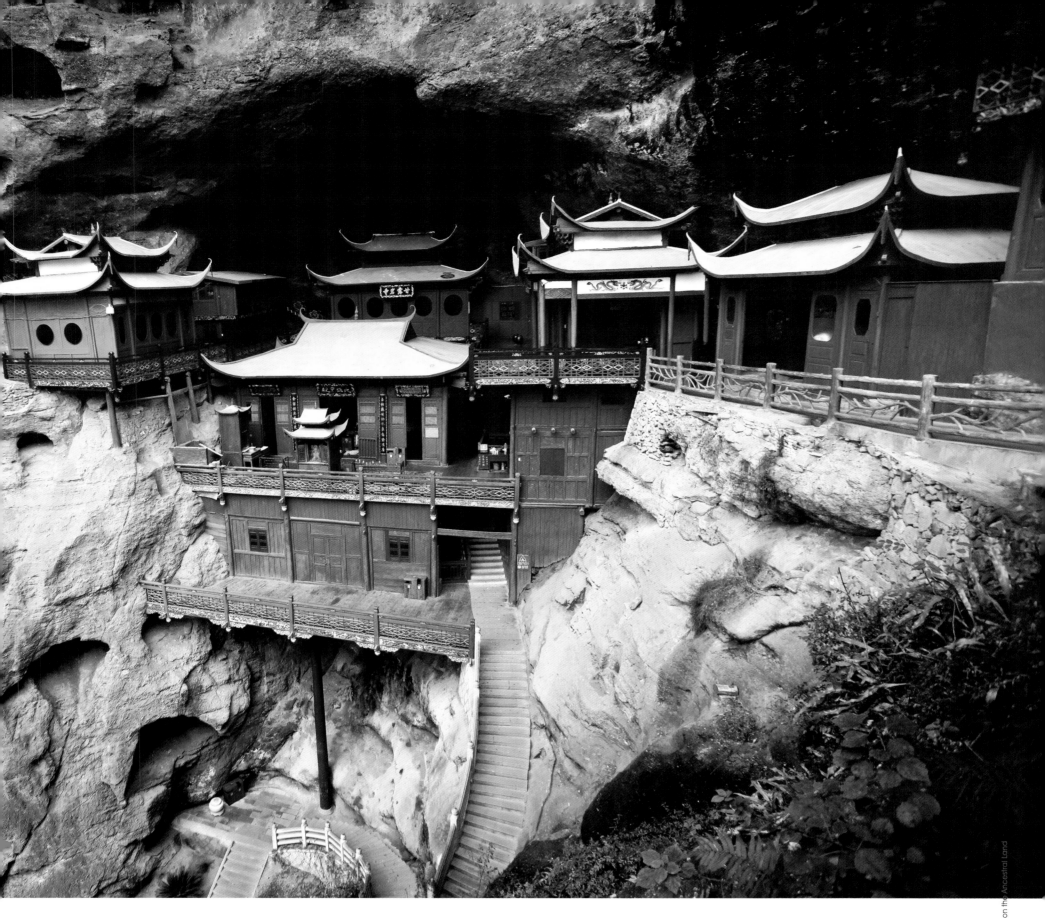

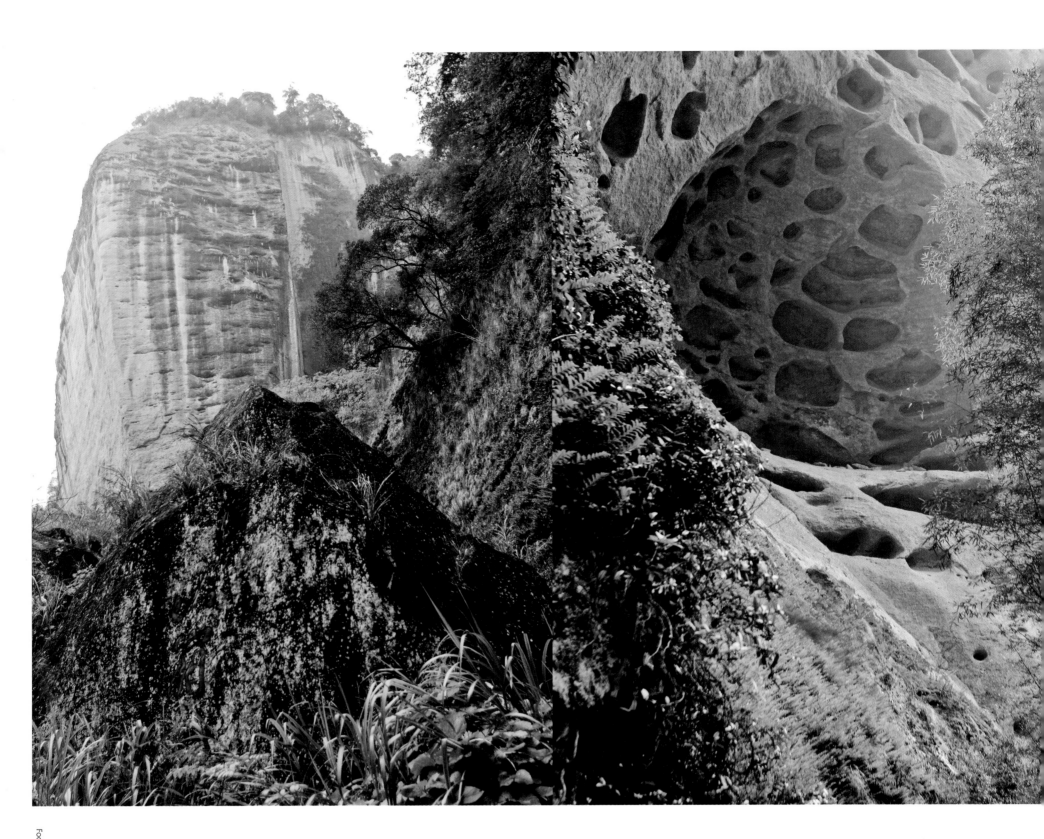

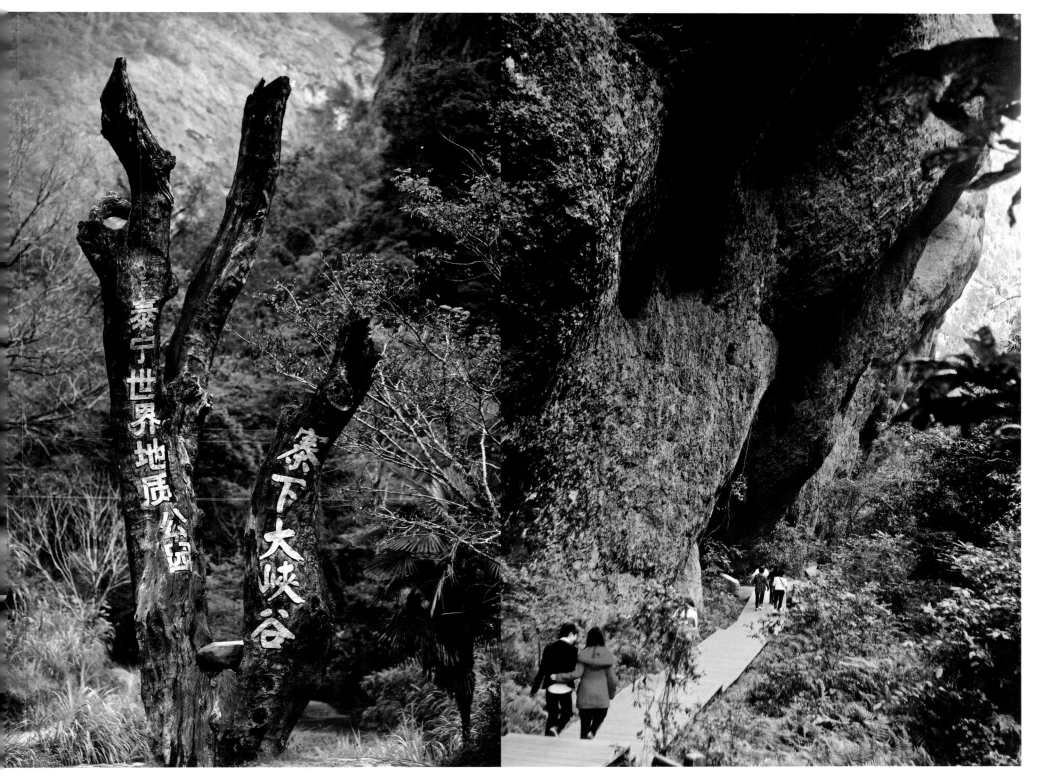

寨下大峡谷
Grand Canyon in Zhaixia

曾被专家誉为"世界地质公园样板景区"。由悬天峡、通天峡、倚天峡及石塘溪四大部分组成，充分展现出泰宁丹霞地貌的典型特征。

It was once labeled by experts as the draft resorts for the world geological parks. It is composed of four parts: the Xuantian Canyon, Tongtion Canyon, Yition Canyon and Shitang Stream, fully exhibiting the typical characteristics of Danxia landform of Taining.

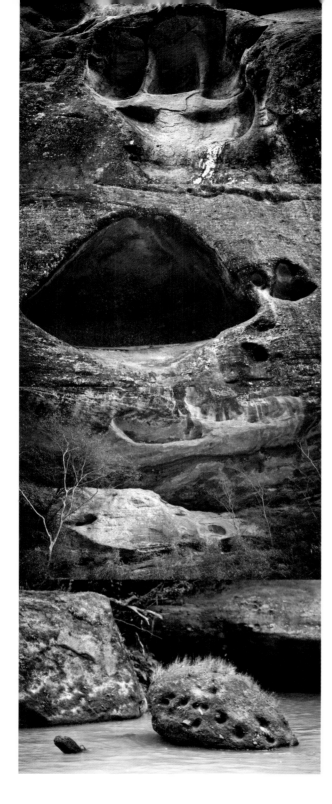

上清溪位于泰宁东北部，全程计有"九十九曲八十八滩"。向以"野、幽、奇、趣、险"著称于世，被誉为"中国最美丽的漂流"。

Shangqing stream is located in the northeast part of Taining. There are 99 twists and 88 rapids. It is famous for its wildness, secrecy, fun and excitement and reputed as the most beautiful drifting in China.

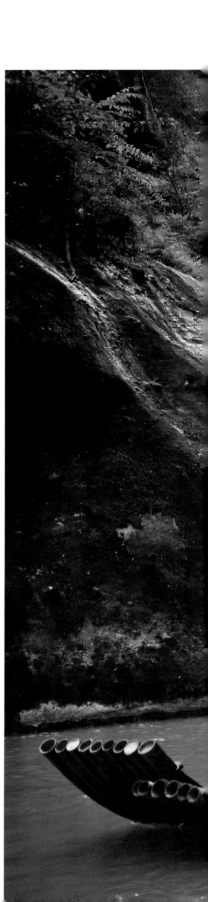

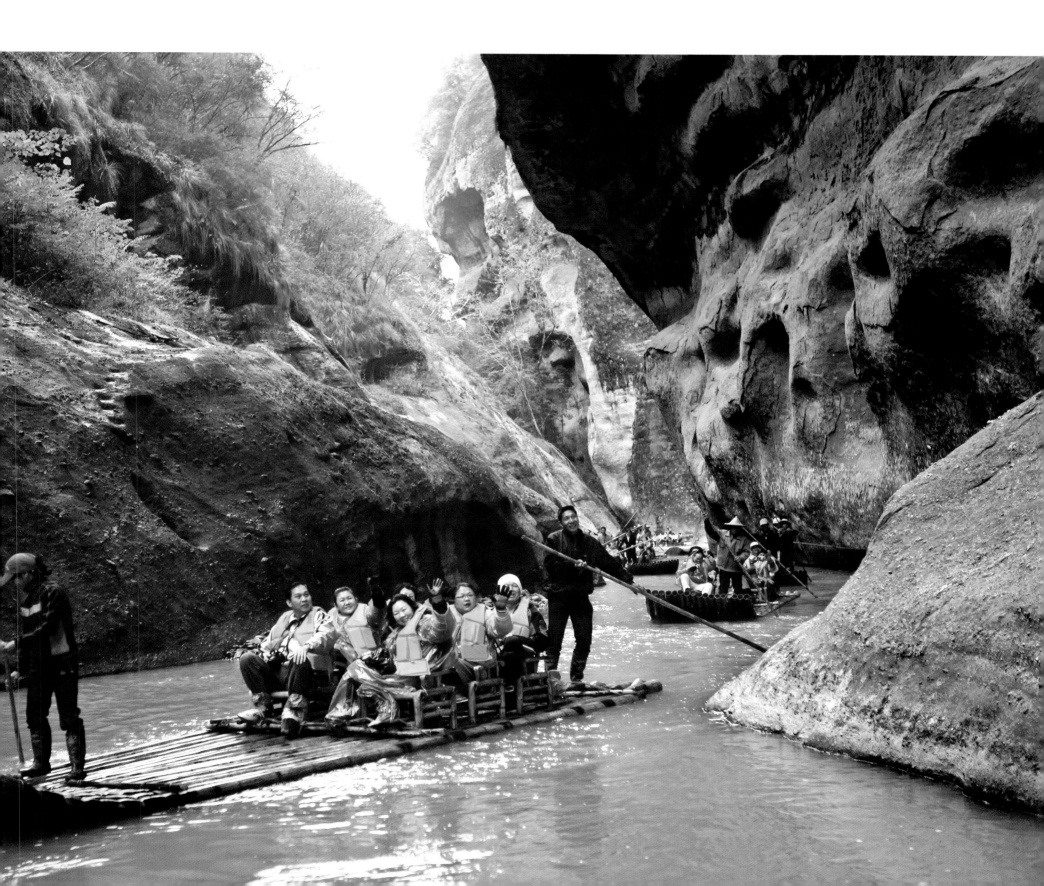

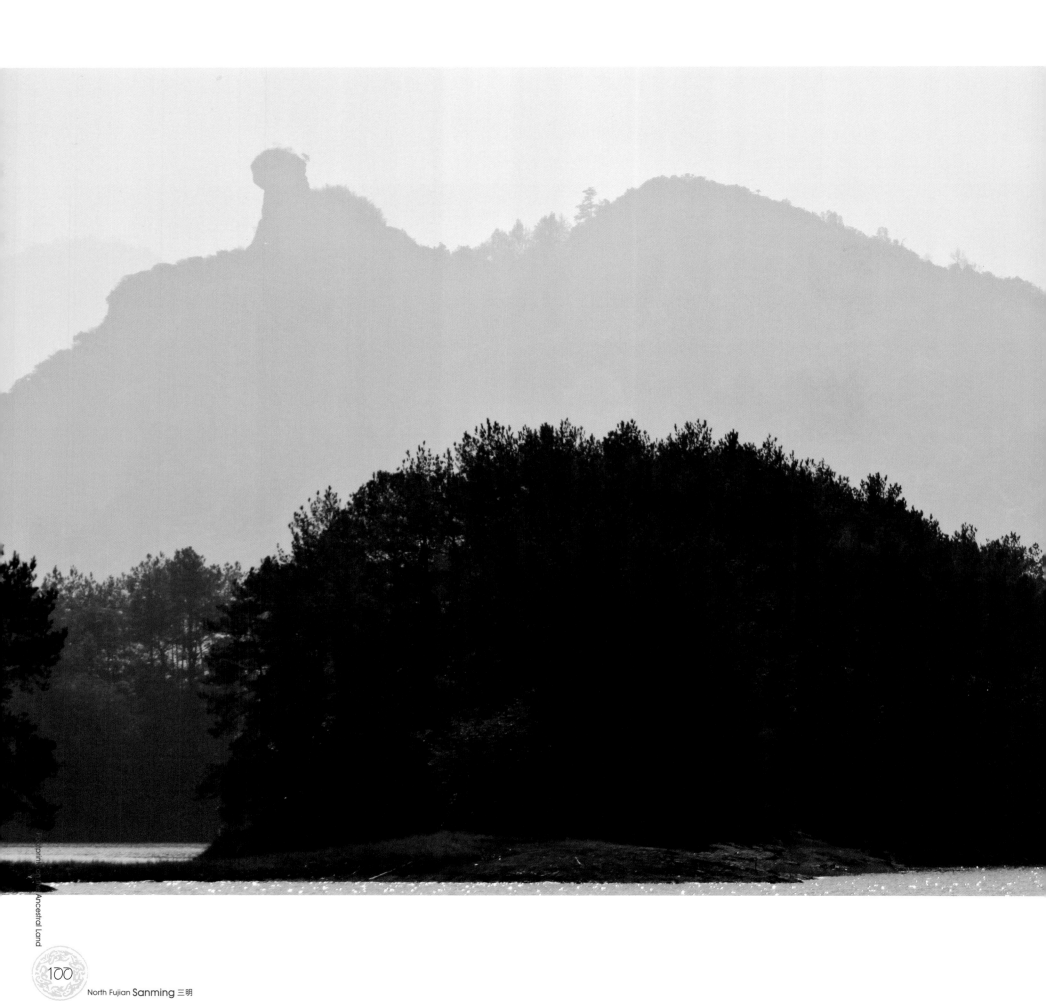

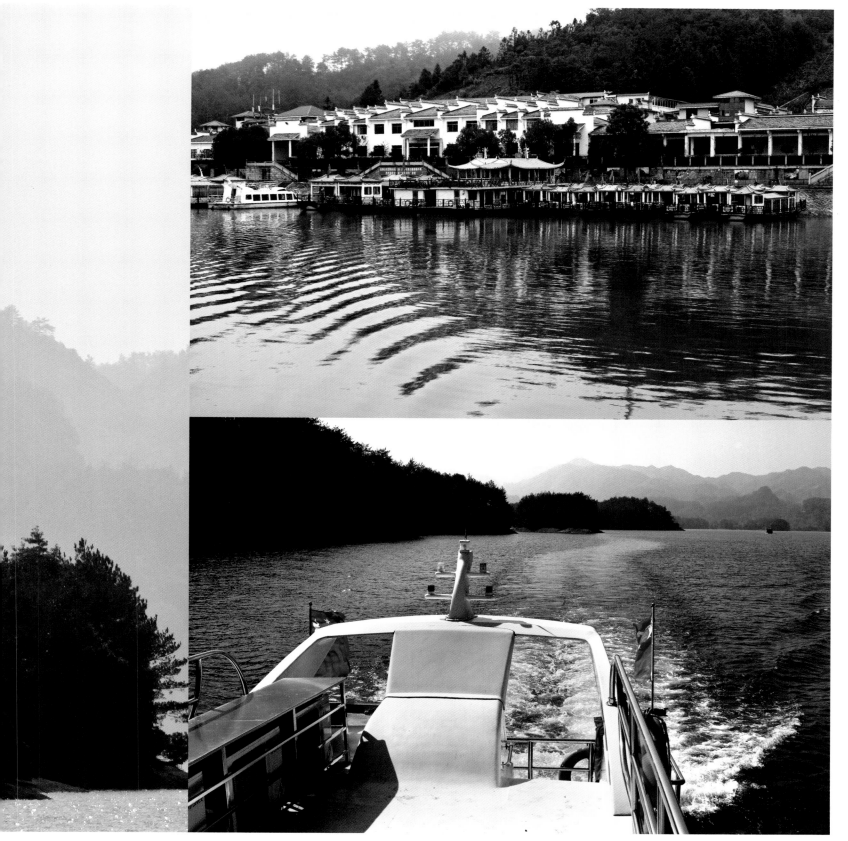

船游大金湖 Dajin Lake Tour by Boat

大金湖于 2005 年 2 月 11 日成为联合国教科文组织评定的「泰宁世界地质公园」核心组成部分，是继武夷山成为「双世遗」之后，又一个人主世界级别的福建旅游景区。船游其间美景尽收眼底，令人流连忘返。

It is the core parts of Taining World Geological Park which is approved by UNICEF on the 11th of Feb. 2005. It is the second world-level dual-heritage tourist site in Fujian after the Wuyi Mountain.People can enjoy all the beautiful sieneries by touring by boat.

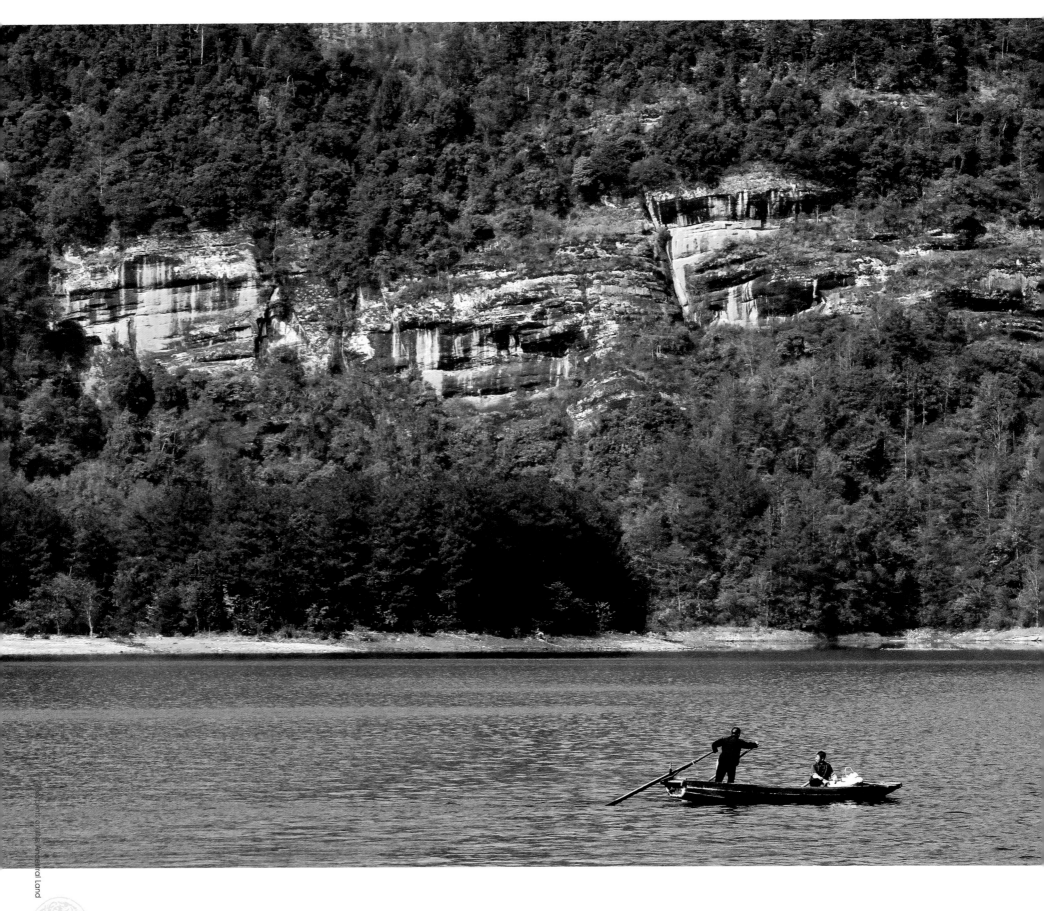

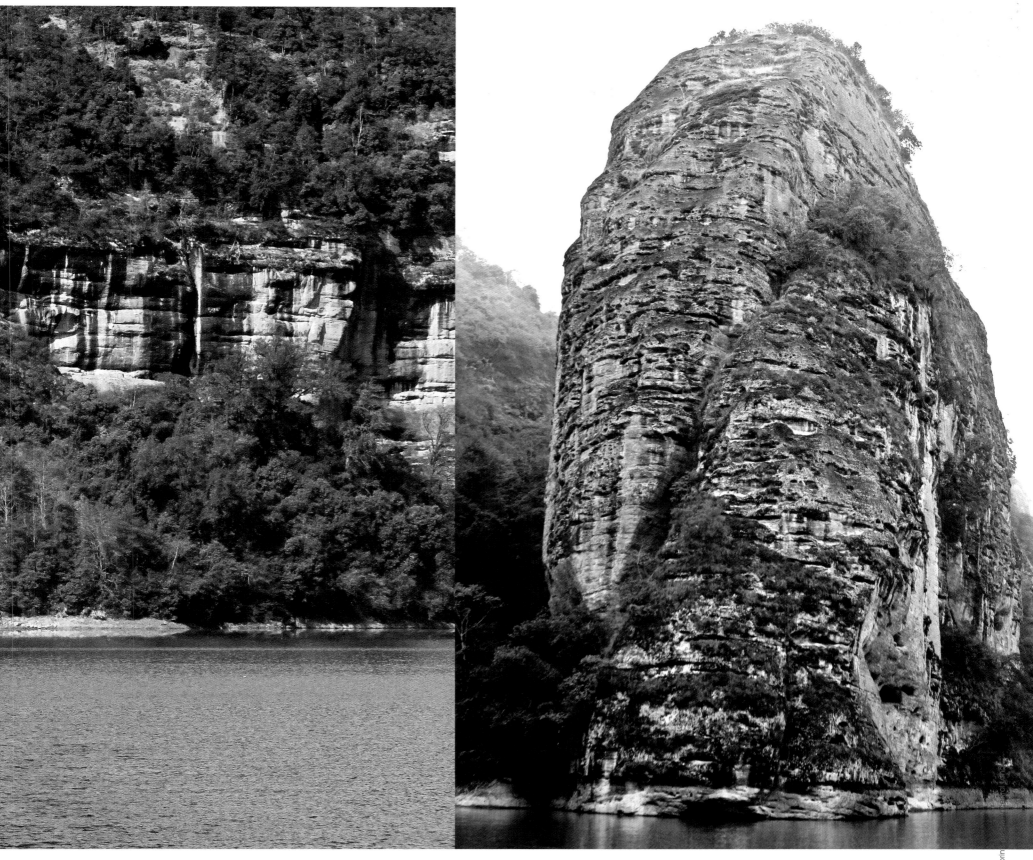

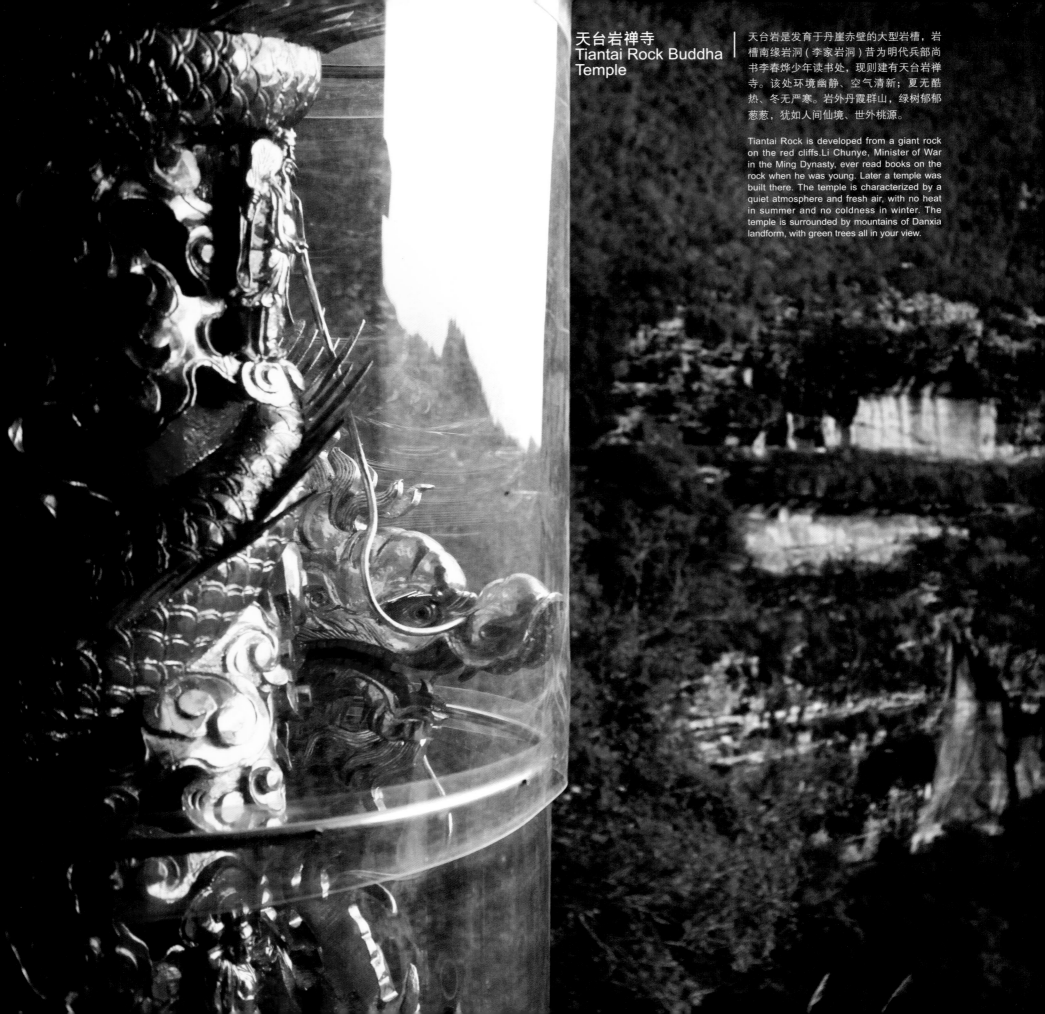

天台岩禅寺
Tiantai Rock Buddha Temple

天台岩是发育于丹崖赤壁的大型岩槽，岩槽南缘岩洞（李家岩洞）昔为明代兵部尚书李春烨少年读书处，现则建有天台岩禅寺。该处环境幽静、空气清新；夏无酷热、冬无严寒。岩外丹霞群山，绿树郁郁葱葱，犹如人间仙境、世外桃源。

Tiantai Rock is developed from a giant rock on the red cliffs.Li Chunye, Minister of War in the Ming Dynasty, ever read books on the rock when he was young. Later a temple was built there. The temple is characterized by a quiet atmosphere and fresh air, with no heat in summer and no coldness in winter. The temple is surrounded by mountains of Danxia landform, with green trees all in your view.

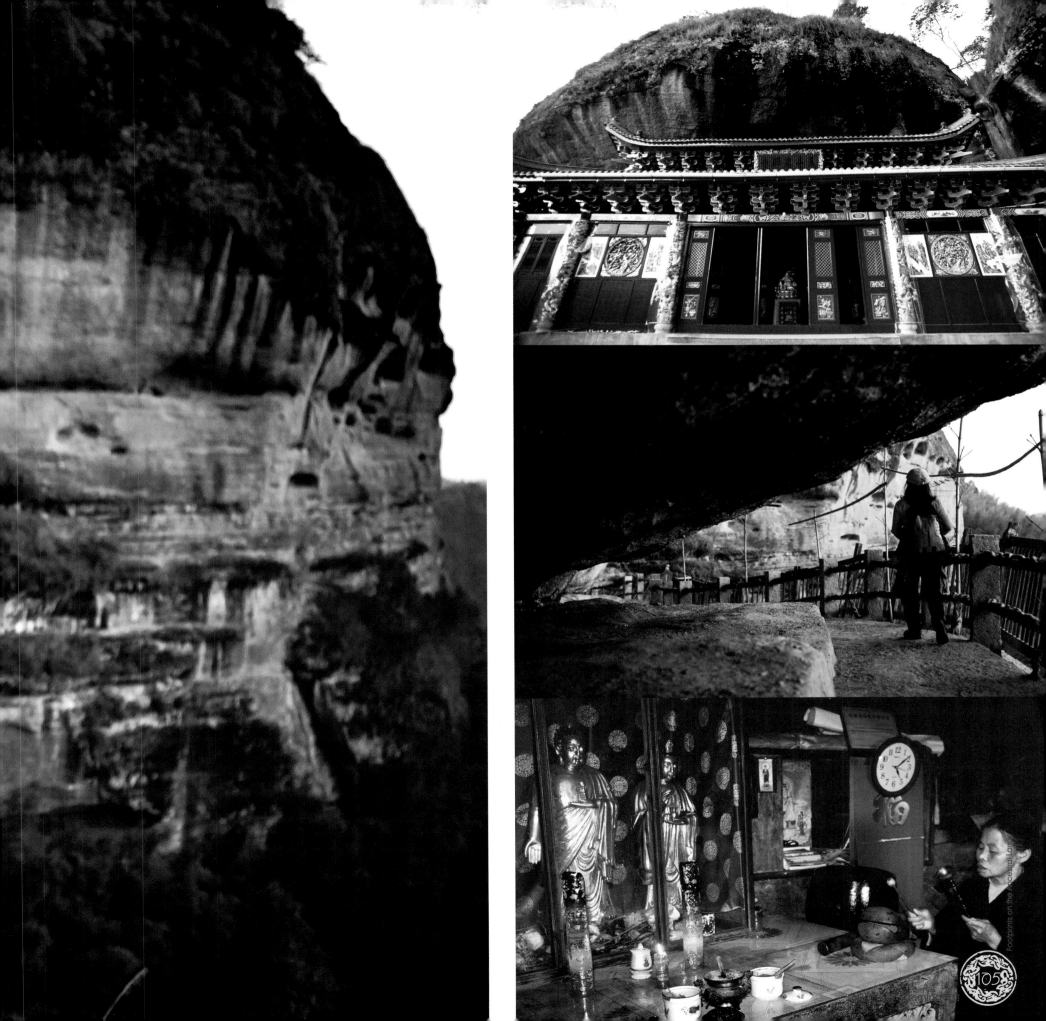

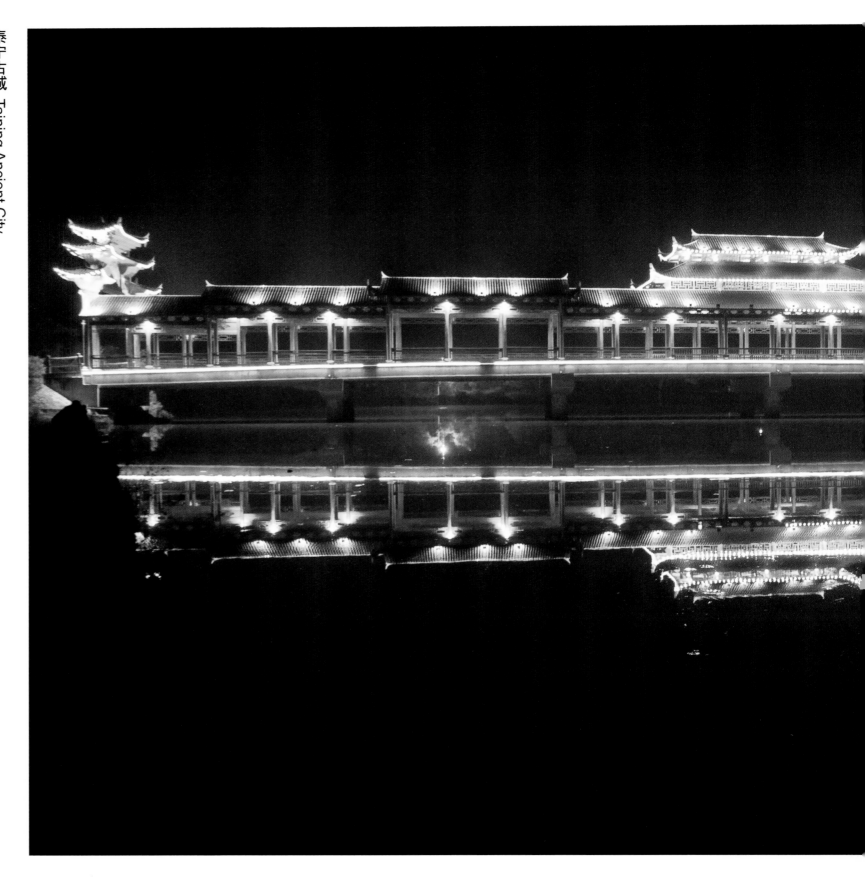

泰宁古城 Taining Ancient City

素有『汉唐古镇，两宋名城』的美誉，步入古城，古街、古巷、古民居、古井、古牌坊比比皆是，古风悠远。

It is reputed as the "ancient town in Han and Tang dynasties" and "famous city in the two Song dynasties". Walking into the city, you can feel the ancient flavor, with ancient streets, lanes, folk houses and wells everywhere.

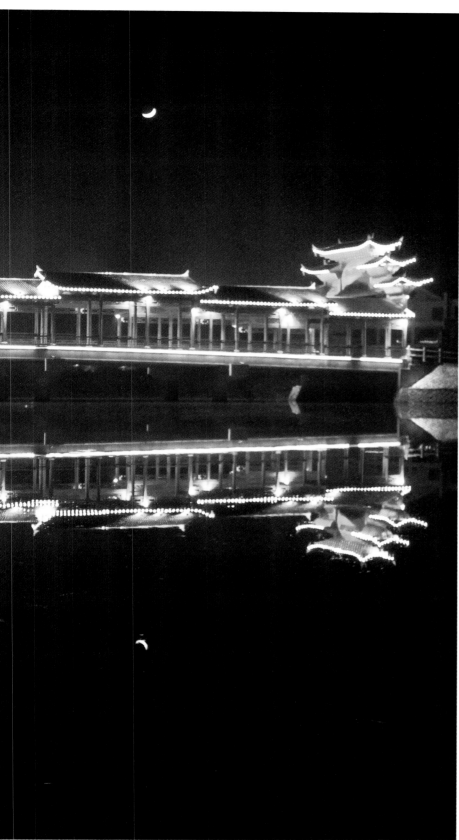
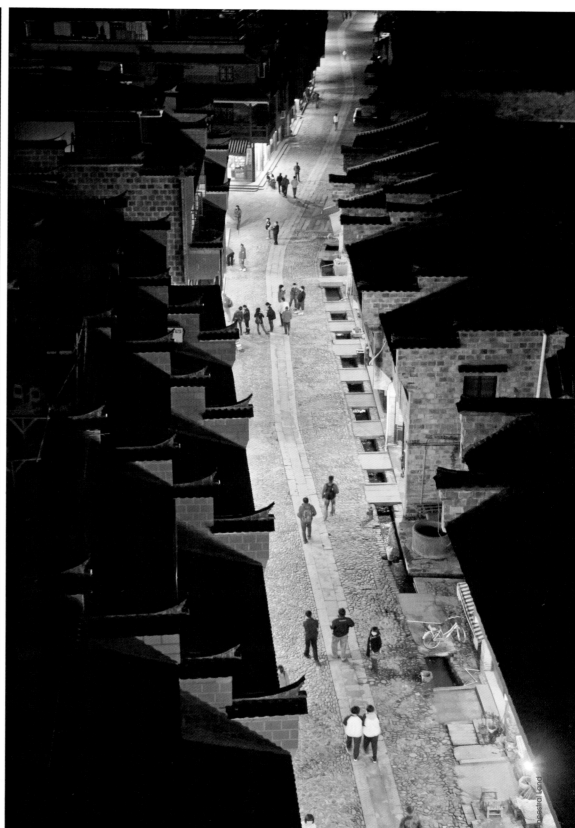

尚书第 |
Shangshu Mansion |

又称"五福堂"，建于明万历末至天启年间，是明代兵部尚书李春烨的府第。其布局严谨、宏伟壮观，为迄今江南地区保存最为完整且独具风格的明代建筑群，有"江南第一民居"之美誉。

The Shangshu Mansion is also called "Wufu Tang". Built in the period from the end of Wangli Reign in the Ming Dynasty to the Tianqi Reign, it was the mansion house for the principle officer of the Bin Bu in the Ming Dynasty. With orderly and magnificent layout, the mansion is the most well-preserved and unique building group of the Ming Dynasty in the south of the Yangtze River. It enjoys the reputation of "the first residence in the south of the Yangtze River".

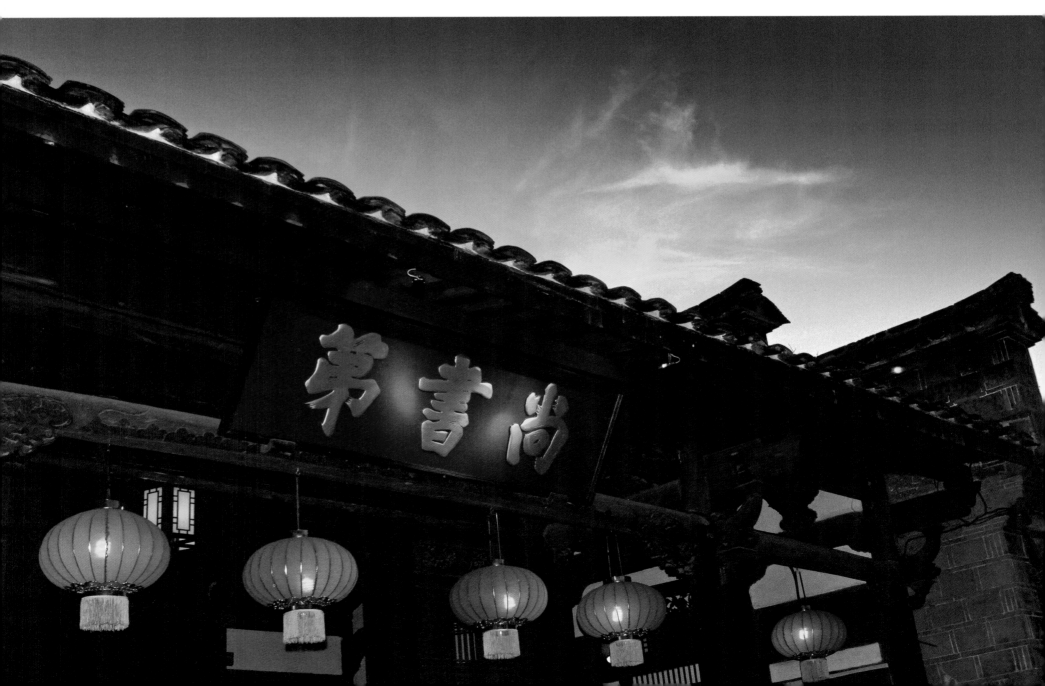

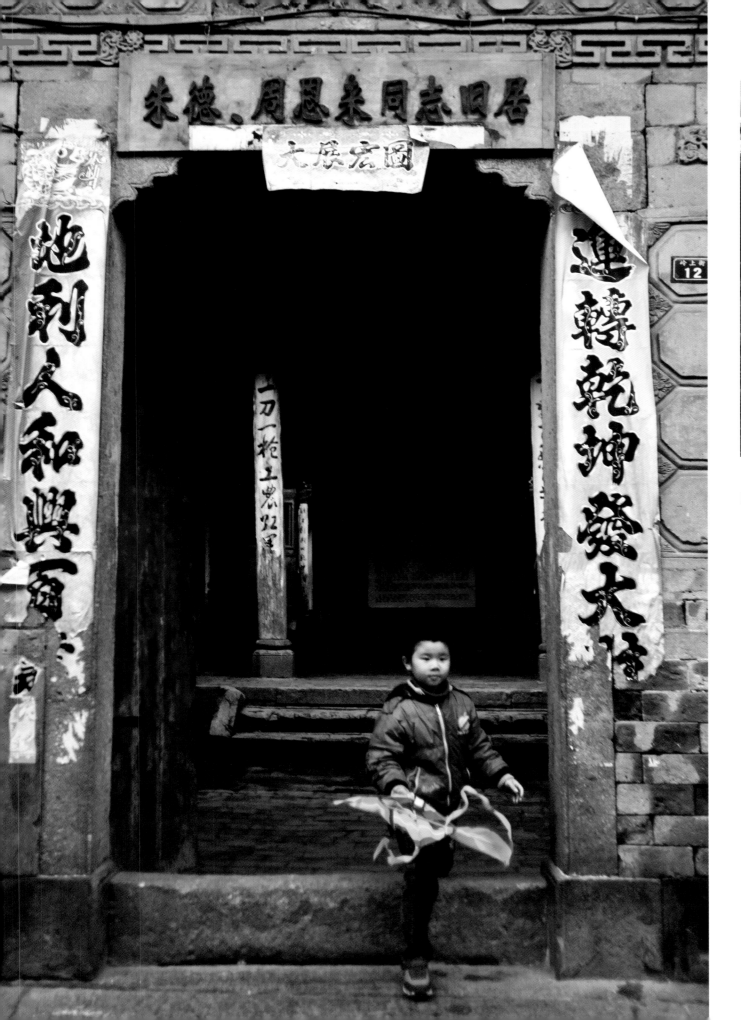

红军街
Red Army Street

泰宁古城内保有完整的红军街、红军总部、东方军司令部等旧址，周恩来、朱德、彭德怀、杨尚昆、康克清等曾在这里运筹帷幄，指挥作战。漫步其中，思古幽情油然而生。

There is a well-kept Red Army street in Taining Ancient City, with the original site of headquarters where Zhou Enlai, Zhu De, Peng Dehuai, Yang Shngkun and Kang Keqing used to work, command and combat. Wandering along the street, you have nostalgia feelings.River. It enjoys the reputation of "the first residence in the south of the Yangtze River".

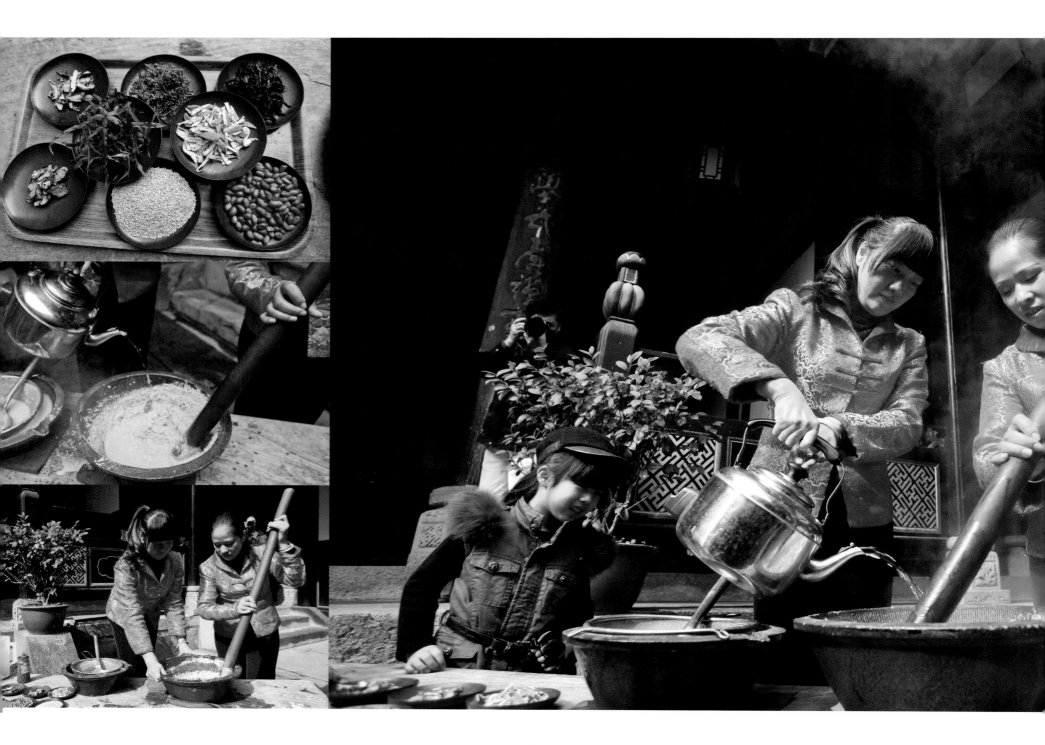

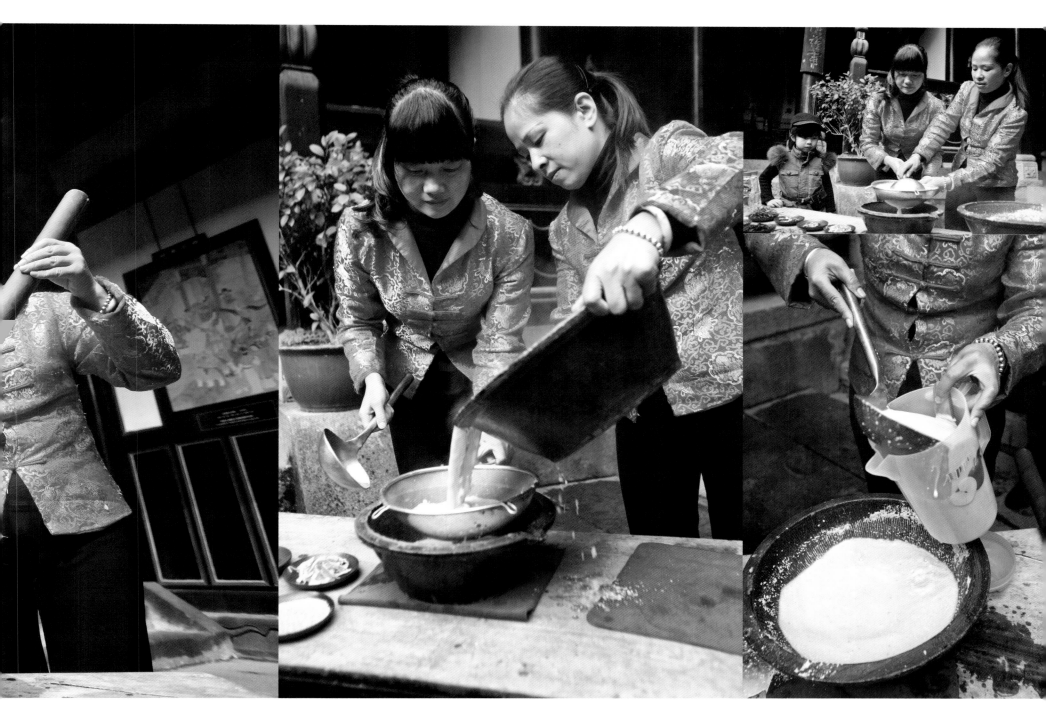

客家擂茶
Hakkas Grinding Tea

在中国博大精湛的茶文化中，客家擂茶是一枝独秀的奇葩。其以"古朴见奇趣、保健见奇效"名闻遐迩，是中国最古老的茶道之一。客家人热情好客，以擂茶待客更是传统而普遍的礼节，无论婚嫁喜庆、亲友造访，都会奉上香气四溢的客家擂茶。

The Hakkas grinding tea is a unique brand in various tea brands. It is famous for its simplicity and special health supplement functions, and one of the most ancient tea ism. The Hakkas families are very hospitable, and it is their traditional and common etiquette to entertain guests with grinding tea. No matter when marriage ceremonies are held or friends visit, the grinding tea will be served.

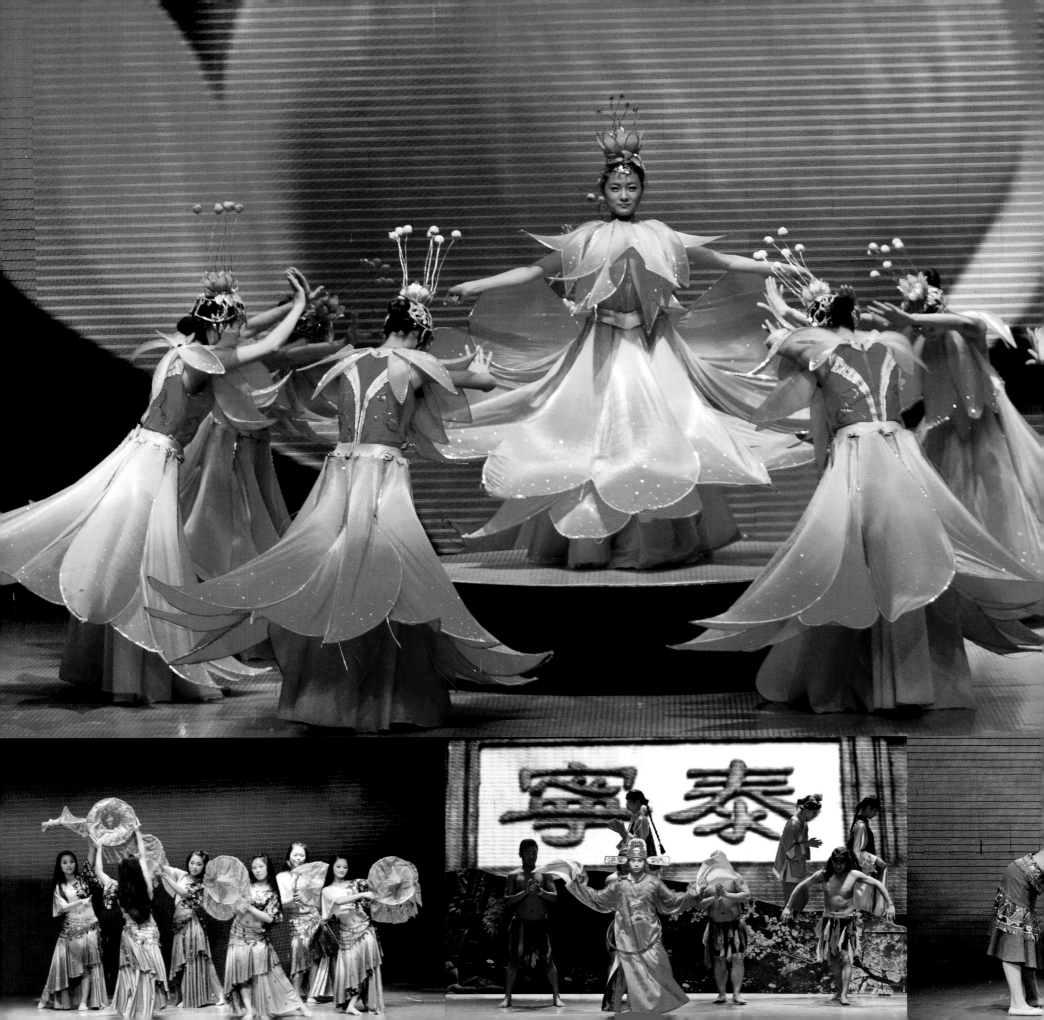

梦回泰宁 Dreaming back to Taining

大型民俗歌舞剧，融合了舞蹈、杂技、武术、服饰表演等多元化艺术，再加上声、光、电等舞台效果，让人在紧张、刺激的无穷变幻中，尽享惊险、刺激与浪漫。

It is a giant folk-custom drama, which involves dance, acrobatics, martial arts, dress show and other diversifying arts. Assisted with sounds, lights and electrical props, it can make the audience feel the excitement and romance along with tension.

梅林戏
Meilin Opera

俗称土戏、土京戏，因形成于泰宁县朱口乡梅林村而得名。"梅林十八坊，十户子弟九担箱，敲起叮当鼓，唱起梅林腔。"深受民众喜爱的梅林戏可说是中原文化与闽越古文化结合的表演艺术，已被列为首批国家级非物质文化遗产。

Nicknamed Tu Opera, it is similar to the Beijing Opera. It is very popular with local people, and a perfect combination of central plains culture and Minyue ancient culture. It has already listed as one of the national-level non-material cultural heritage.

永安玉华洞
Yong'an Yuhua Cave | 列为中国四大名洞之一，誉称"形胜甲闽山，人间瑶池景"。因洞内岩石光洁如玉，华光四射而得名。洞内 180 多个景观，令人目不暇接。

It is listed as one of the four most famous caves in China. There are more than 180 scenic sites inside the cave. Dazzling lights reflect in the cave and the rocks are smooth like jade, thus the cave got its name.

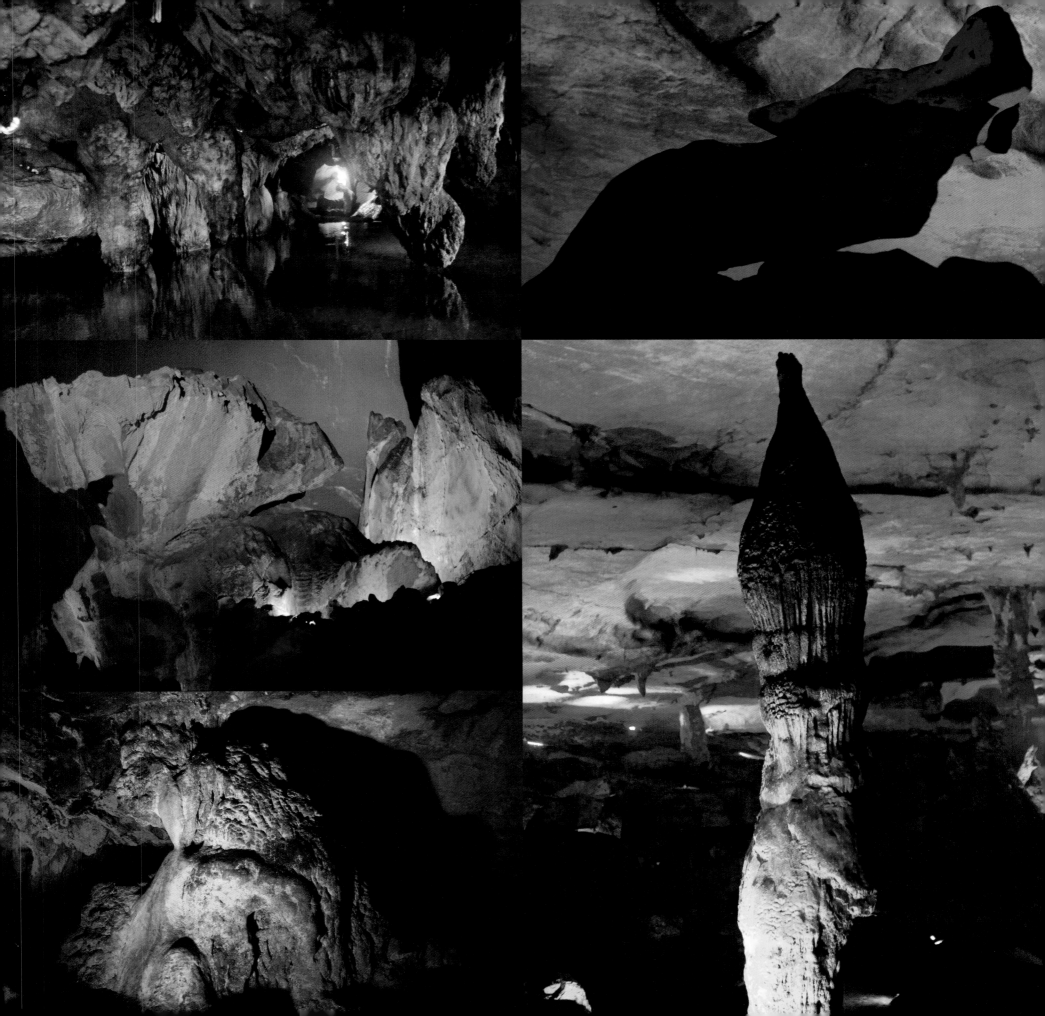

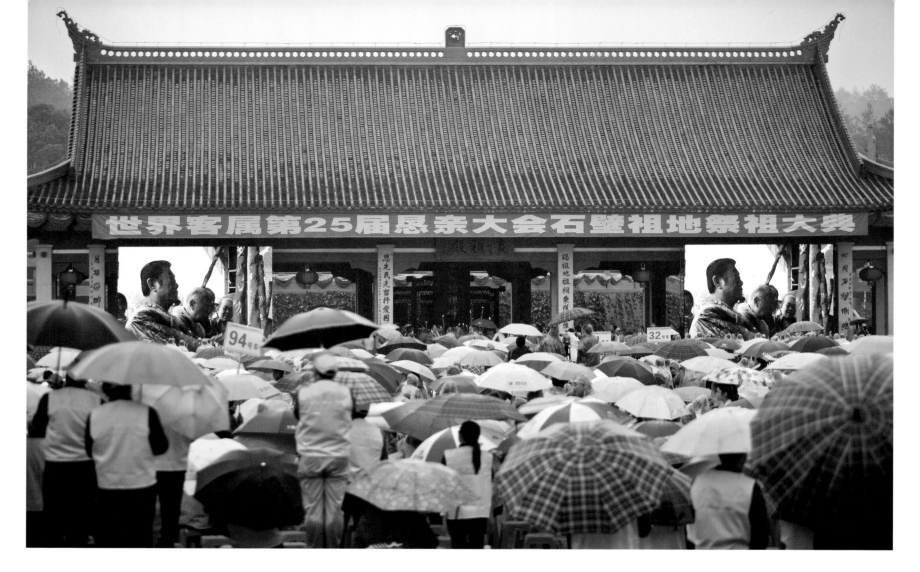

世界客属恳亲大会
World Hakka Conference

是国际上具有广泛影响力的华人盛会之一，也是海内外客属乡亲联络乡谊及合作交流的重要舞台。"第25届世客会"于2012年11月在三明盛大举行，作者有幸躬逢其盛，深受感动、与有荣焉。

As a Chinese gala with well-spread influence around the world, the World Hakka Conference also provides an important stage for the Hakka people both home and abroad to contact each other and carry out cooperation and communication. The author had the honor to attend the 25th World Hakka Conference which was held in Sanming City in November 2012, and was deeply moved.

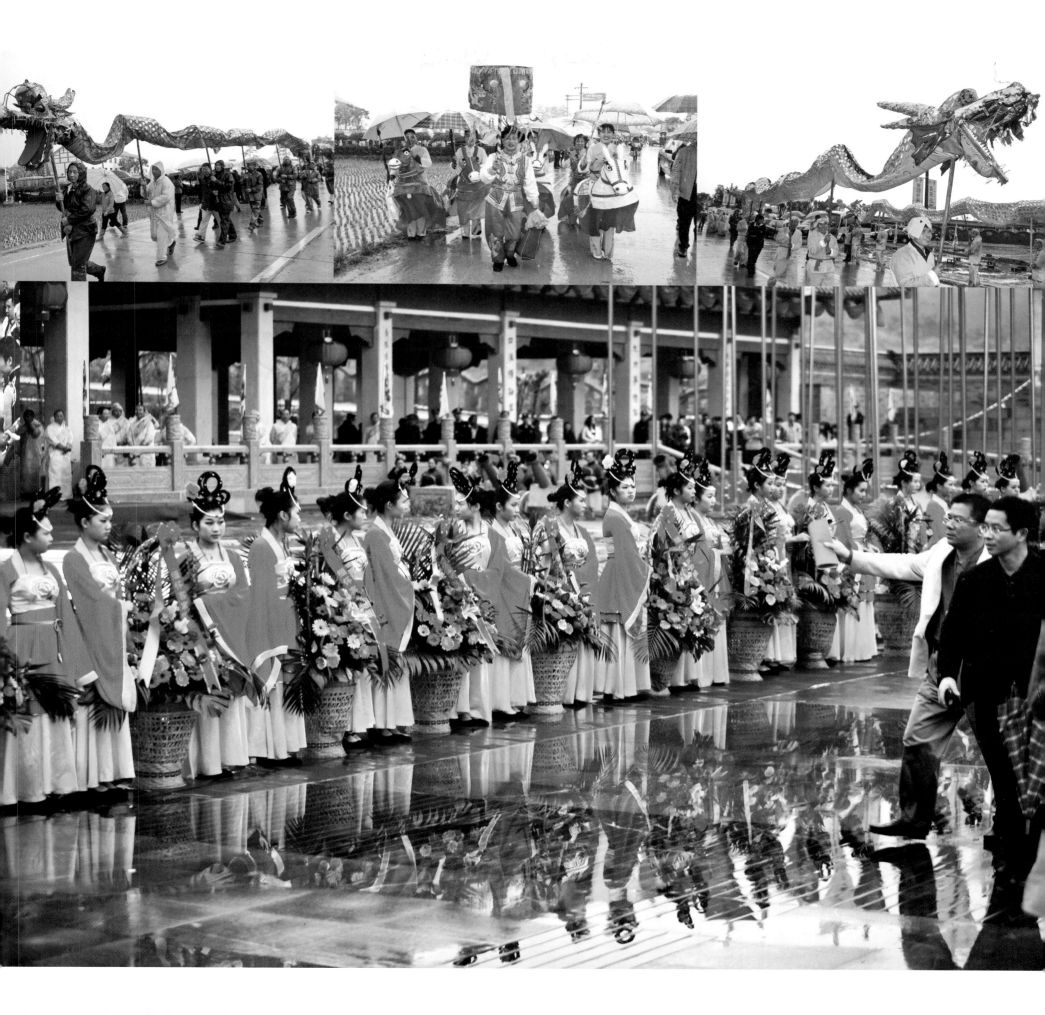

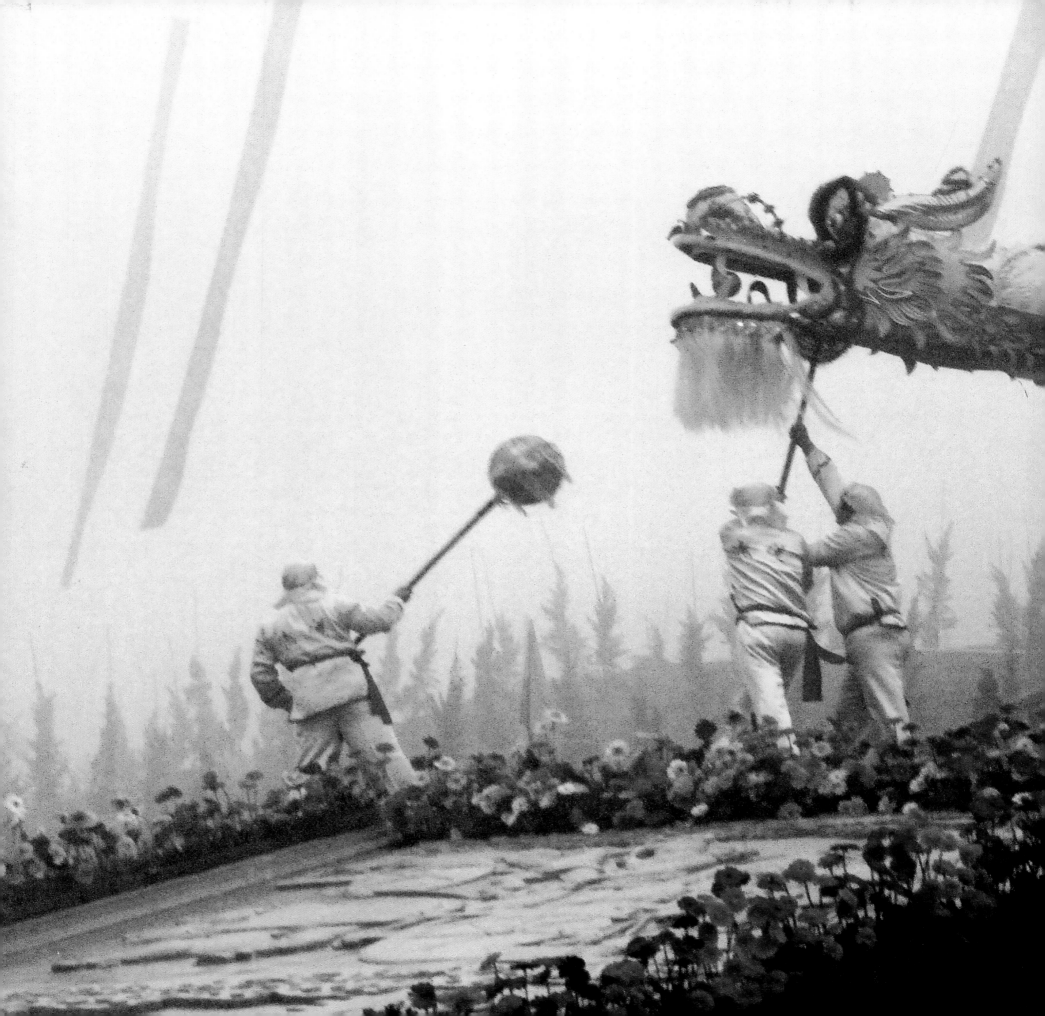

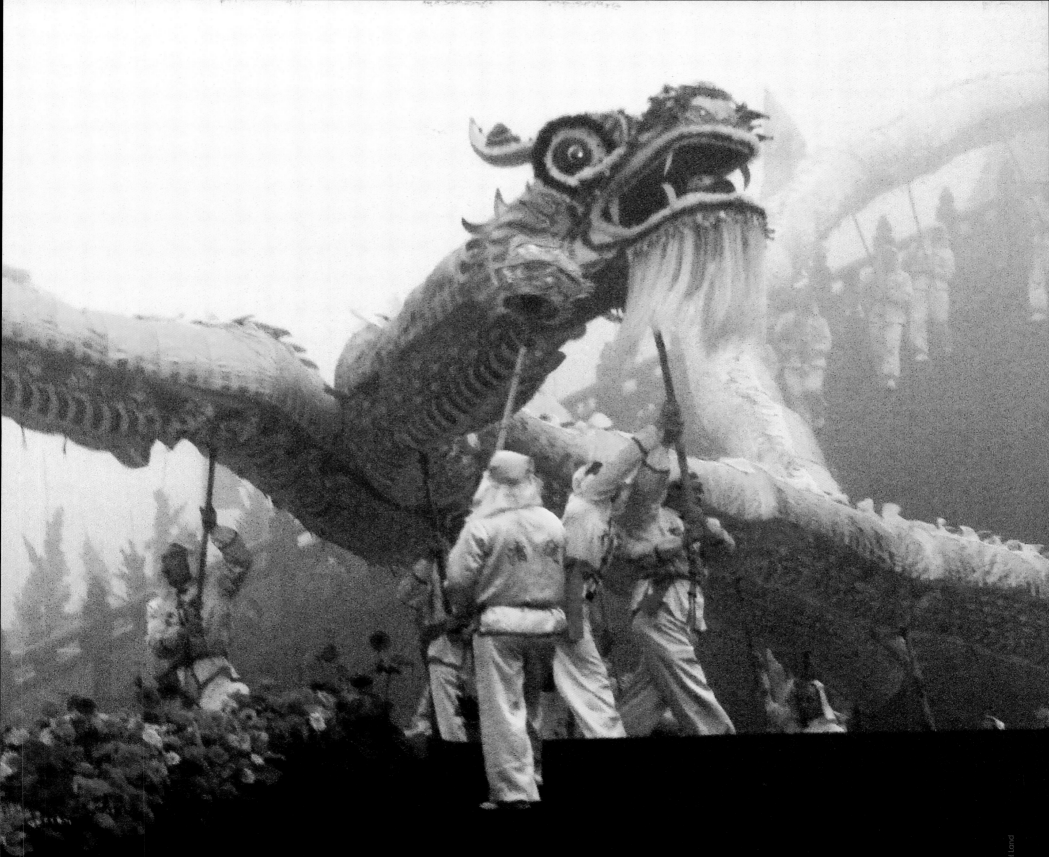

闽西 West Fujian

　　闽西是一块历史悠久、文化厚重的土地。它是福建省最重要的三条大江——闽江、九龙江、汀江的发源地。这里曾经是远古时代"古闽人"的天堂、"闽越人"的祖籍地和"南海国"的国都所在地；近代则是河洛人的重要祖居地和享誉海内外的客家聚居地。河洛文化、客家文化和土著文化在这里相互交融、竞放异彩。

West Fujian area is a land with a long history and abundant culture. It is the originating place for the three most important rivers in Fujian Province: Minjiang River, Nine-dragon River and Tingjiang River. This land was once the heaven for ancient Fujian people in immemorial times, the ancestral homes to Minyue people and the capital city of South Sea State. In modern times it is a gathering place for Heluo people and the Hakka people. Heluo culture, Hakka culture and native culture are overlapped with each other and blossoming.

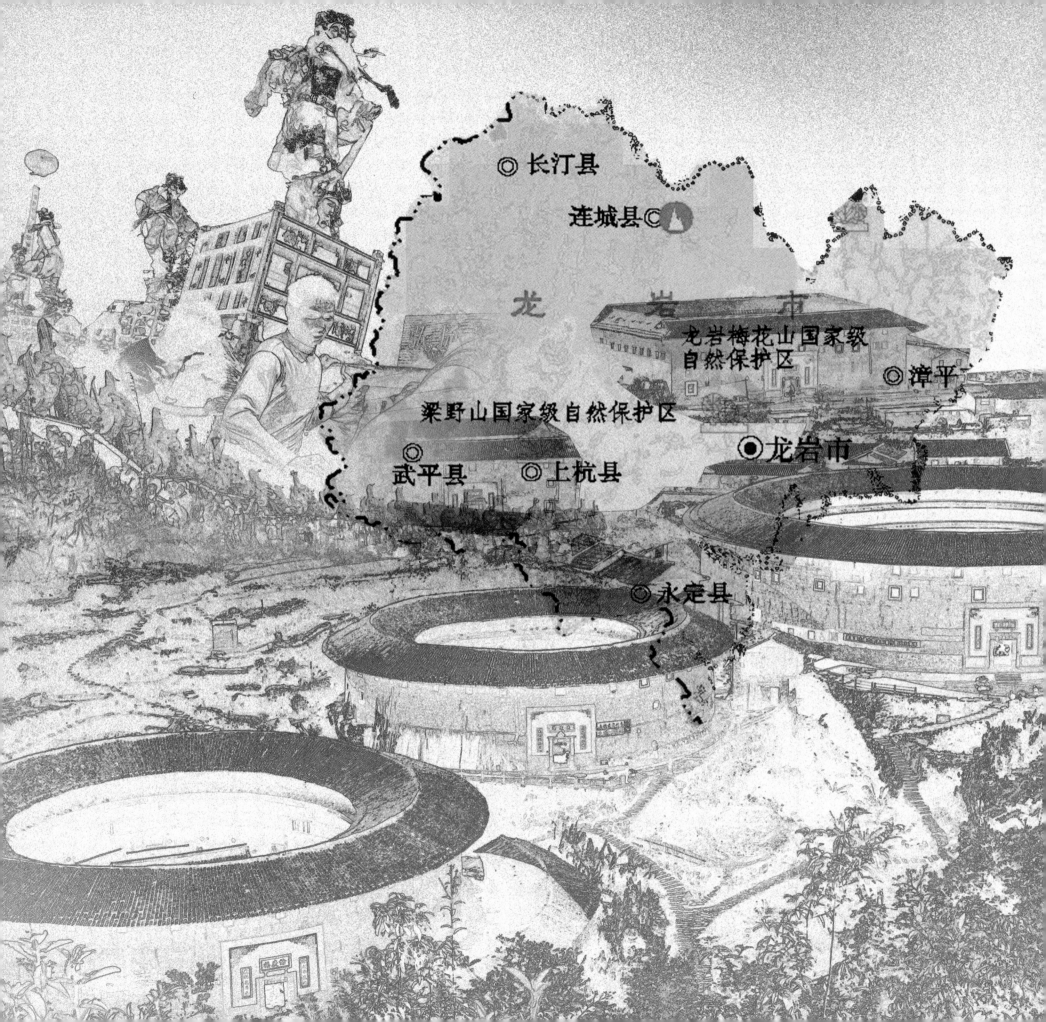

◎ 长汀县

连城县◎

龙　岩　市

龙岩梅花山国家级
自然保护区

◎ 漳平

梁野山国家级自然保护区

◎　　　　　◎上杭县
武平县

◉龙岩市

◎ 永定县

九鹏溪
Jiupeng Stream

位于漳平市南洋乡，是天台国家森林公园的核心景区之一，素有"水上茶乡"盛誉。主要特点是奇山、秀水、茶园、密林和珍禽（鸳鸯）。明代大航海家王景弘经由这里走向世界；旅行家徐霞客亦曾两度泛舟饱览九鹏溪风光。

It is located in Nanyang, Zhangping City, and one of the core tourist sites of the Tiantai National Forest Park, enjoying the reputation of "Tea County above the Water". It is special for unique hills, waters, tea gardens, thick forests and rare birds (like Mandarin Ducks). The great navigator Wang Jinghong in the Ming dynasty has grown up here, and the famous traveler Xu Xiake had visited here twice by boat.

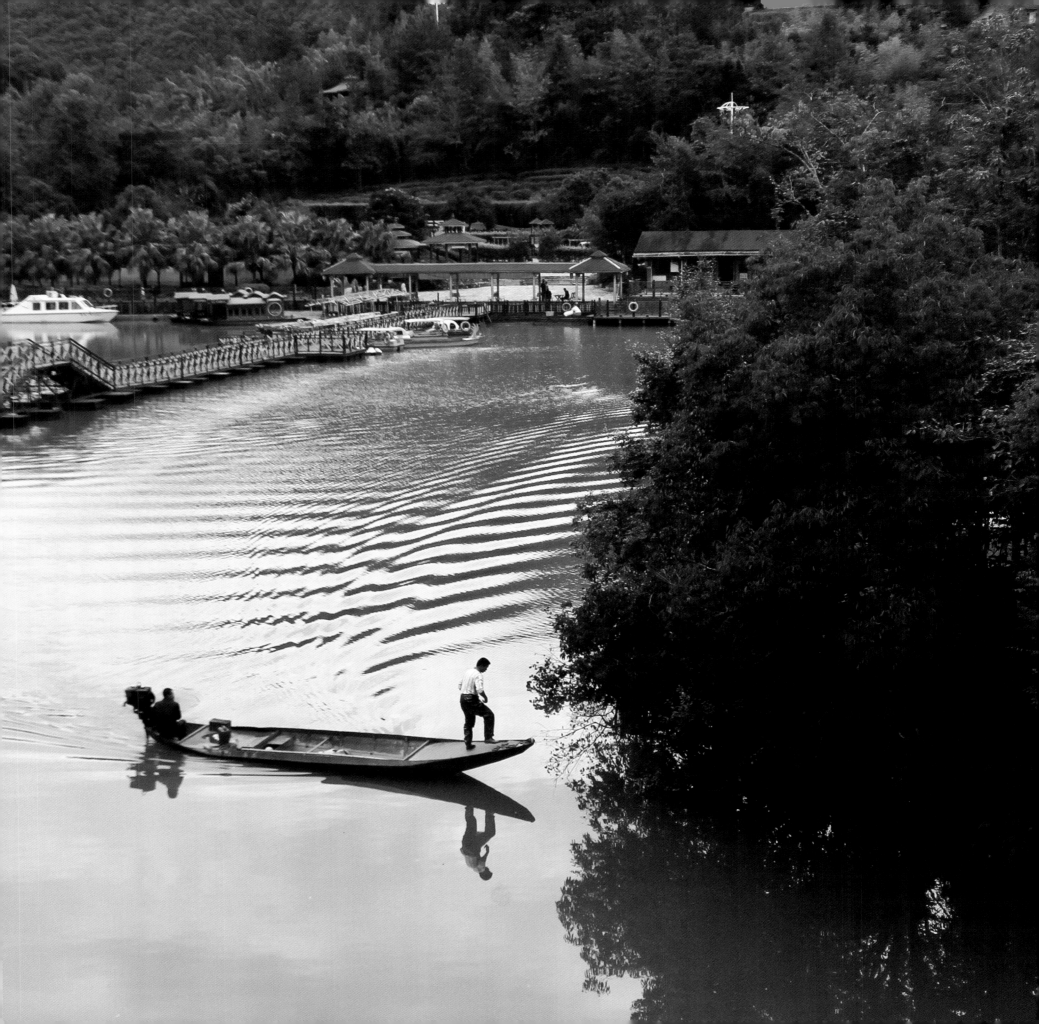

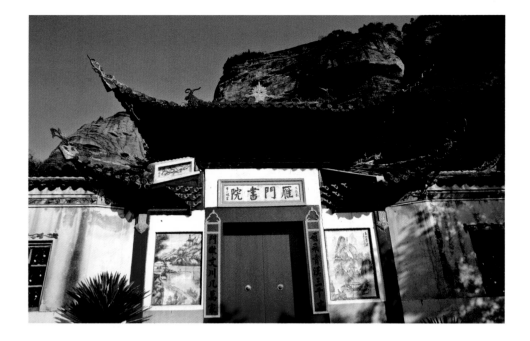

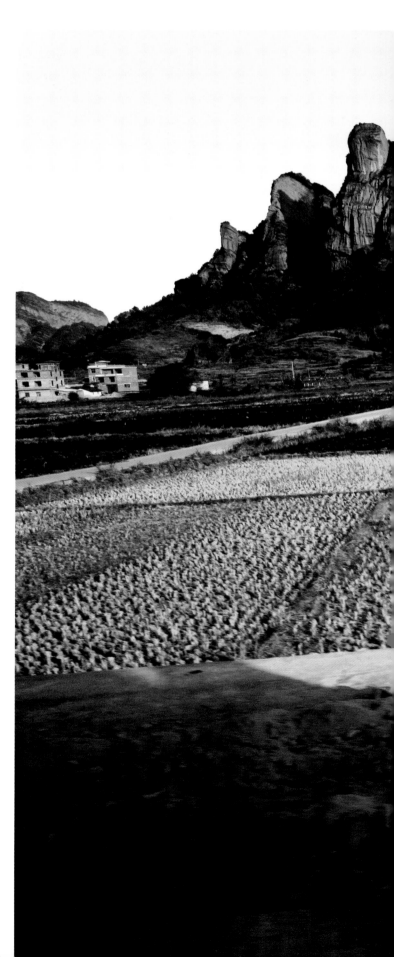

冠豸山
Guanzhai Mountain

为客家神山，以其主峰形似古代獬豸冠而得名，寓含刚正廉明之意。集山、水、岩、洞、泉、寺、园诸神秀于一身，雄奇、清丽、幽深，与武夷山同属丹霞地貌，被誉为"北夷南豸，丹霞双绝"。

It is the holy mountain of the Hakkas with the symbolism of integrity and honesty. The main summit resembles the head of an ancient Chinese animal, from which the mountain's name came. It incorporates mounts, water, rocks, caves, springs, temples and gardens. It is magnificent, deep and serene. Like Wuyi mountain, Guangzhai Mountain exhibits charateristics of Danxia landform.

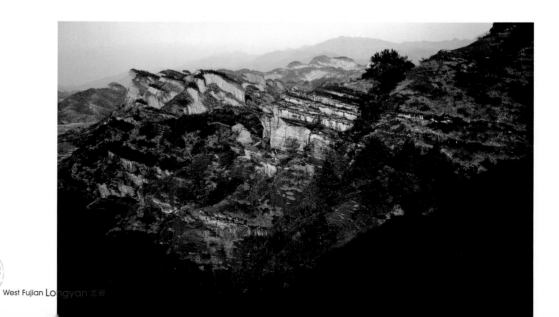

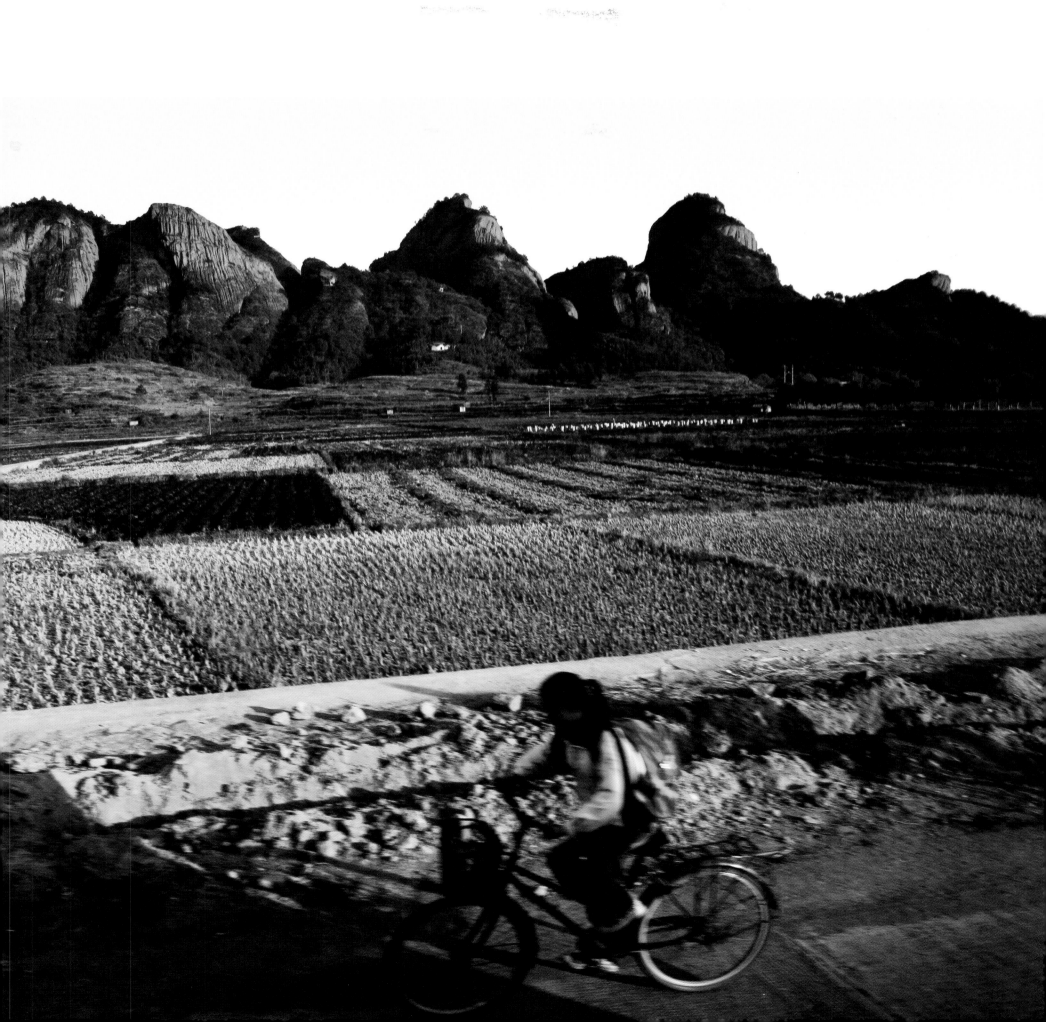

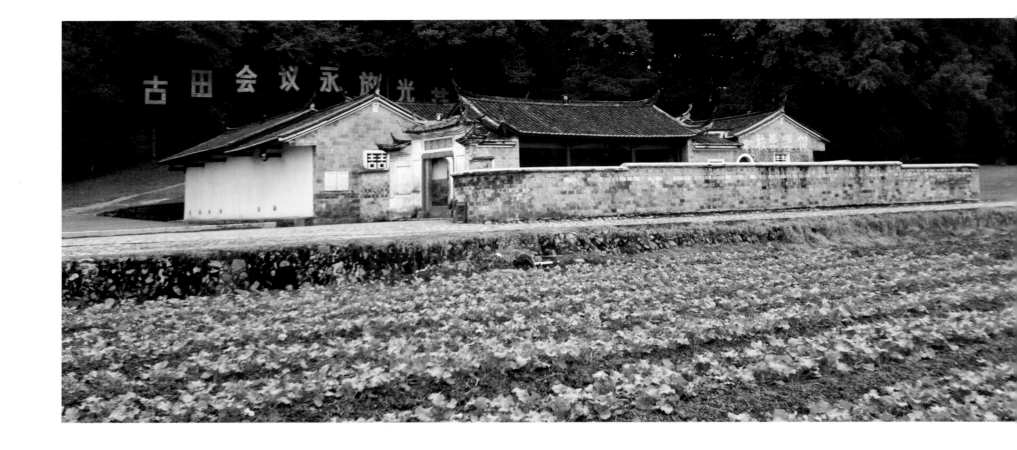

古田会议旧址
Gutian Conference Site

原为廖家祠堂，始建于清朝末年，民国以后曾为和声小学校址。祠堂是一组砖木结构建筑，由前后厅和左右厢房组成。祠堂左侧有水井，右侧有红军检阅台，背后杉柏参天。会址后厅原是学校高年级课堂，1929年12月古田会议就在这里举行。

It is formerly ancestral hall of the Liao's family, built in the late times of the Qing dynasty, and was once the site of an elementary school. It is architecture of bricks and woods. In Dec. of 1929 the Gutian conference was held here.

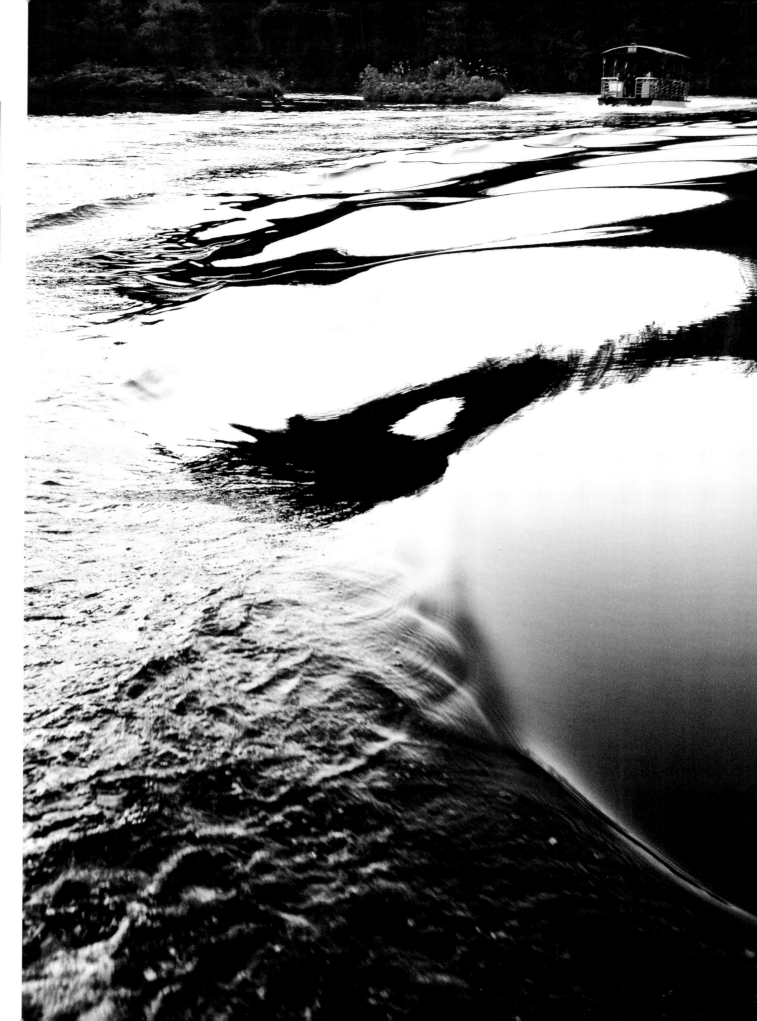

石门湖
Shimen Lake

坐落于福建连城冠豸山东南方的石门湖，面积四百多亩，如一块翡翠，镶嵌在冠豸山的险峰奇谷中，四周环山，是连城昔日八景之一的『石门宿云』所在地。

Shimen Lake is located to the southeast of Guangzhai Mountain in Liancheng, Fujian. It covers more than four hundred acres of land with the outline resembling a jade embedded in the cliffs and surrounded by hills.

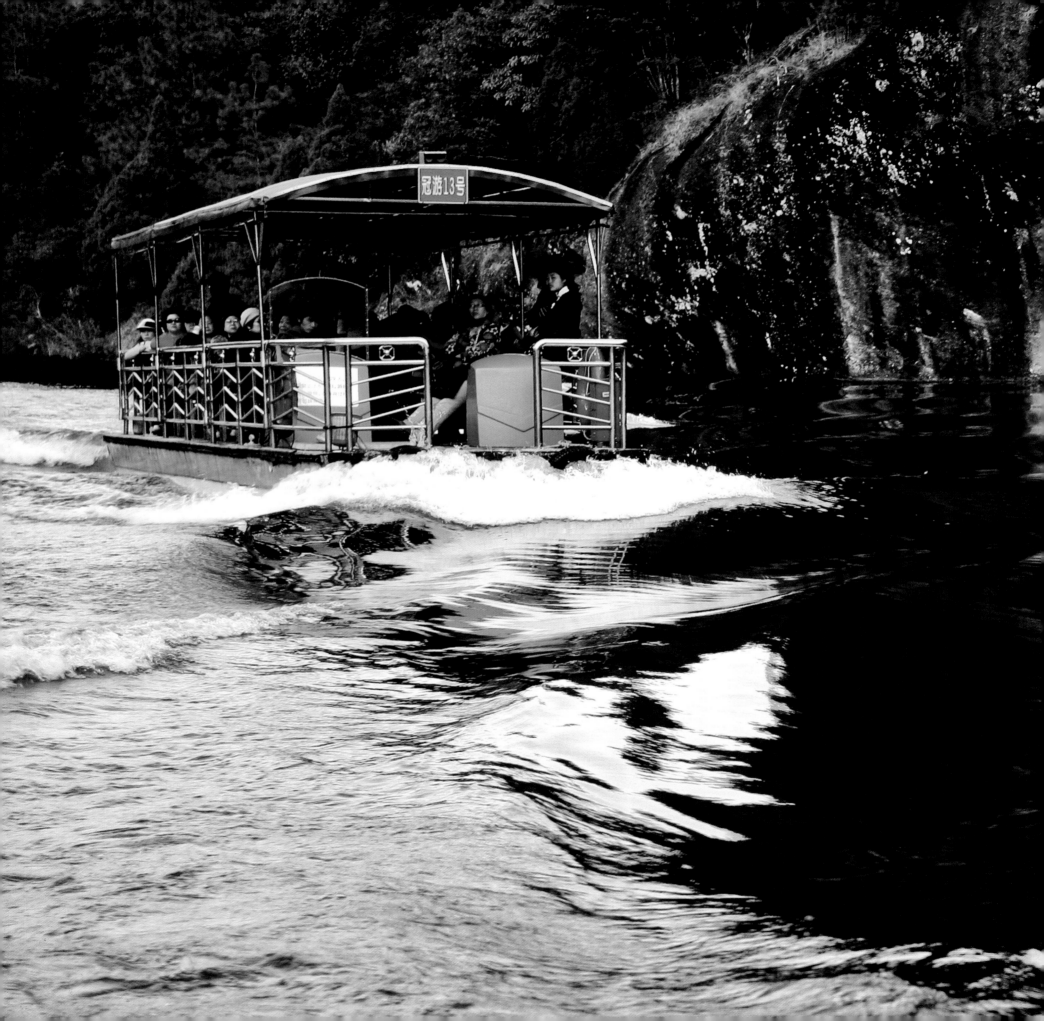

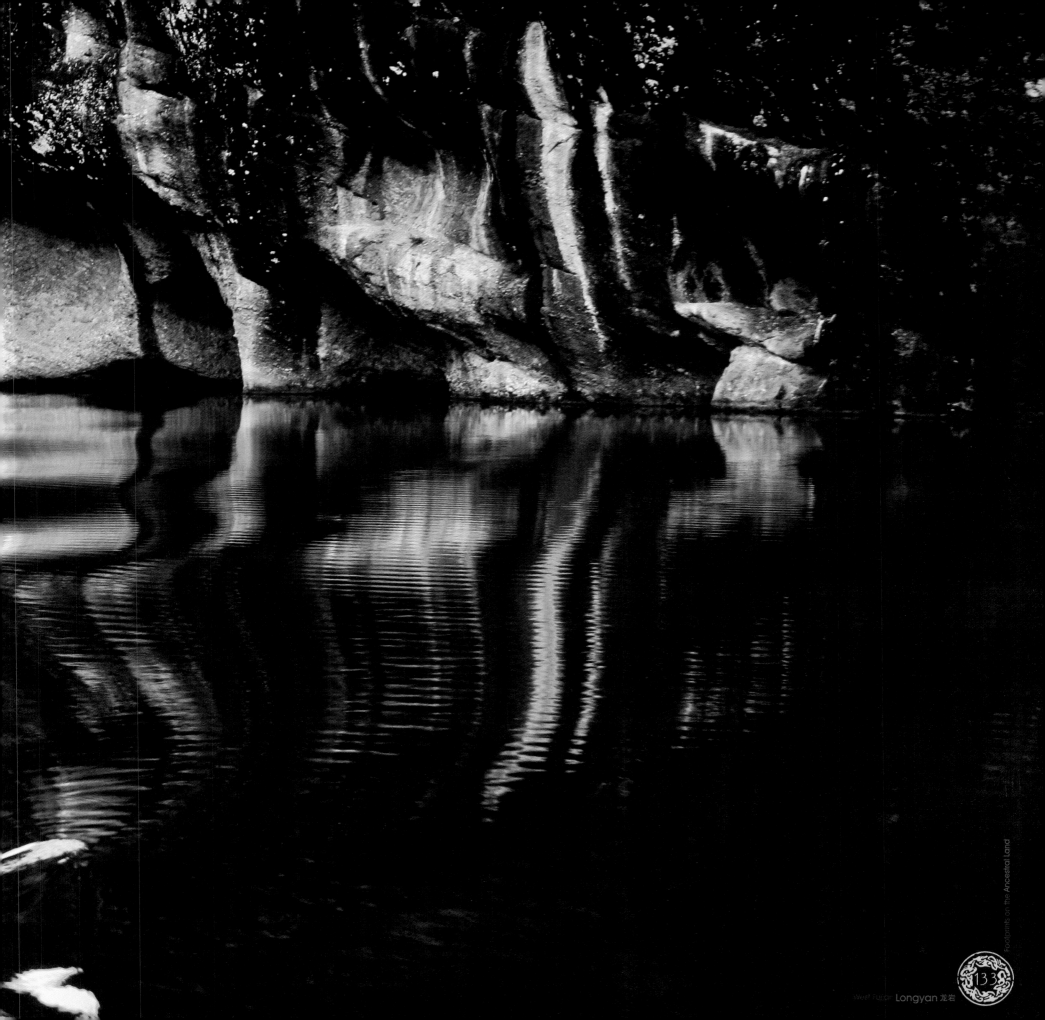

West Fujian Longyan 龙岩

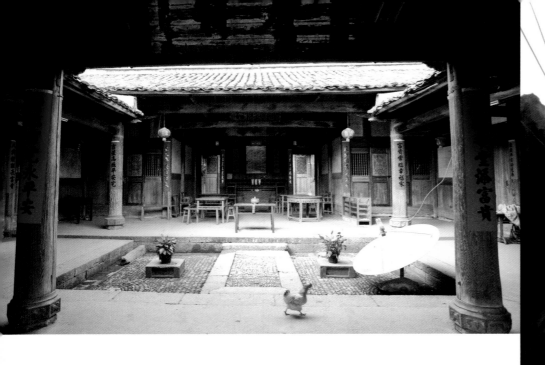

培田古民居
Peitian Old Residences

是中国历史文化名村，位于连城县境内，是客
家人另一种截然不同的建筑风格，素有"民间
故宫"之称。它以"九厅十八井"为基本特征，
厅高堂阔，雕梁画栋，纵主横次，厅厢配套，
堪称建筑工艺与近代科技的完美结合。

It is a famous village and located in the county
of Liancheng, which shows us a totally different
style of the Hakkas architecture and nicknamed
folk Forbidden City. It is typical of nine halls and
eighteen wells, and the halls are open and wide.
The whole building is a perfect combination of
architecture and modern technologies.

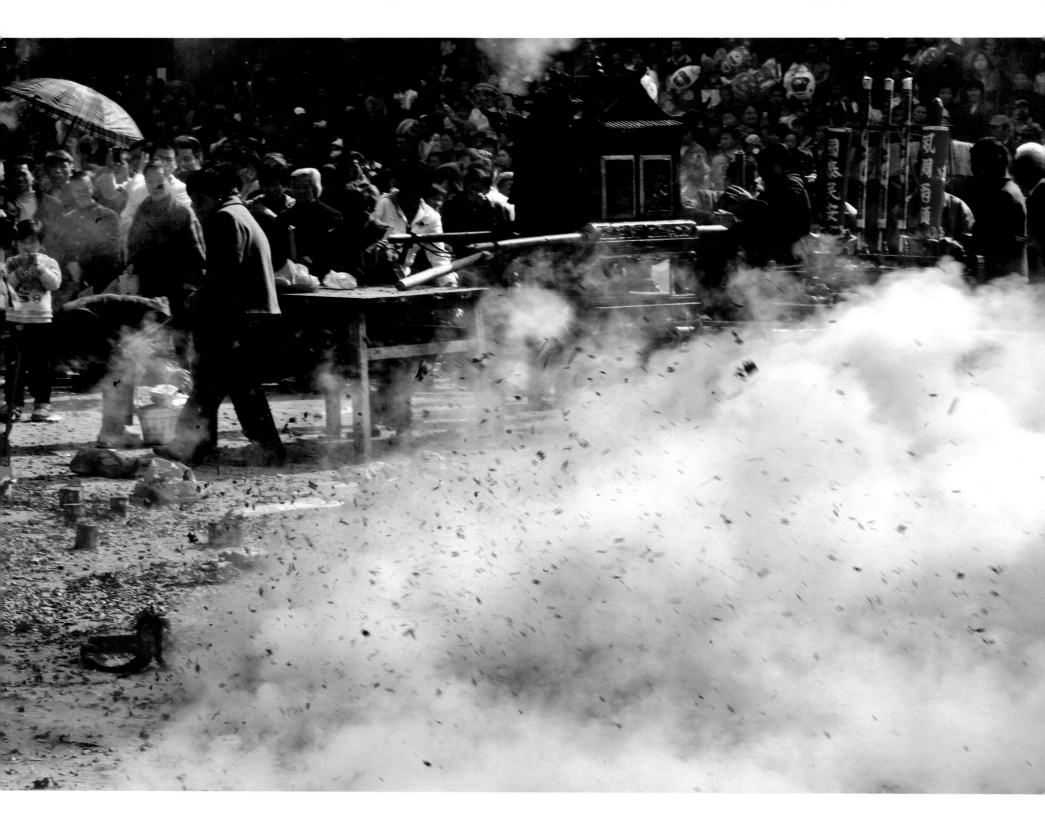

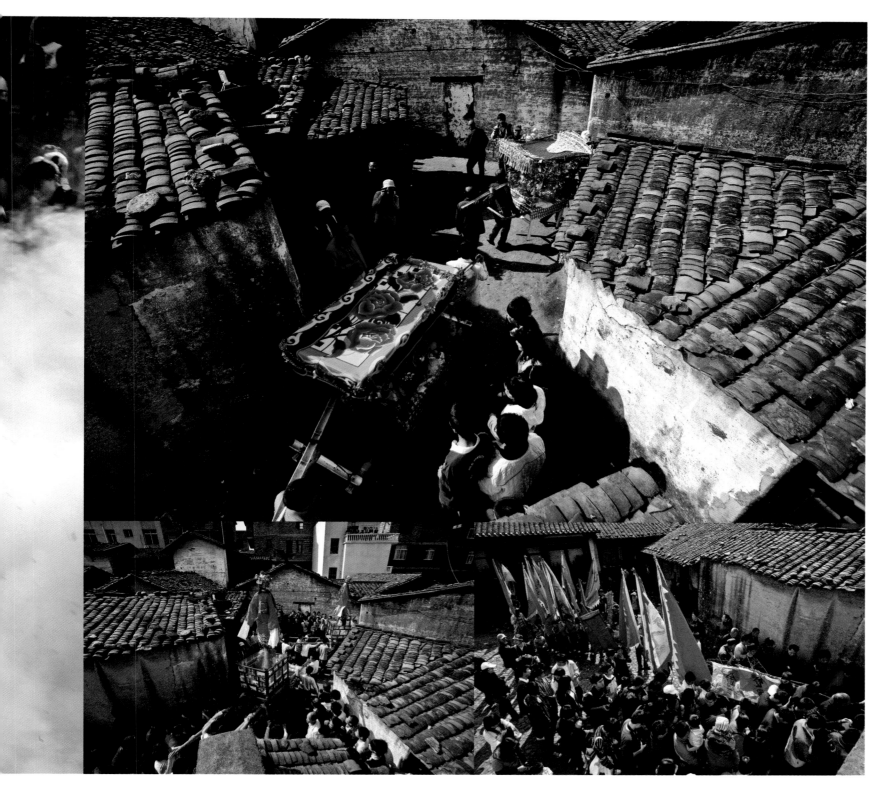

罗坊走古事
Luofang Zou Gu Shi

元宵佳节，连城县境盛行走古事，其中尤以罗坊蔚为壮观。据传昔日常闹旱涝之灾，曾任武陵知县、陕西宁州知府等要职的罗氏第十四世祖卸任时，即把流传于湖南的走古事移授乡梓，借以祈求风调雨顺、国泰民安，兼兴民间娱乐活动。

During the Lantern Festival, it is quite popular to hold ancient fairs in Lianjiang County, especially as such in Luofang. According to legend, draught and flood often tortured the county. When the 14th generation of the Luo Family resigned from the post of county chief, he taught the local people to hold ancient fairs to pray for favorable climatic weathers and a peaceful life of the people, as well as providing entertainment activities for the people.

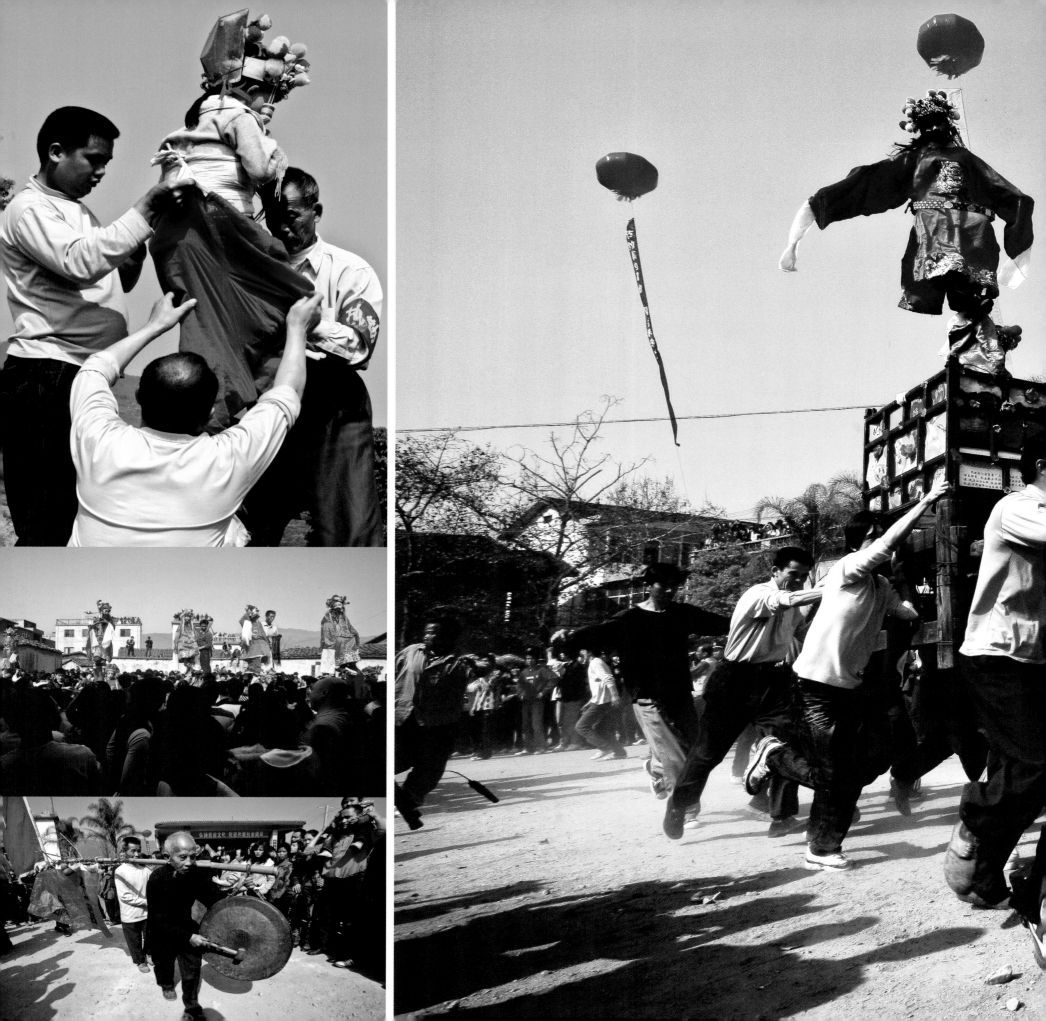

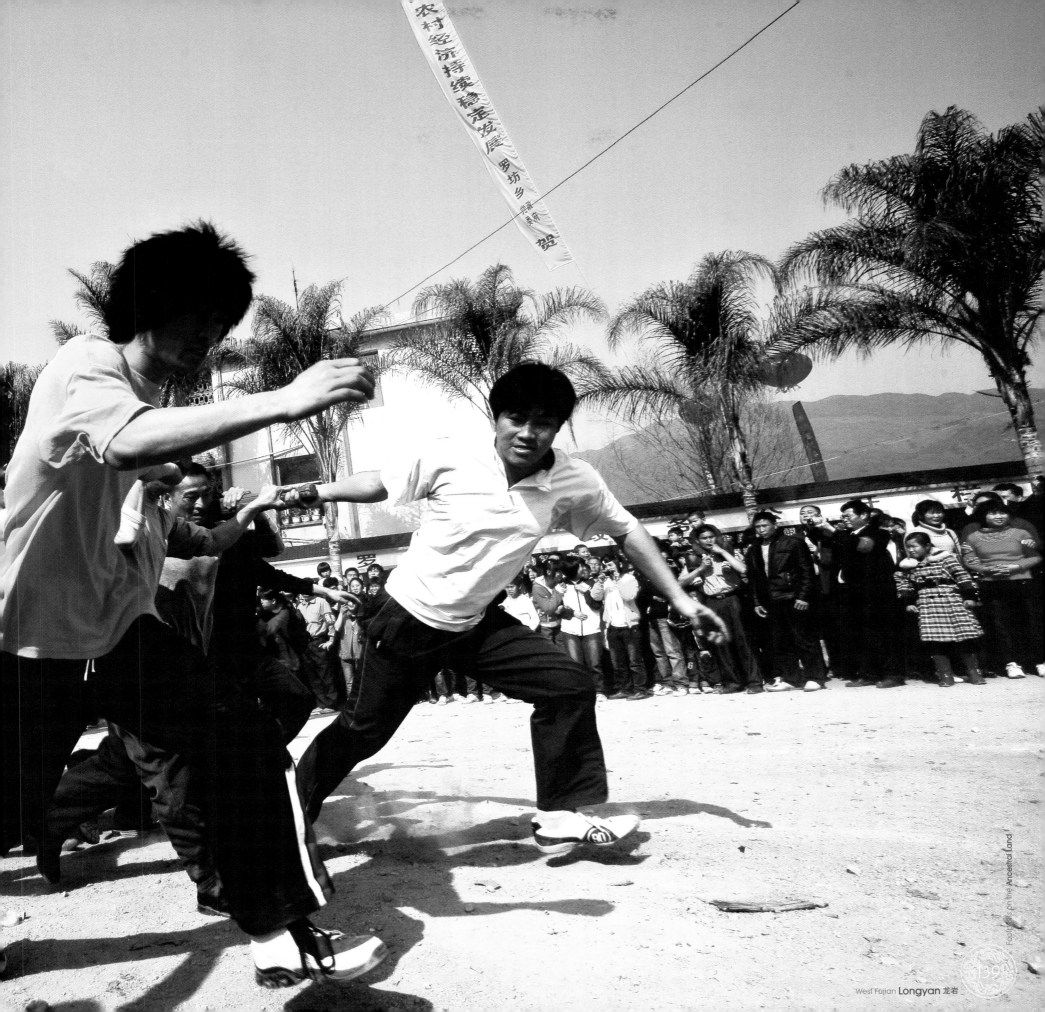

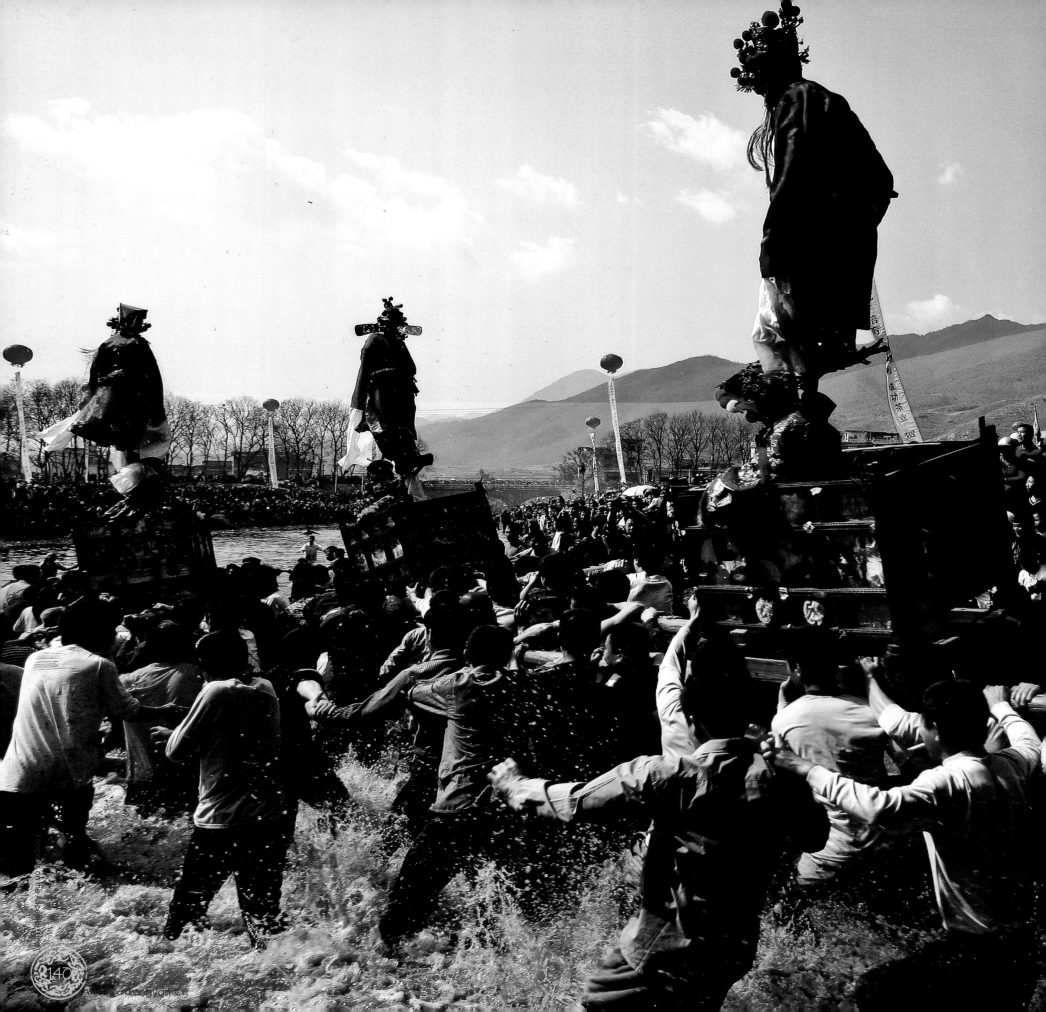

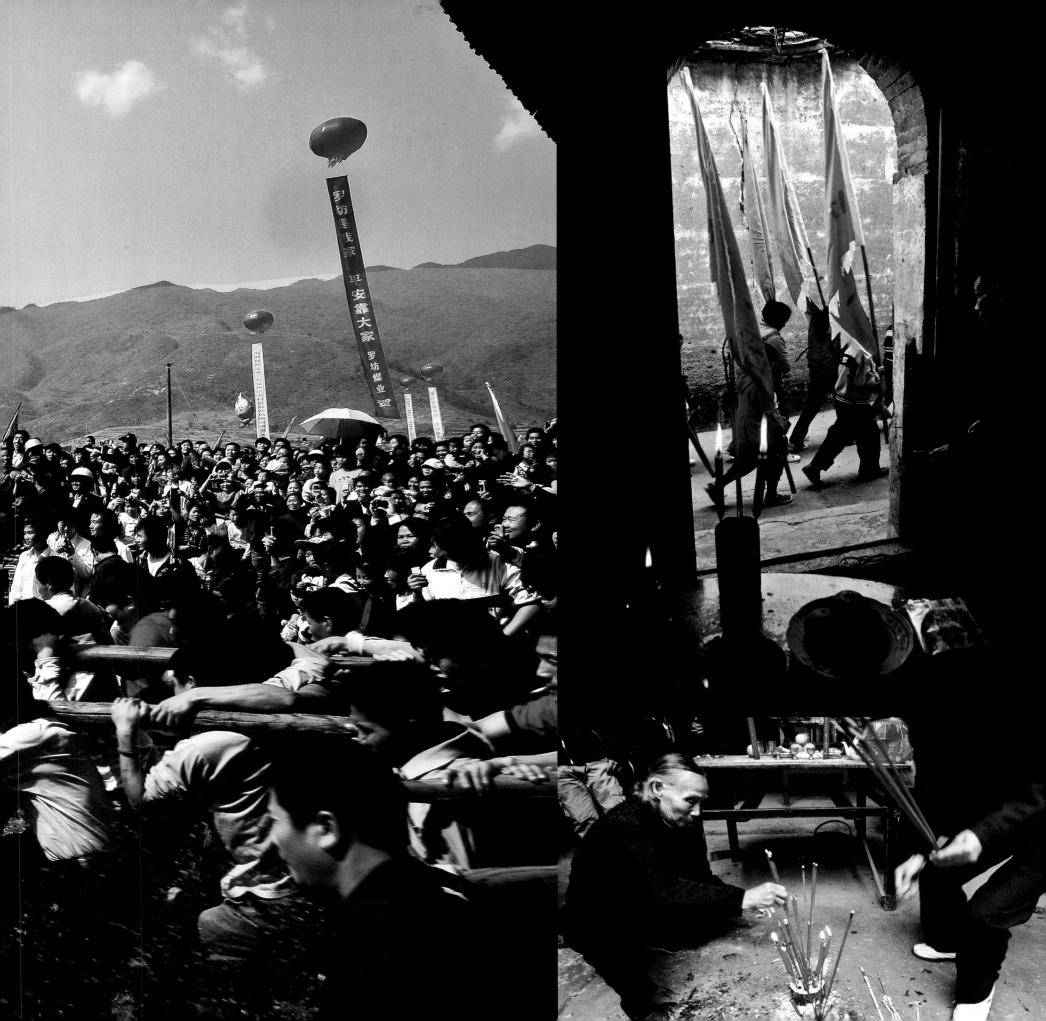

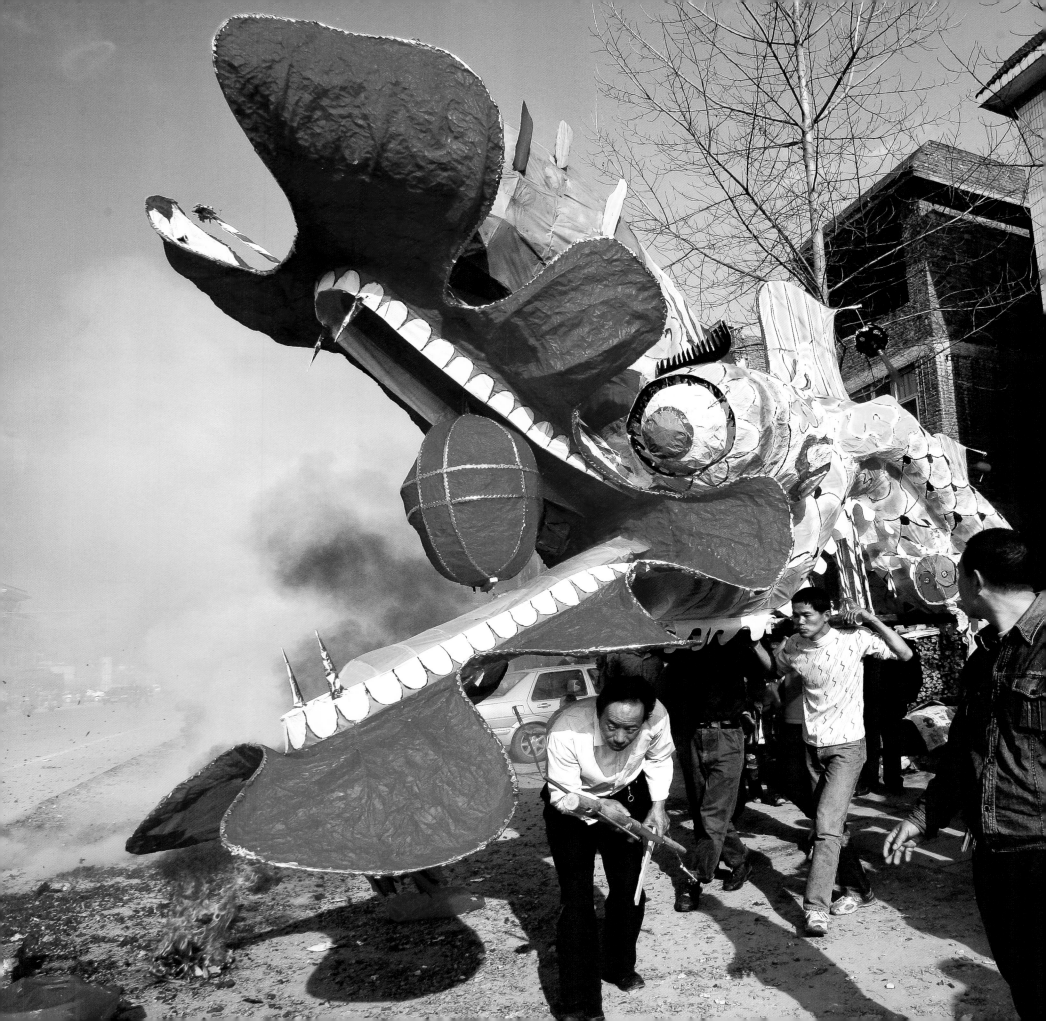

姑田游大龙
Gutian Dragon Playing

游大龙是连城县姑田镇元宵佳节的传统文娱活动，始于清乾隆十六年（公元 1751 年）。姑田纸扎龙直径 70 厘米，长 600 余米，由 150 节板凳组成，多达 600 余名青壮年参与，被誉为 "天下第一龙"。

In Gutian Town of the Liancheng County. Dragon Playing is a traditional entertainment activity during the Lantern Festival, which dates back to 1751AD. The paper-made dragon has a diameter of 70cm and length of more than 600 meters, and composed of 150 sets of wooden benches. More than 600 strong adults will take part in the activity, and it is called the longest dragon around the world.

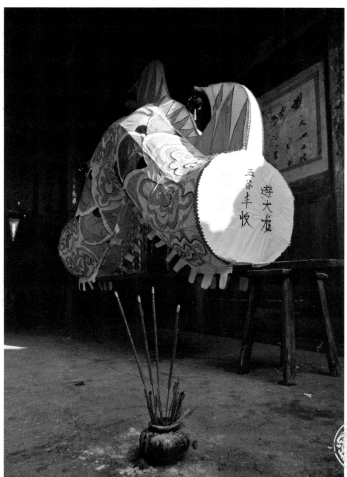

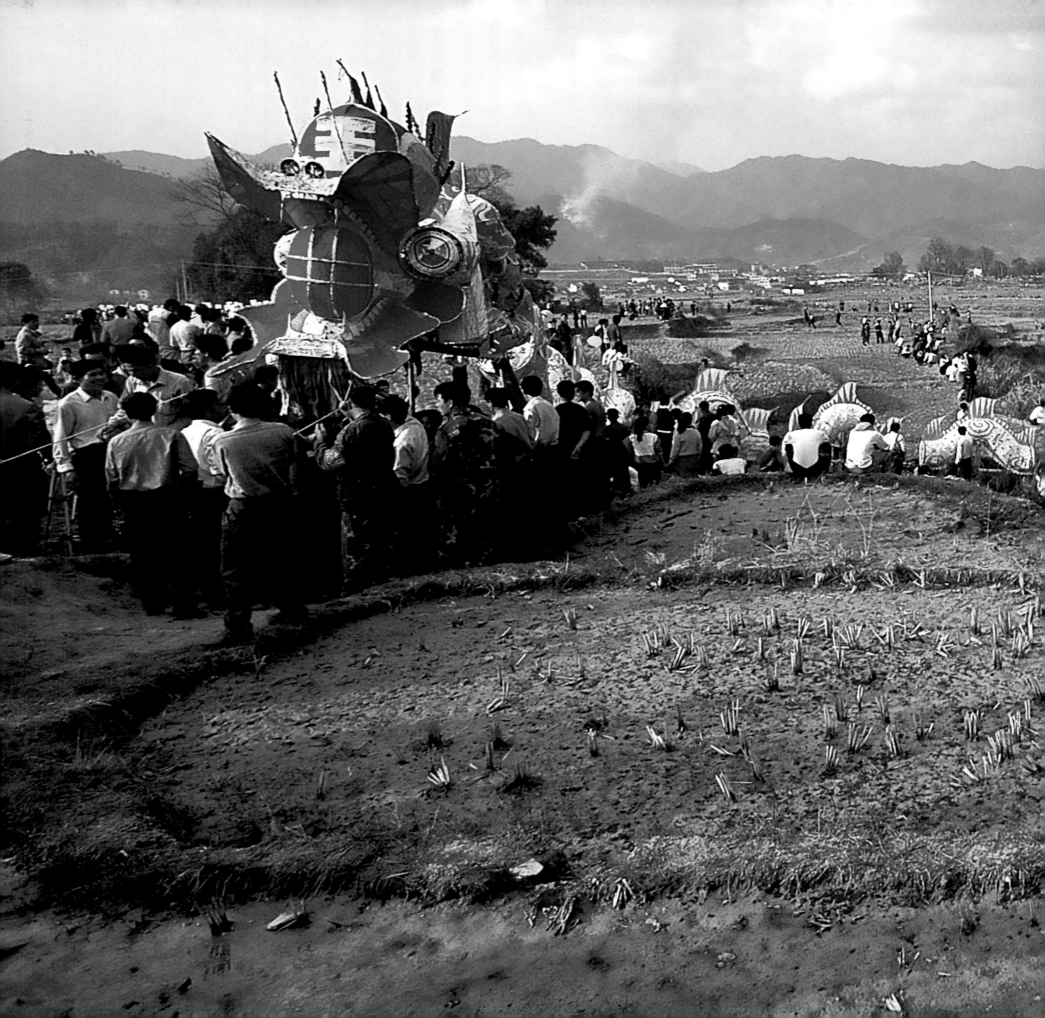

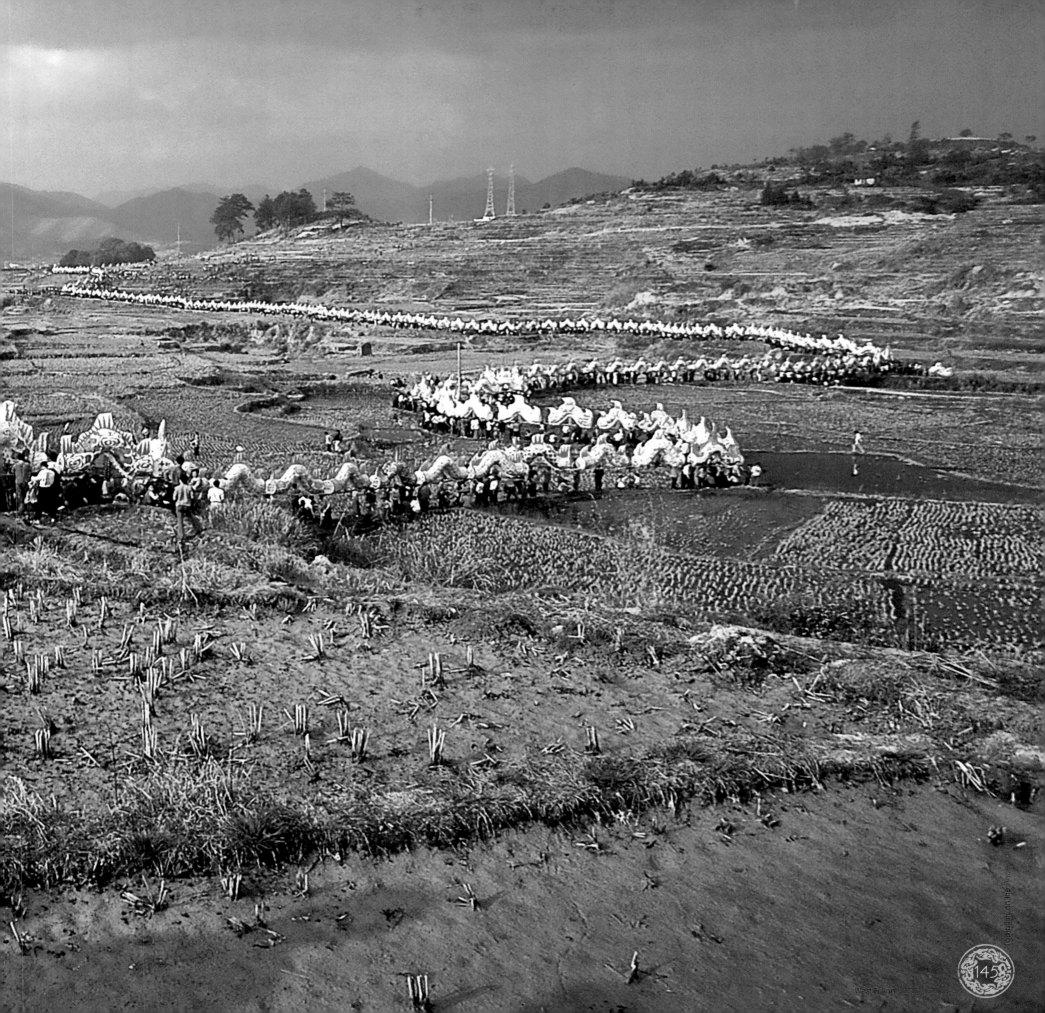

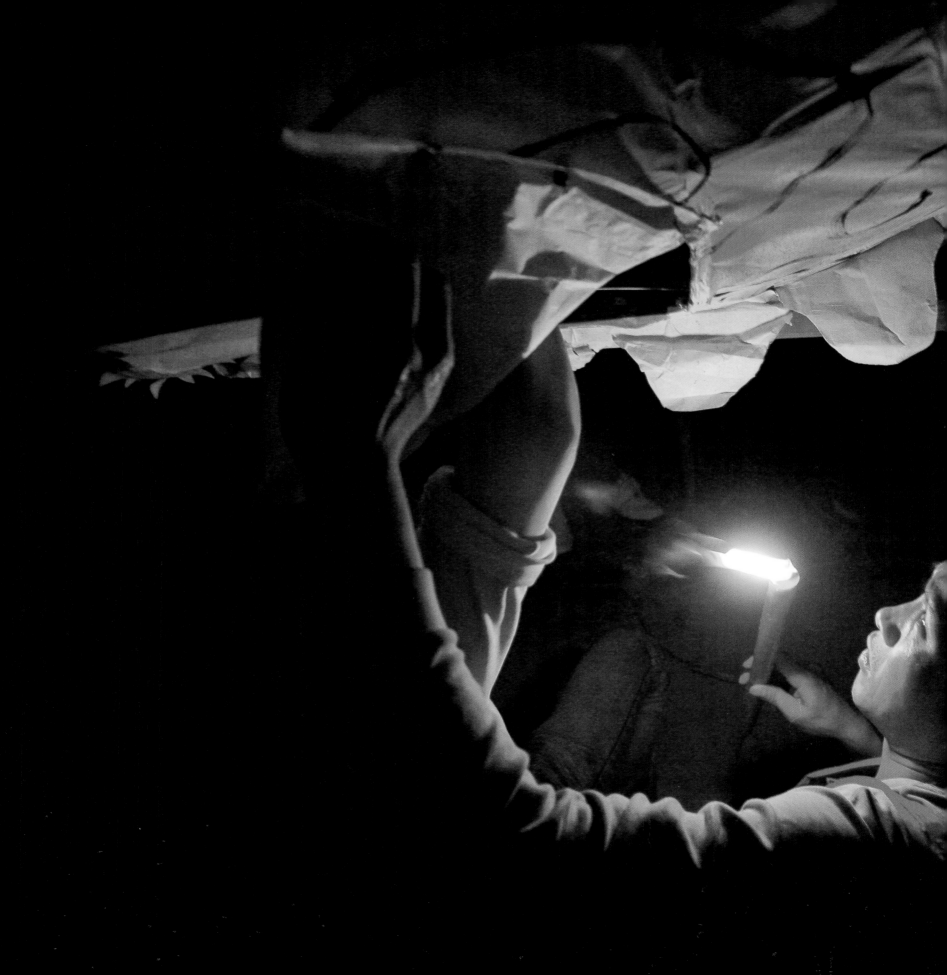

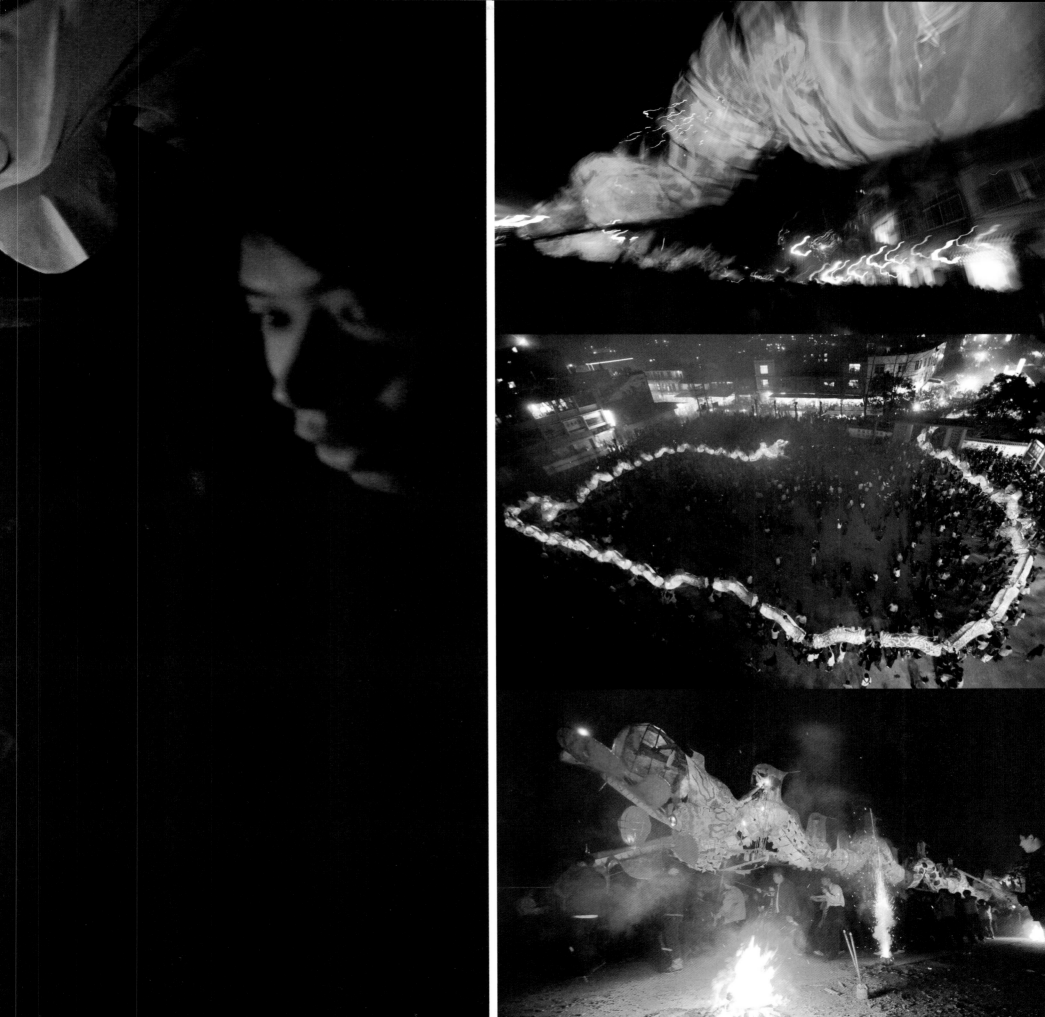

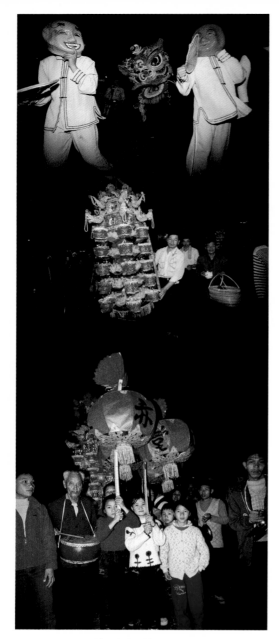

芷溪游花灯
Zhixi Lanterns Parade

源自苏州，保留了古苏州的花灯艺术和锣鼓音乐，300 年来代代传承着"纸包火"的奇迹。每个花灯有 99 盏火，由琉璃杯装棕油点亮，通透澄莹、熠熠生辉。多时达百余个花灯组成一支花灯长队，首尾相接、明烛夜空；花团锦簇、琳琅满目，在长时间的摄影曝光下展示出壮观的影像。

It was originated from Suzhou, which retains the ancient Suzhou lantern art and drum music. And for 300 years, it has been inheriting the miracle of "fire in paper" from generation to generation. Each lantern has 99 small cups of fire, with palm oil lit in glazed glasses. They are transparent and crystal clear, and sparkling all the time. Sometimes up to hundreds of lanterns make up a long queue, nose to tail, lightening up the night of the night. They are always richly decorated and dazzling, and form spectacular images with a longtime photograplic exposure.

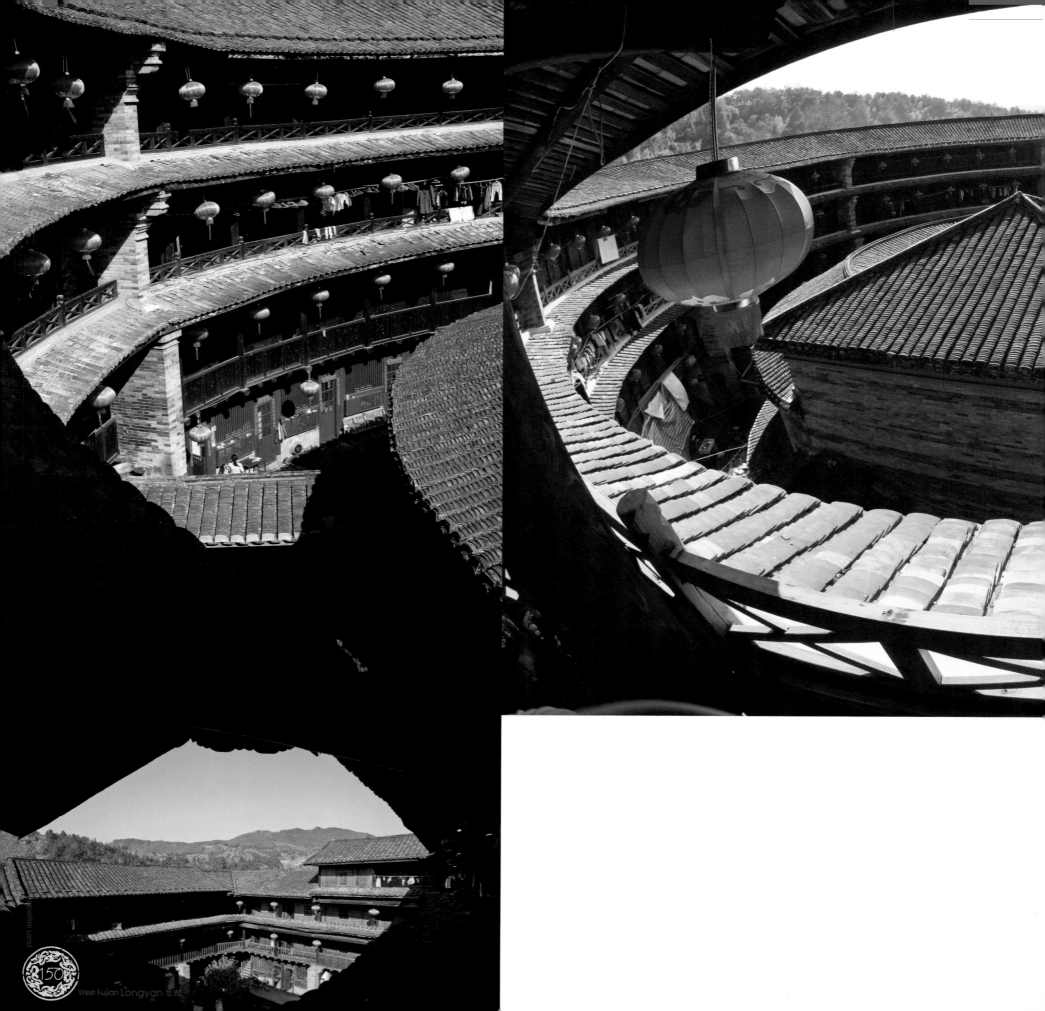

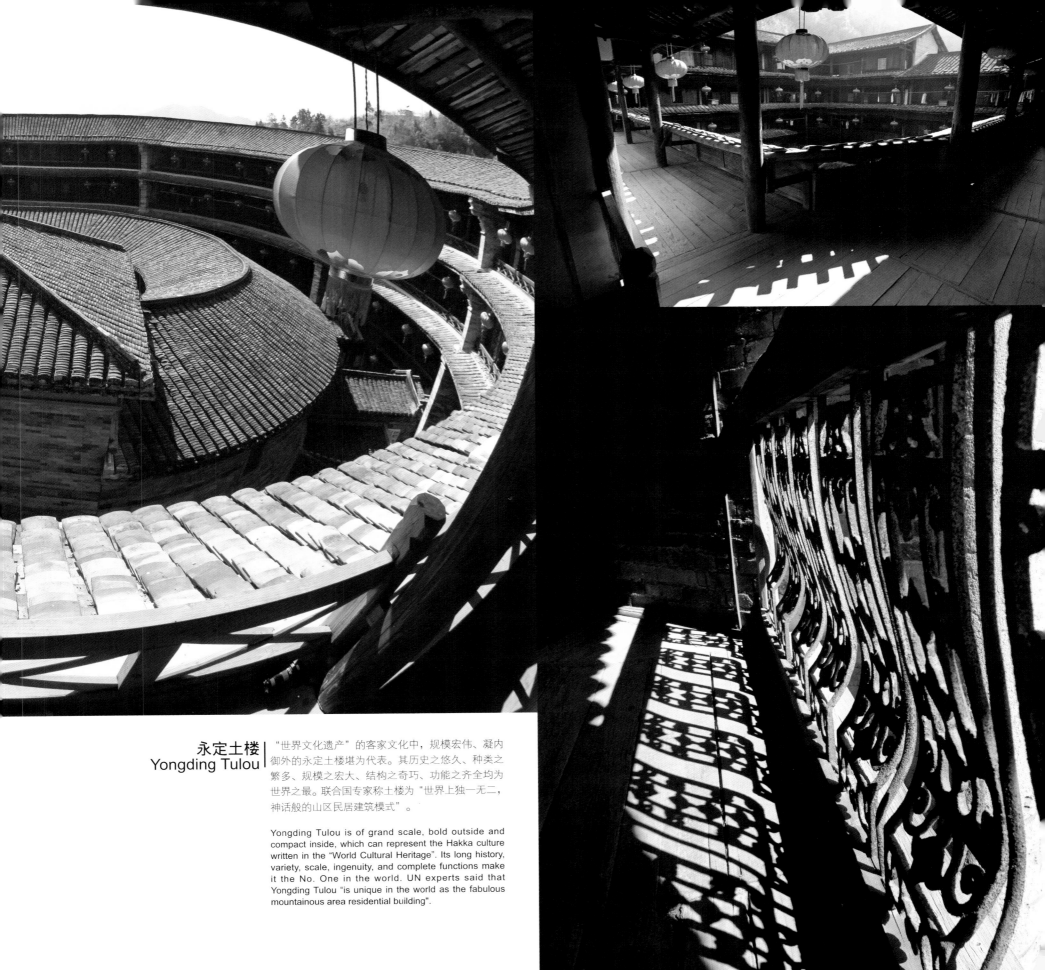

永定土楼
Yongding Tulou

"世界文化遗产"的客家文化中，规模宏伟、凝内御外的永定土楼堪为代表。其历史之悠久、种类之繁多、规模之宏大、结构之奇巧、功能之齐全均为世界之最。联合国专家称土楼为"世界上独一无二，神话般的山区民居建筑模式"。

Yongding Tulou is of grand scale, bold outside and compact inside, which can represent the Hakka culture written in the "World Cultural Heritage". Its long history, variety, scale, ingenuity, and complete functions make it the No. One in the world. UN experts said that Yongding Tulou "is unique in the world as the fabulous mountainous area residential building".

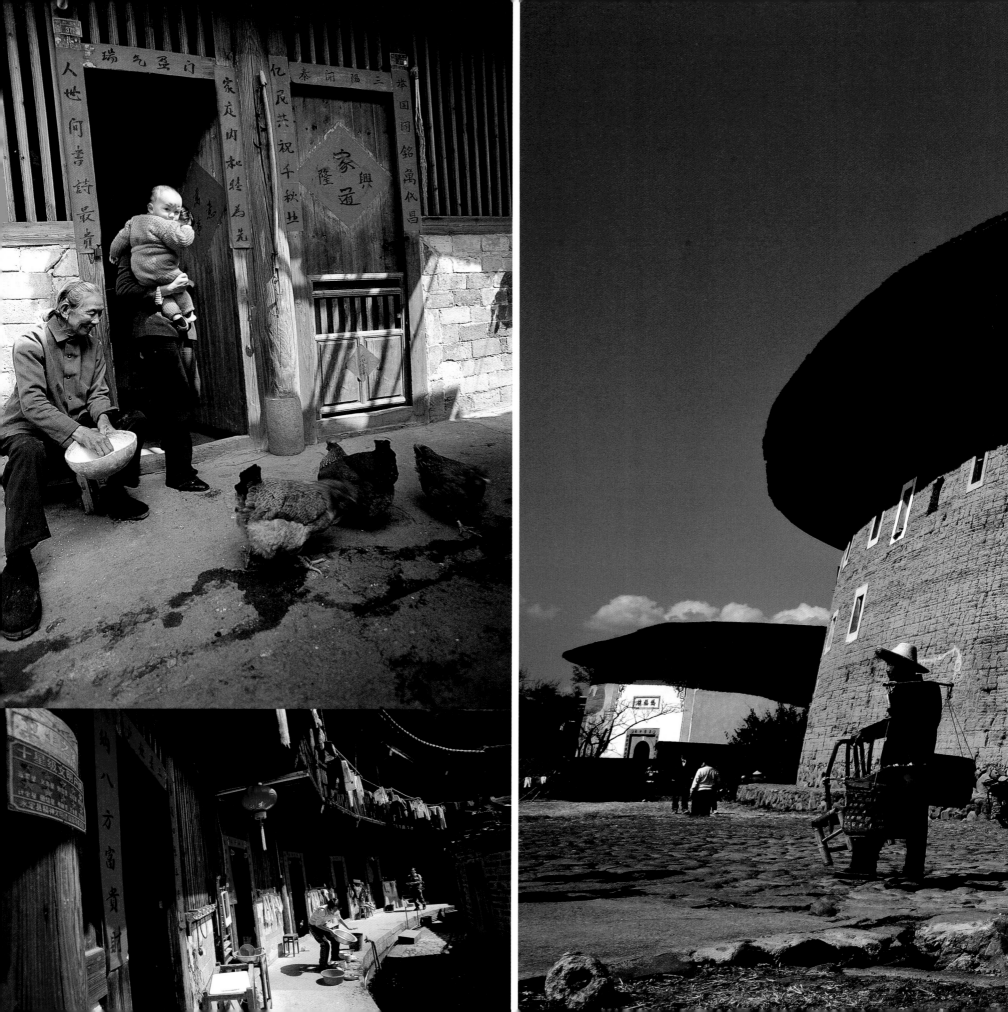

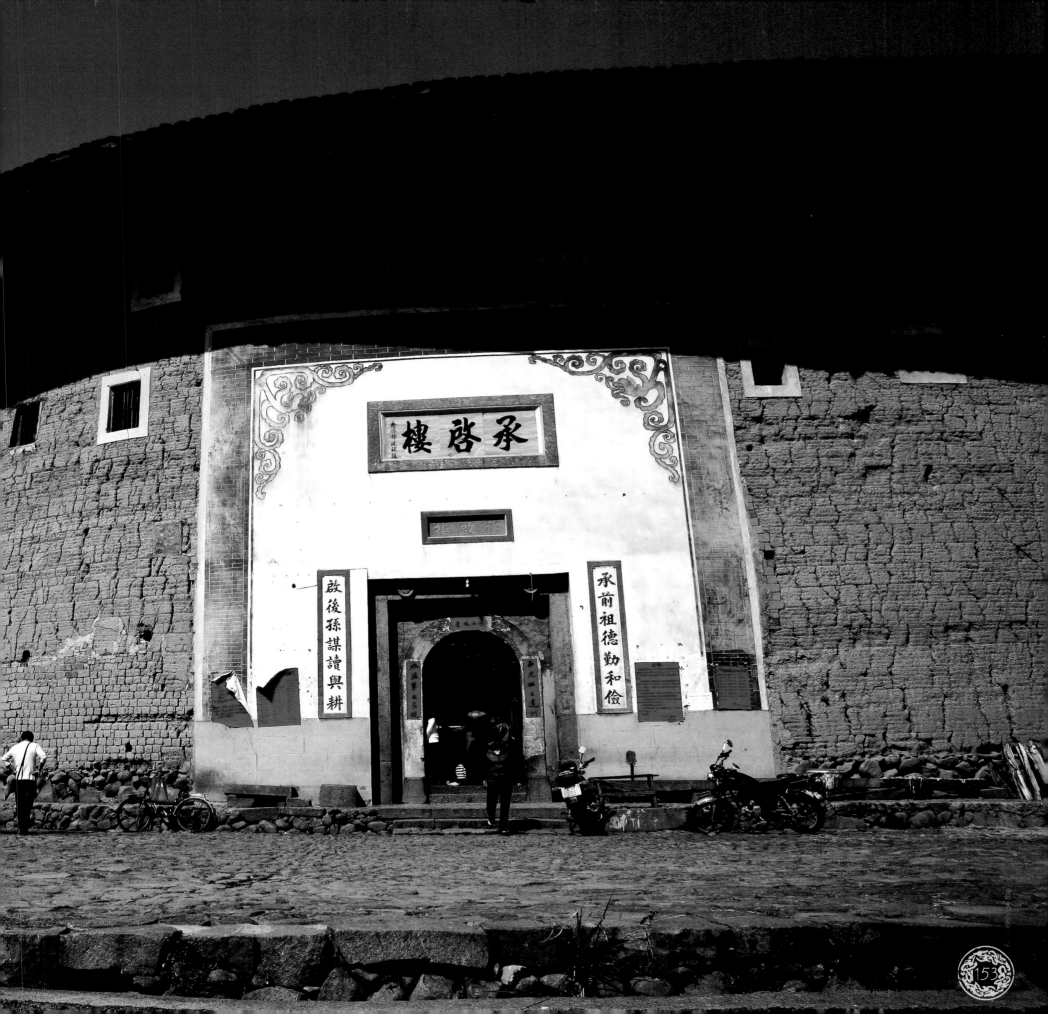

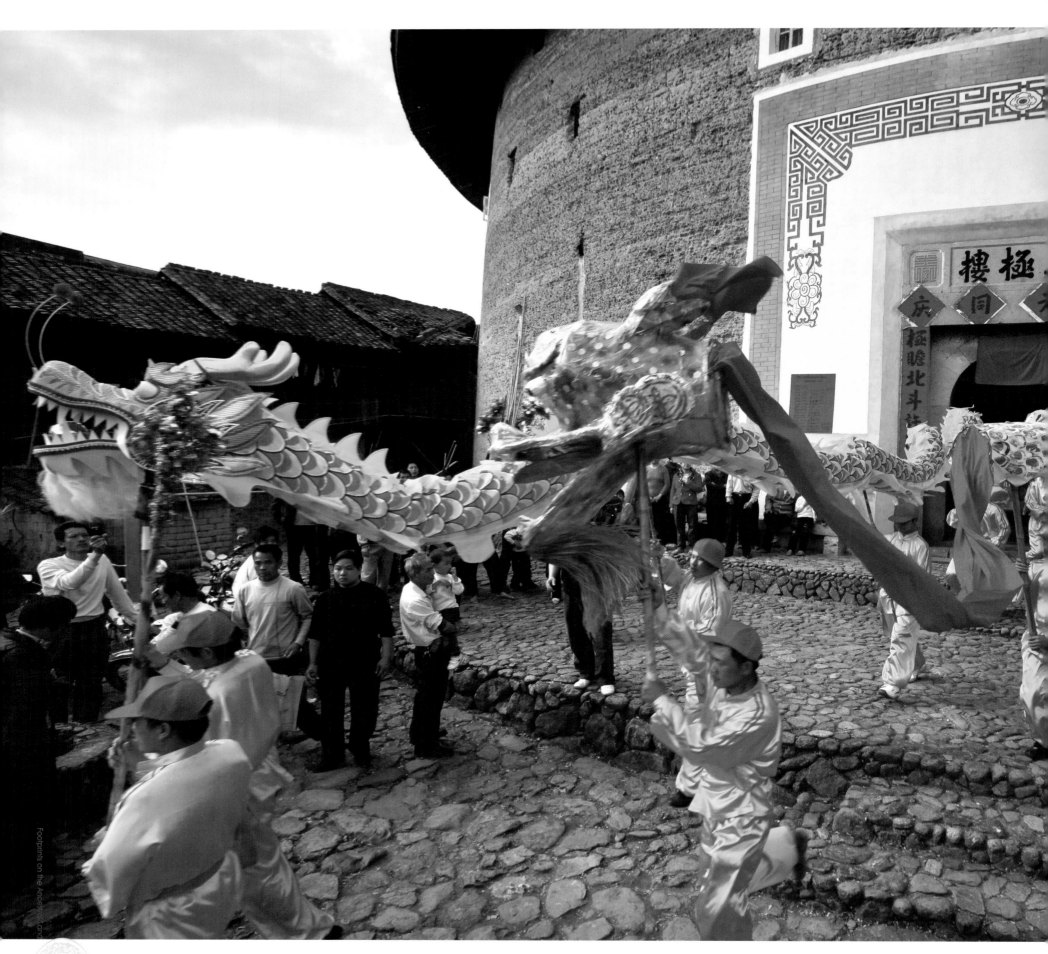

West Fujian **Longyan** 龙岩

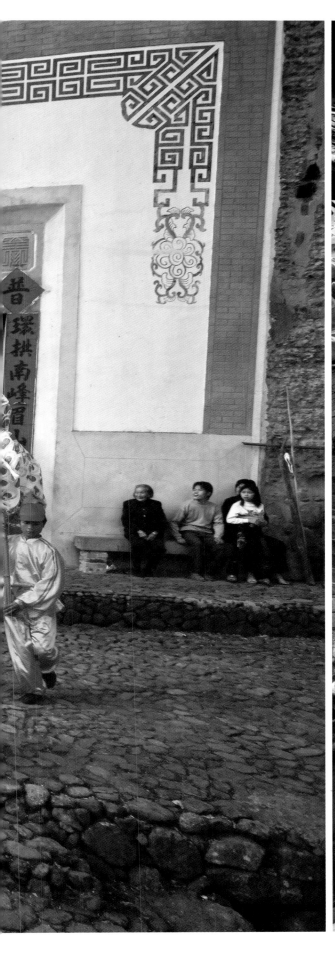
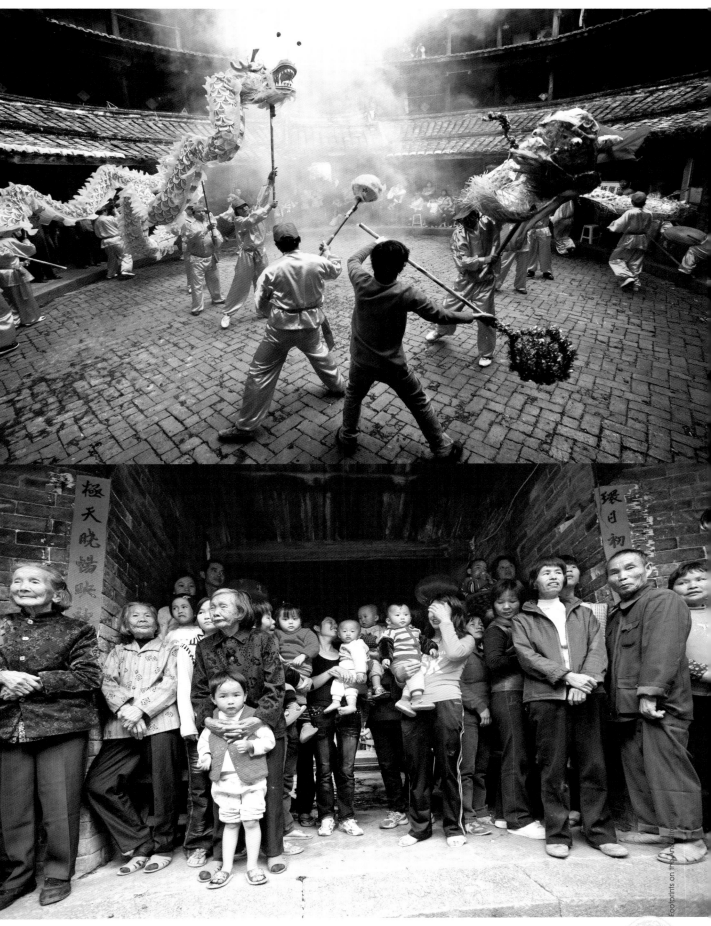

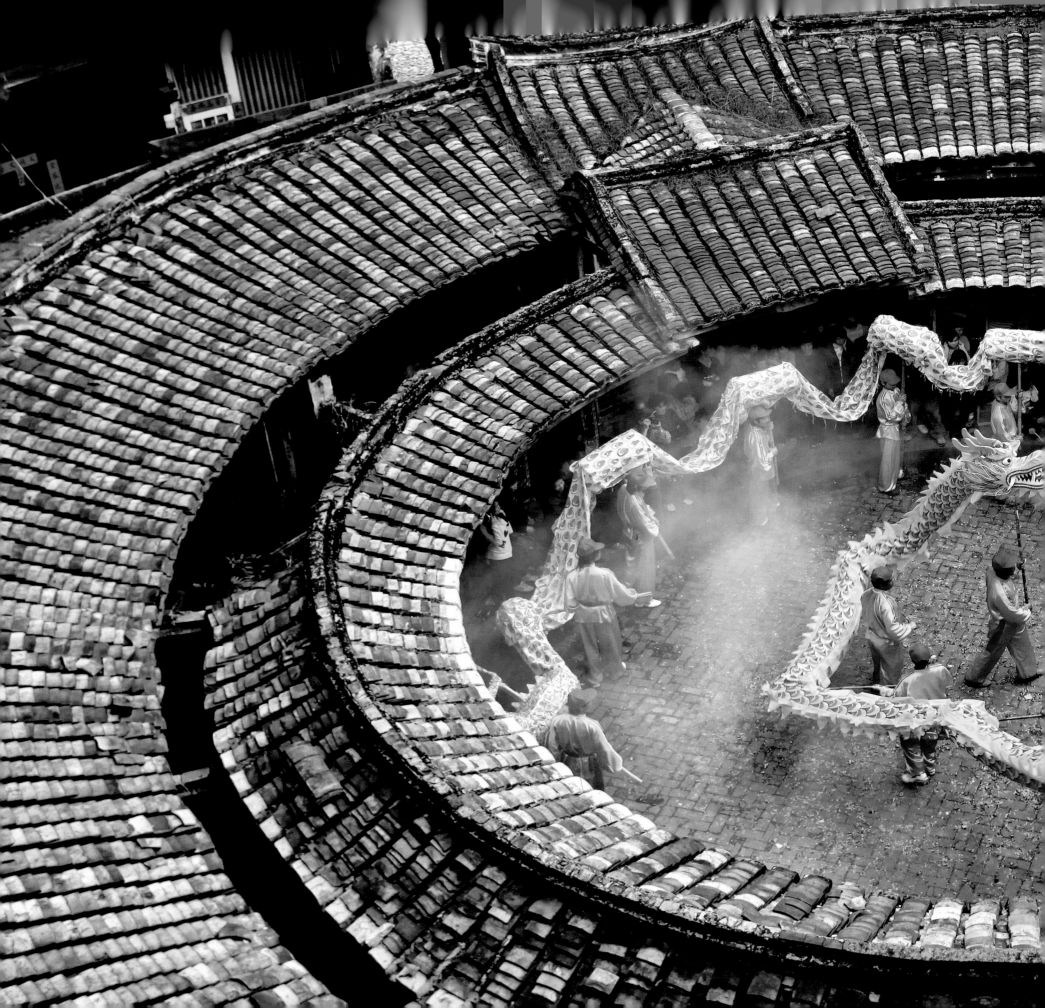

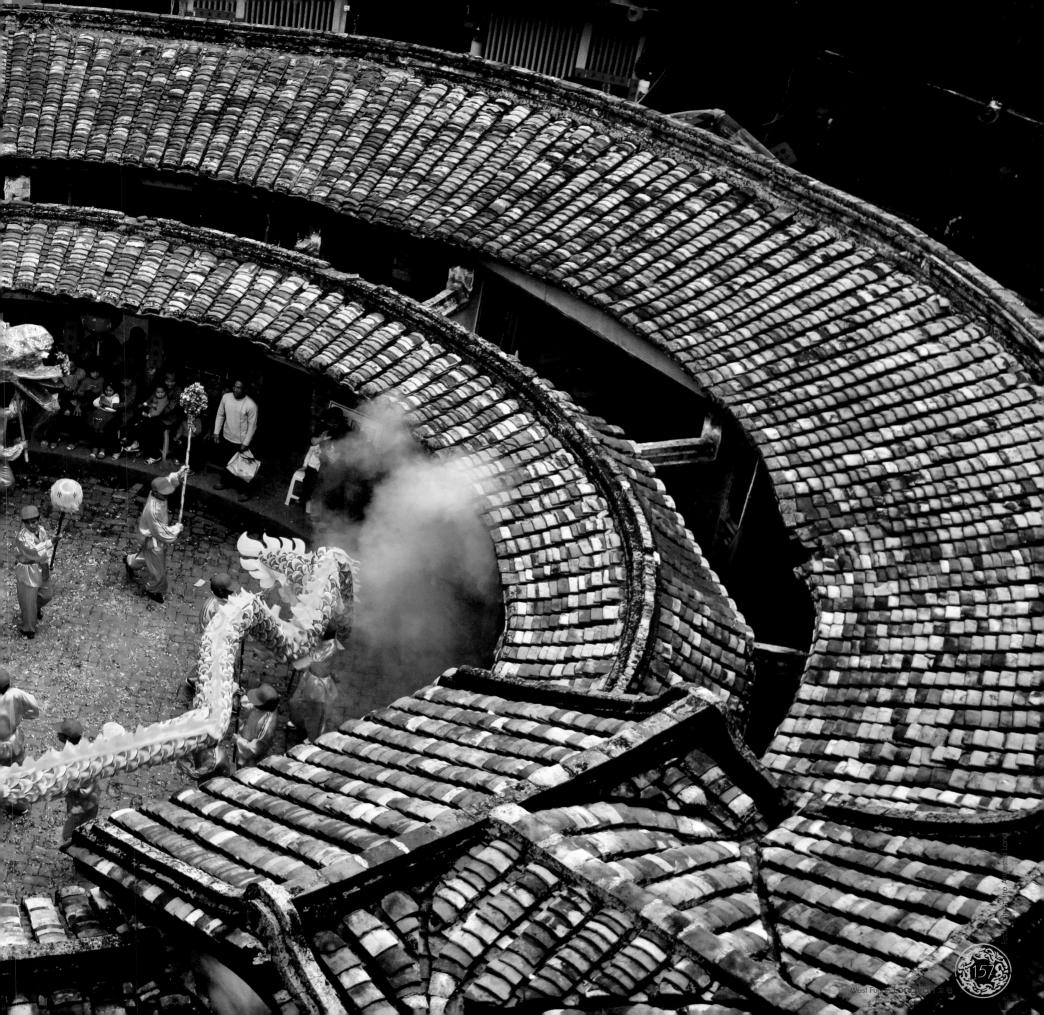
West Fujian—Longyan 龙岩

Folk rituals in the ancestral hall

闽南

South Fujian

闽南即指福建的南部，东临台湾海峡，与台湾的金门近在咫尺。从地理、习俗、方言等方面去划分，厦门、漳州、泉州三个地区合称为闽南。由于经济发达、交通便利，向有"闽南金三角"之称。早年曾是著名的侨乡，很多台湾人和南洋华人祖籍都在这里。作为一个特定文化传承的区域，其影响之深远不言而喻。

Minnan is the south of Fujian, facing Taiwan Strait on the east, quite close to Jinmen. In terms of geography, customs and dialects, the three areas of Xiamen, Zhangzhou, Quanzhou form Minnan. Due to its developed economy, convenient transportation, Minnan is always known as the "Southern Golden Triangle". Early years it was a famous hometown of overseas Chinese. Many Taiwanese and Nanyang Chinese root in here. As a particular cultural heritage area, its significance becomes self-evident.

戴云山国家级

德化县

永春县

泉港区

泉 州 市

安溪县

惠安县

华安县

南安市

泉州市

晋江市

石

虎伯寮国家级
自然保护区

厦 门 市

长泰县

南靖县

漳州市

沪湾海

森林

龙海市

厦

漳 州 市

漳浦县

云霄县

漳江口红树林

诏安县

东山县

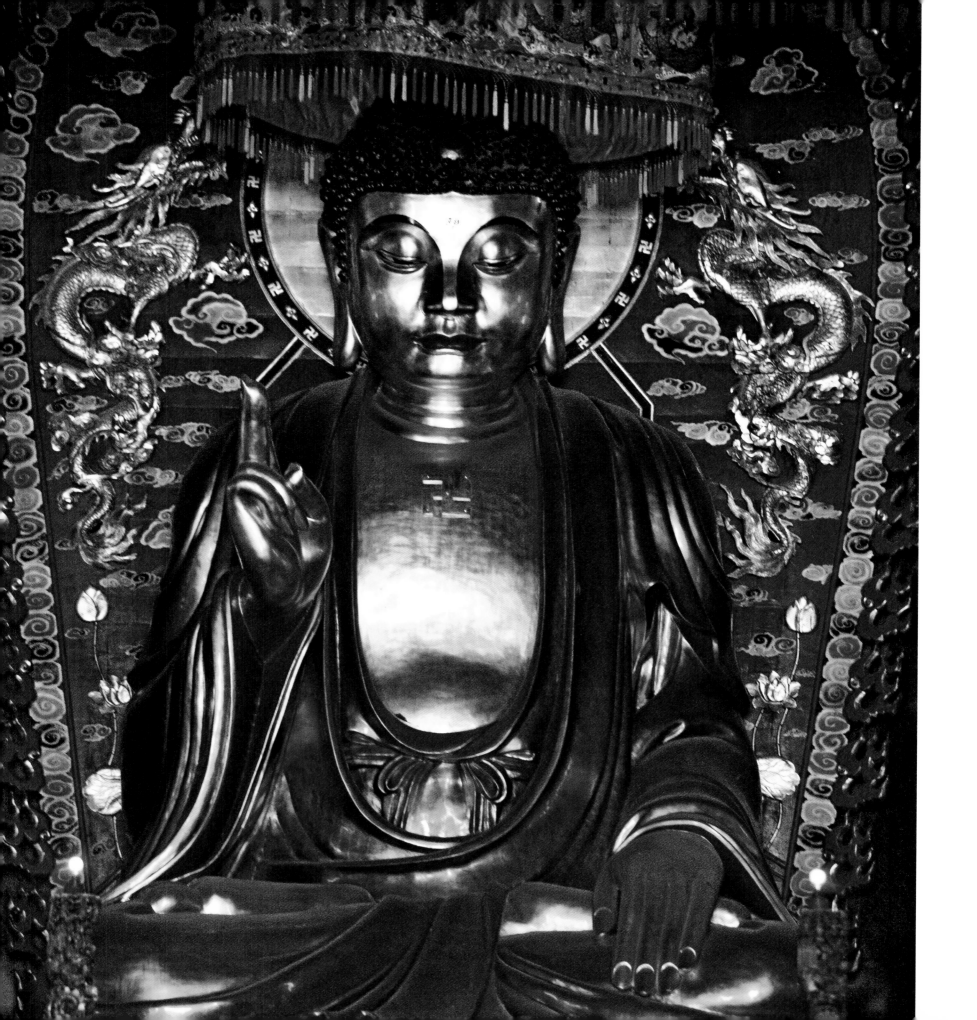

南山寺
Nanshan Temple

位于漳州市区九龙江南畔的丹霞山麓，为漳州八大名胜之一。是有一千二百多年历史的佛教大寺院，闻名四海、游客众多、香火鼎盛。

Located at the foot of the Danxia Mountain at the south bank of the Jiulongjiang River of Zhangzhou, Nanshan Temple is regarded as one of the eight attractions of Zhangzhou. As a grand Buddhist temple with a longstanding history of 1200 years, the world-renowned temple enjoys a high popularity of tourists from the entire world.

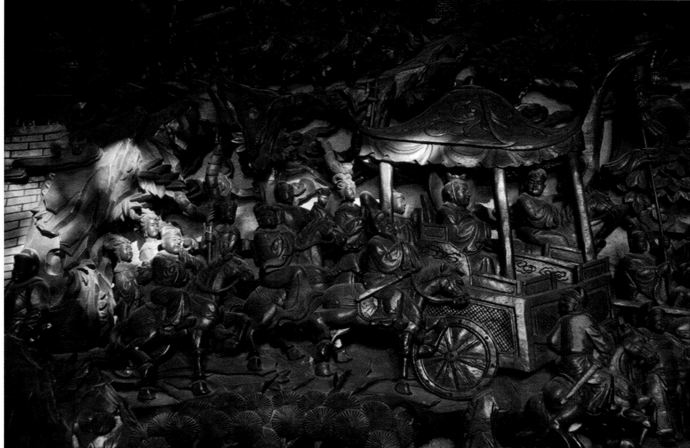

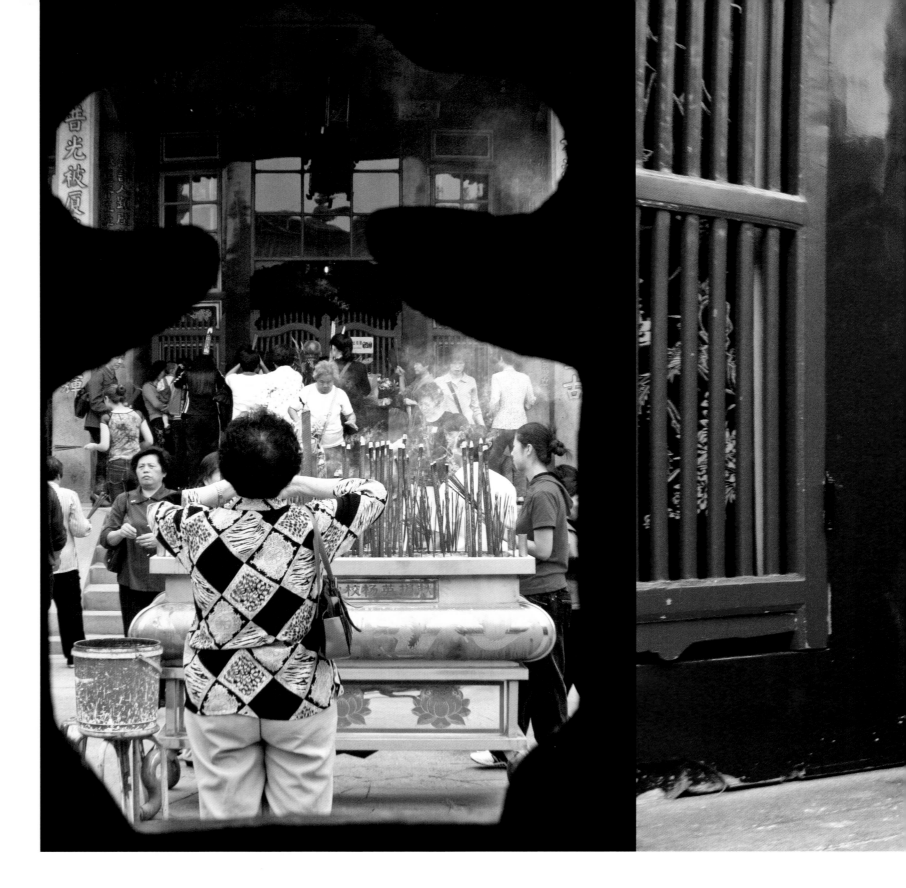

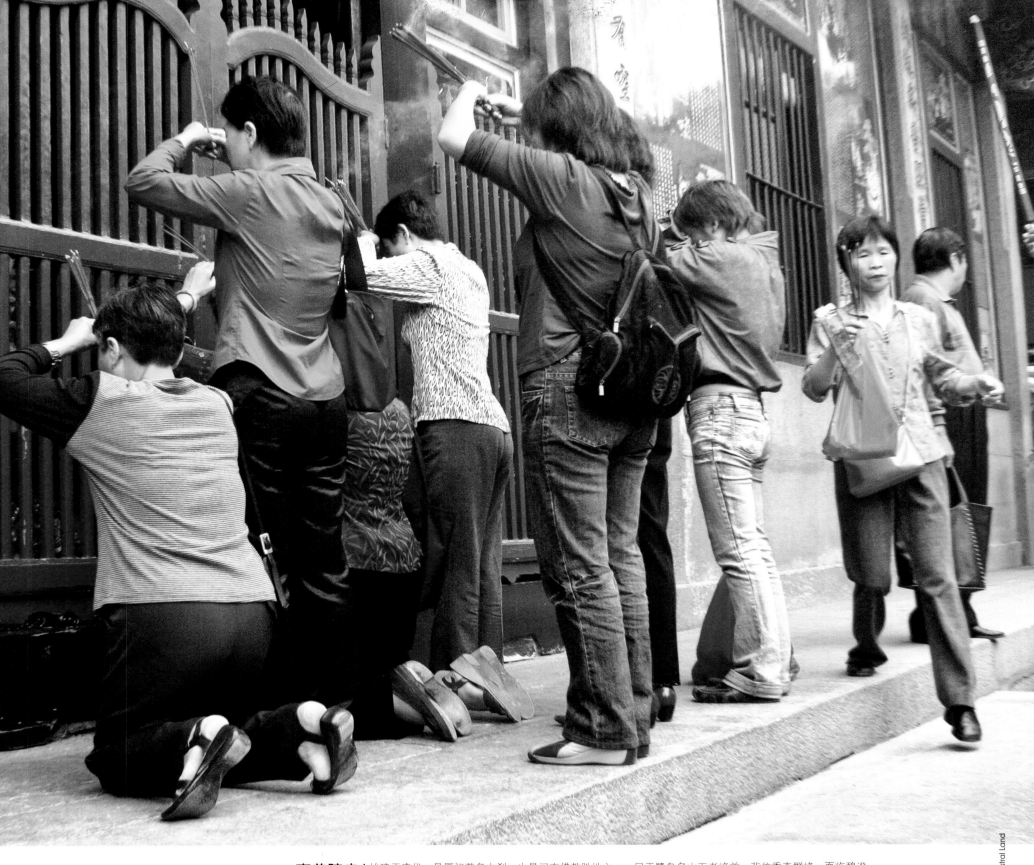

南普陀寺
Nanputuo Temple

始建于唐代，是厦门著名古刹，也是闽南佛教胜地之一。居于鹭岛名山五老峰前，背依秀奇群峰，面临碧澄海港，风景绝佳。寺内佛殿建筑精美、雄伟宏丽，珍藏之佛教文物尤其丰富多彩。

First built during the Tang dynasty, Nanputuo Temple is a famous ancient temple in Xiamen, as well as one of the most famous Buddhist attractions. Located in front of Wulaofeng Mountain the famous mountain in Xiamen, the temple has stunning scenery with the magnificent mountains and blue sea harbor surrounding it. The Buddhist halls in the temple are delicate in structure, grand in shape and beautiful in decoration, especially famous for the numerous Buddhist antiquities in the temple.

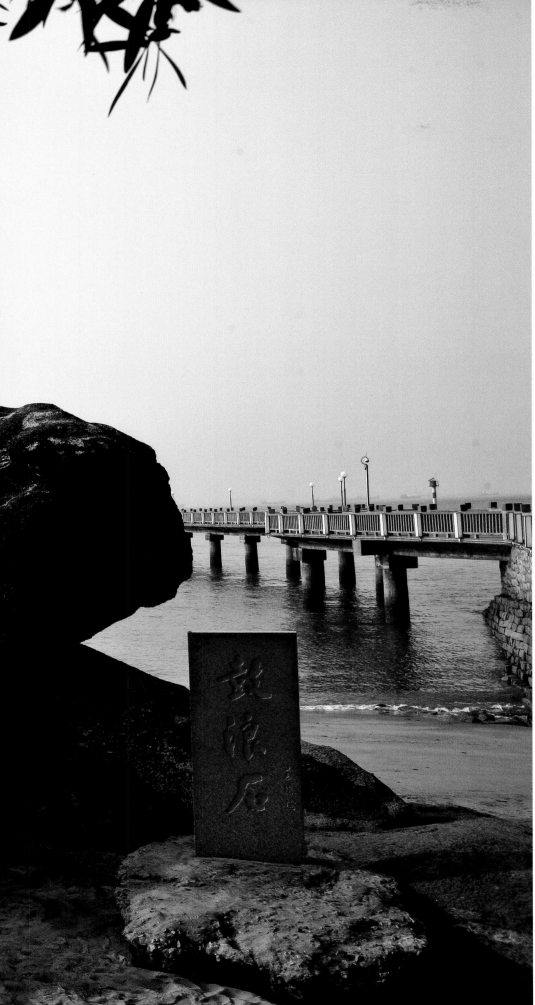

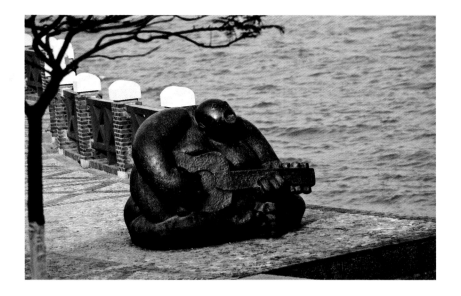

厦门鼓浪屿 |
Gulangyu Island in Xiamen |

原名圆沙洲、圆洲仔，因西南有海蚀洞受浪潮冲击，声如擂鼓，明朝雅化为今名。由于历史原因，中外风格迥异的建筑被完好地汇集、保留，有"万国建筑博览"之称。鼓浪屿也是音乐的沃土，人才辈出，钢琴拥有密度居全国之冠，又得美名"钢琴之岛"、"音乐之乡"。

With its original names of "Yuanshazhou Island" and "Yuanzaizhou Island", the Gulangyu Island got its present name during the Ming Dynasty from the huge reef surrounding it. When the tide comes in, the waves pound the reef and it sounds like the beating of a drum. The island came to be named "Gulang". Gu in Chinese means "drum", and Lang, "waves". Because of historical reasons, buildings of domestic and exotic architectural styles are well-kept on the island, winning the honor of "world architecture expo". Also as a fertile soil of music, the island produced generations of music talents. With the number of piano per household ranking the champion of China, the island also enjoys the reputation of "Piano Island" and "Home of Music".

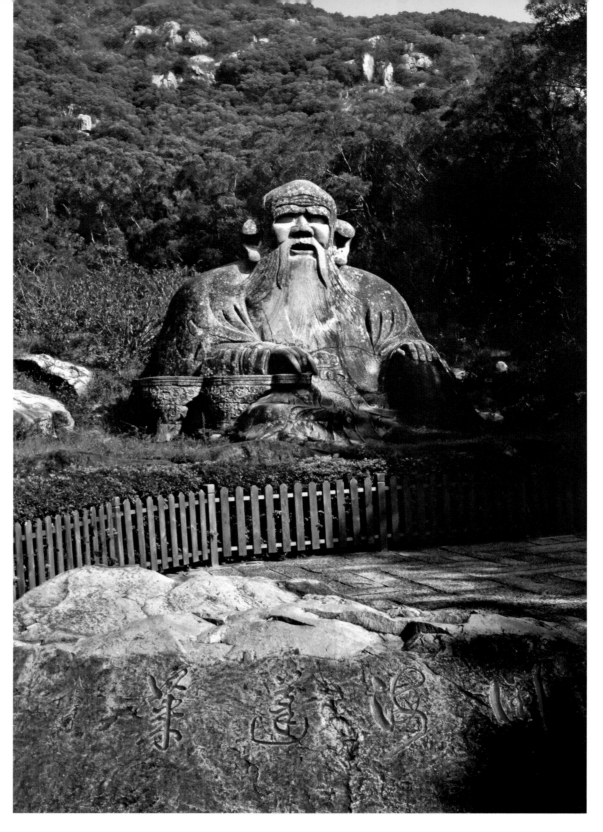

清源山老君岩
Laojun Rock
on
Qingyuan Mountain

位于泉州西峰罗山山麓，是由一块形似人像的巨大天然花岗岩雕琢而成的老子坐像。这是中国现存最大的宋代道教石像，也是清源山的标志性景点，其雕工精湛，极富历史和艺术价值。

Situated at the foot of Luoshan Mountain in Quanzhou City, Laojun Rock is a sitting Laozi sculpture carved from a huge piece of granite with a shape of a person. It is the biggest Taoist stone sculpture in the Song dynasty, as well as the iconic attraction of Qingyuan Mountain. The exquisite carving of the rock outlined its huge historical and art values.

开元寺
Kaiyuan Temple

位于泉州市鲤城区西街，始建于唐垂拱二年（公元686年），初名莲花寺。由于建寺时出现了紫云覆地的祥瑞之象，因此又名紫云寺，后改为兴教寺、龙兴寺。直到开元26年（公元738年）唐玄宗诏告天下诸州各建一寺，以年号为名，遂改今名。该寺规模宏大、景色优美，曾与洛阳白马寺、杭州灵隐寺、北京广济寺齐名。

Located in the West Avenue, Licheng District, Quanzhou City, the Kaiyuan Temple was first built in the 2nd Year of Chuigong in the reign of Empress Wu Zetian of the Tang Dynasty (686A.D.), originally named "The Lotus Temple". Because the temple was covered by purple clouds when it was built, it was renamed "Ziyun Temple" (meaning Purple Clouds Temple in Chinese), and then Xingjiao Temple and Longxing Temple. In the 26th year of Kaiyuan (738A. D.), Emperor Xuanzong decreed that every prefecture in the whole country build a kaiyuan Temple, therefore the temple got its present name. With its grand scale and beautiful scenery, the temple enjoyed an equal popularity with the Baima Temple in Luoyang, the Lingyin Temple in Hangzhou, and the Guangji Temple in Beijing.

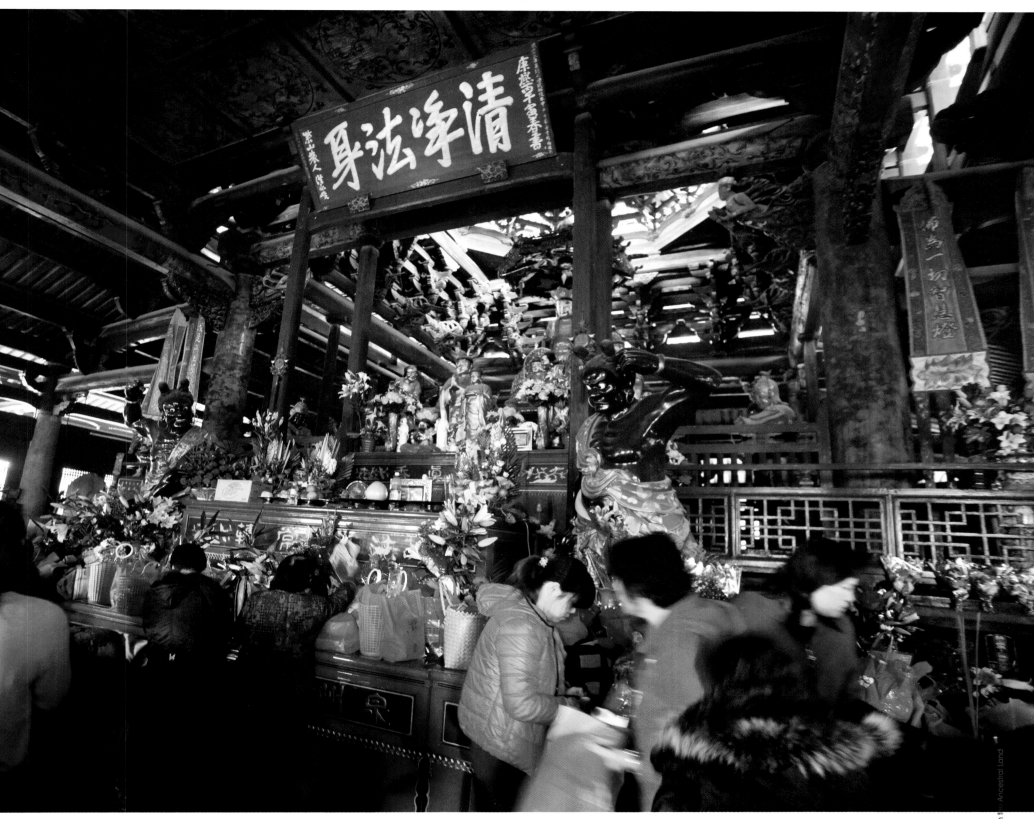

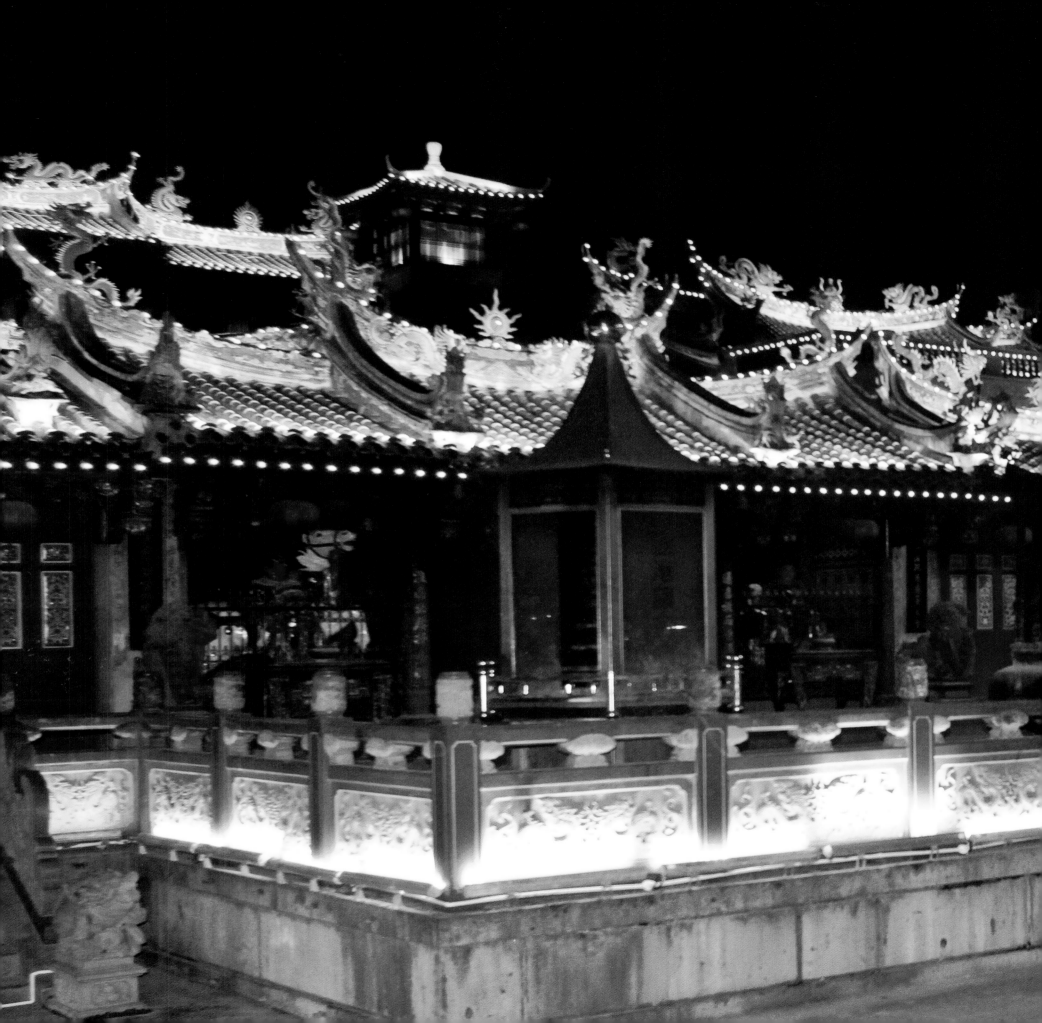

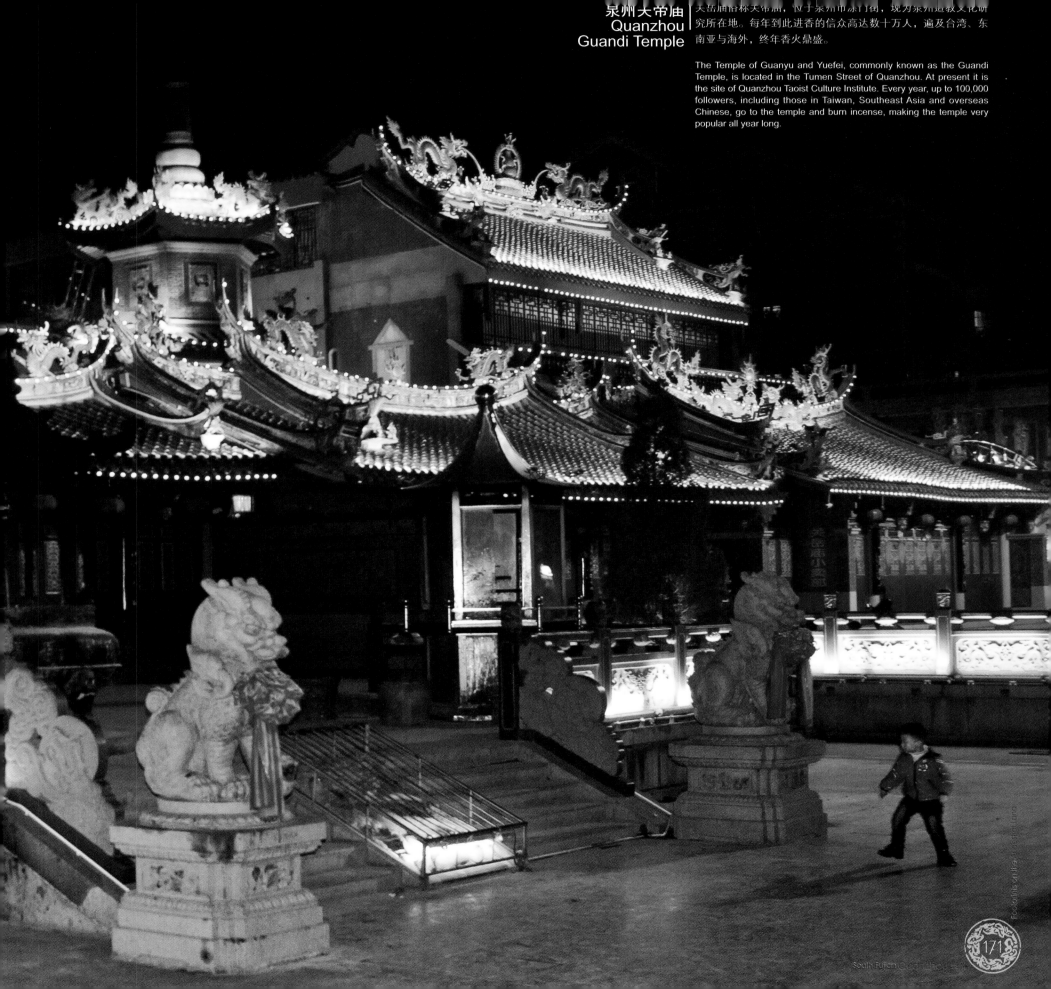

大岳庙俗称天帝庙，位于泉州市涂门街，现为泉州道教文化研究所在地。每年到此进香的信众高达数十万人，遍及台湾、东南亚与海外，终年香火鼎盛。

The Temple of Guanyu and Yuefei, commonly known as the Guandi Temple, is located in the Tumen Street of Quanzhou. At present it is the site of Quanzhou Taoist Culture Institute. Every year, up to 100,000 followers, including those in Taiwan, Southeast Asia and overseas Chinese, go to the temple and burn incense, making the temple very popular all year long.

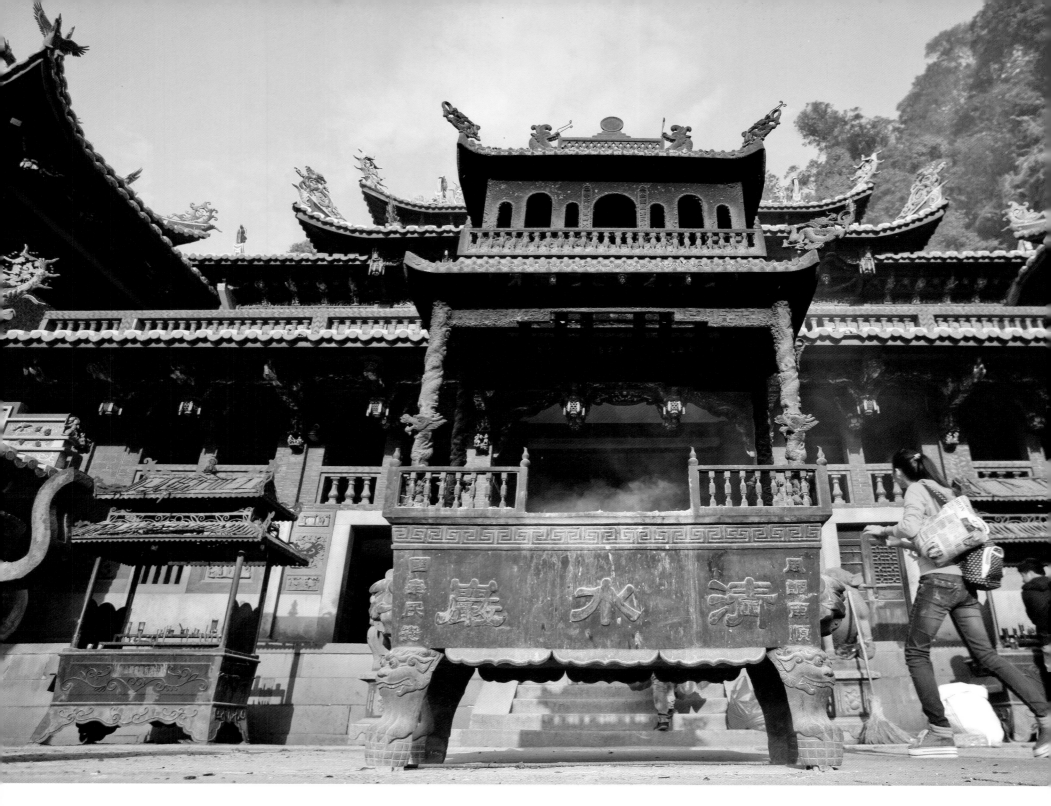

清水岩寺
Qingshuiyan Temple

始建于北宋元丰六年（公元 1083 年），原叫张岩，其山所处的蓬莱原叫彭内，因山界权属张姓、地界有彭氏一族聚居而得名。明代安溪人开始大规模迁居台湾，清水祖师香火也传入台湾，成为民众信奉的主神之一。

First built in the 6th year of Yuanfeng (1083A.D.) in the Song dynasty, the temple was originally named "Zhangyan". During the Ming Dynasty, when people in Anxi County migrated to Taiwan at a large scale, the followers of the Founder of the Qingshui School came to Taiwan, making Qingshui one of the major Gods worshipped by people in Taiwan.

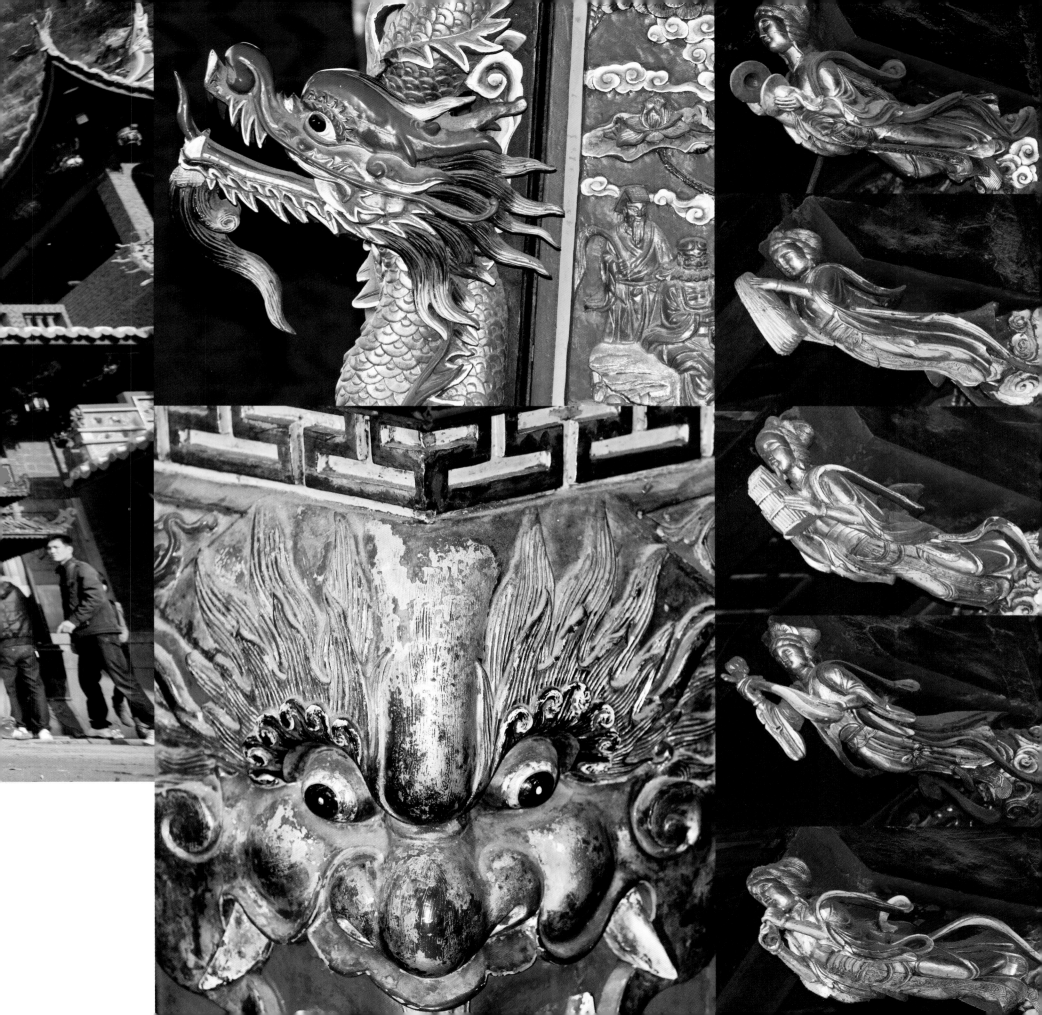

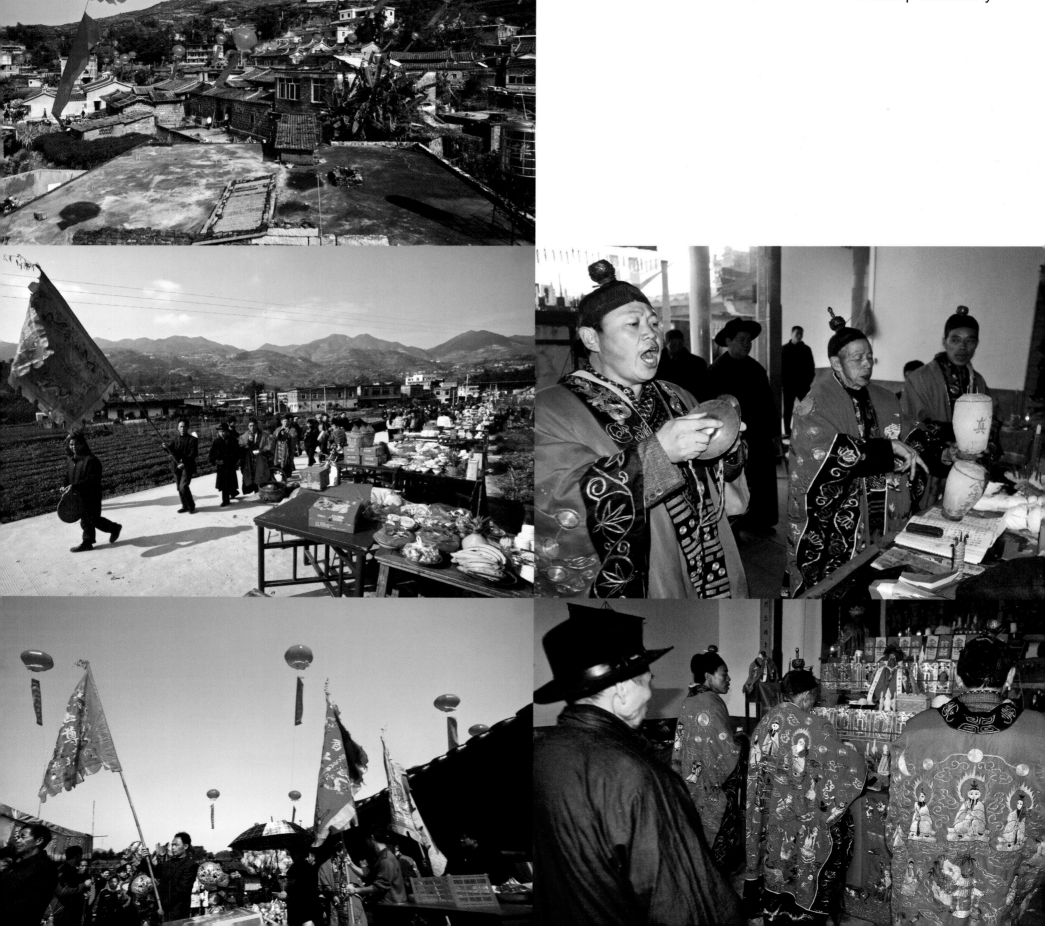

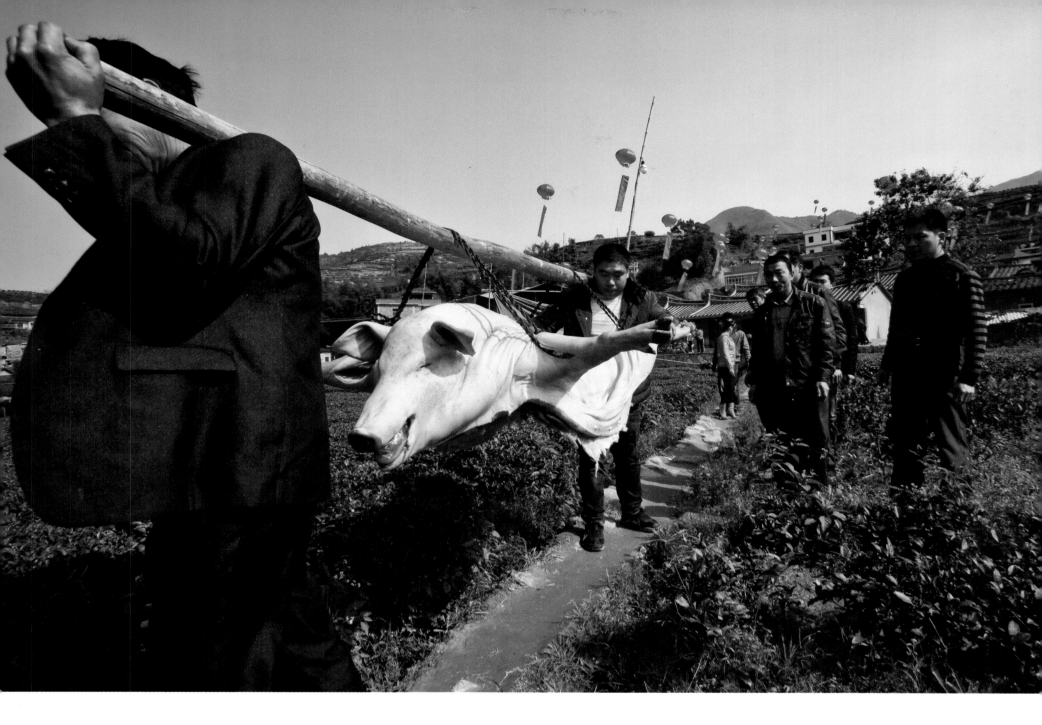

安溪显仁庙是极少数供奉感应尊王的庙宇之一，深受当地官民重视。作者巧遇年度庙会，感受了一场即传统又熟悉的闽南祭仪。

The Xianren Temple in the Anxi County is one of the few temples, where the deity Ganying Zun Wang is enshrined and worshiped. Local officials and people attach great importance to the temple. The photographer happened to visit the annual temple fair here, and experienced a traditional and familiar worship ceremony with strong features of southern Fujian culture.

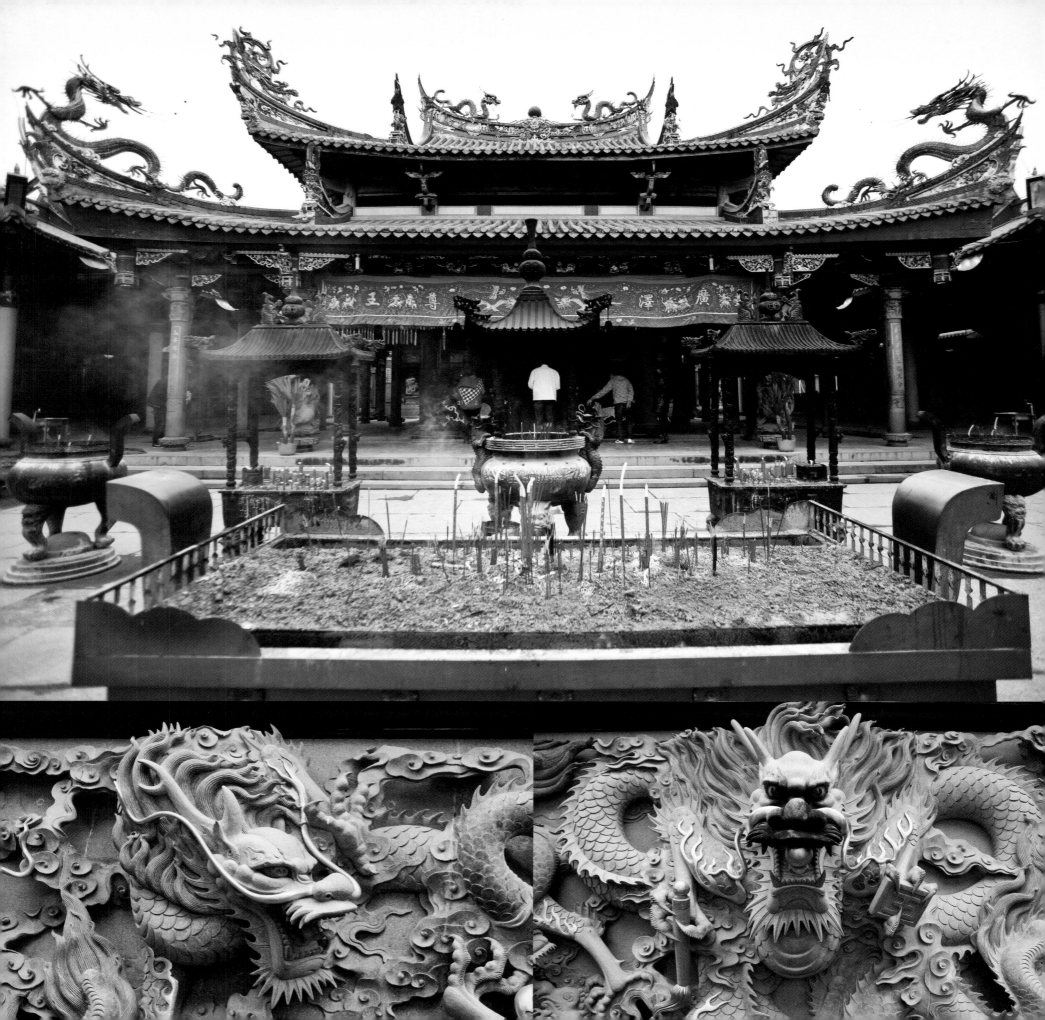

南安凤山寺
Nan'an Fengshan Temple

原名郭山庙，又名将军庙、威镇庙，位于泉州南安诗山镇西北角凤山麓，始建于五代后晋天福初年（公元936-947年）。供奉的郭圣王，也是当地的重要神祇之一。

Originally named Guoshan Temple, also known as General Temple and Weizhen Temple, the Fengshan Temple is situated at the foot of Fengshan Mountain at the northwest corner of Shishan Town, Nan'an County, Quanzhou. It was first built during the first several years of Tianfu (936-947A. D.) in the Houjin dynasty. Guosheng King, worshipped in the temple, is one of the most important gods cherished by local people.

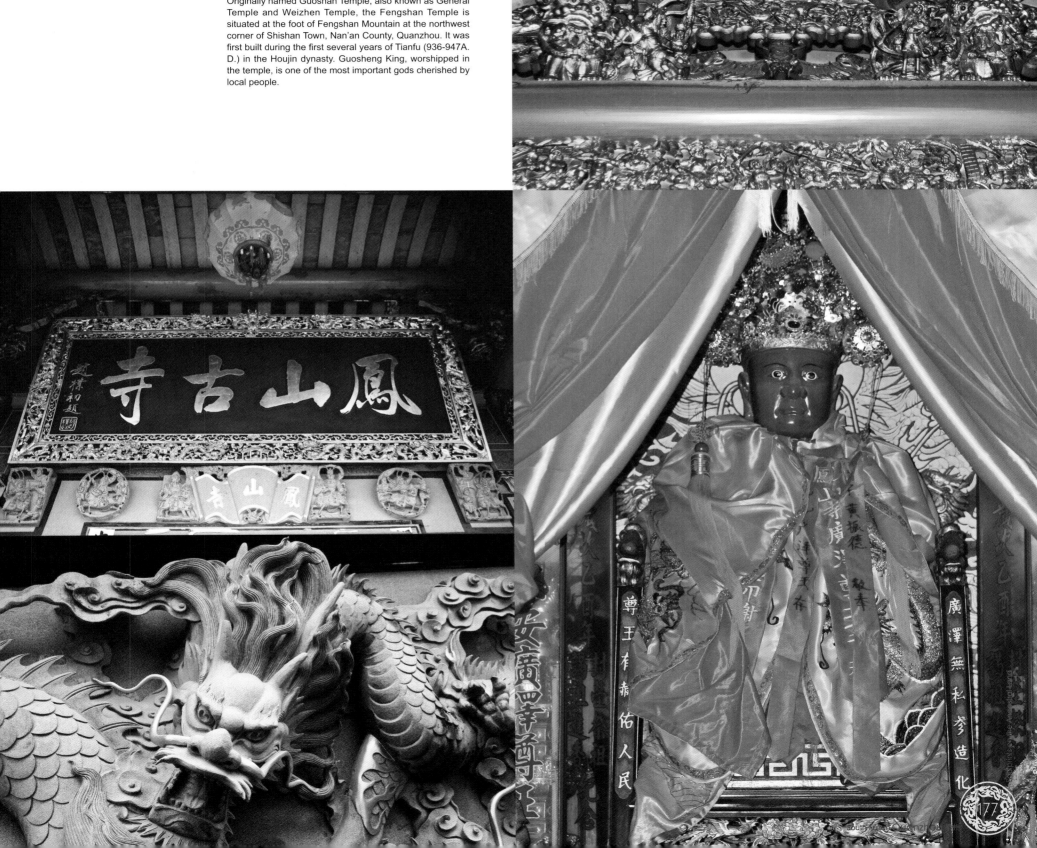

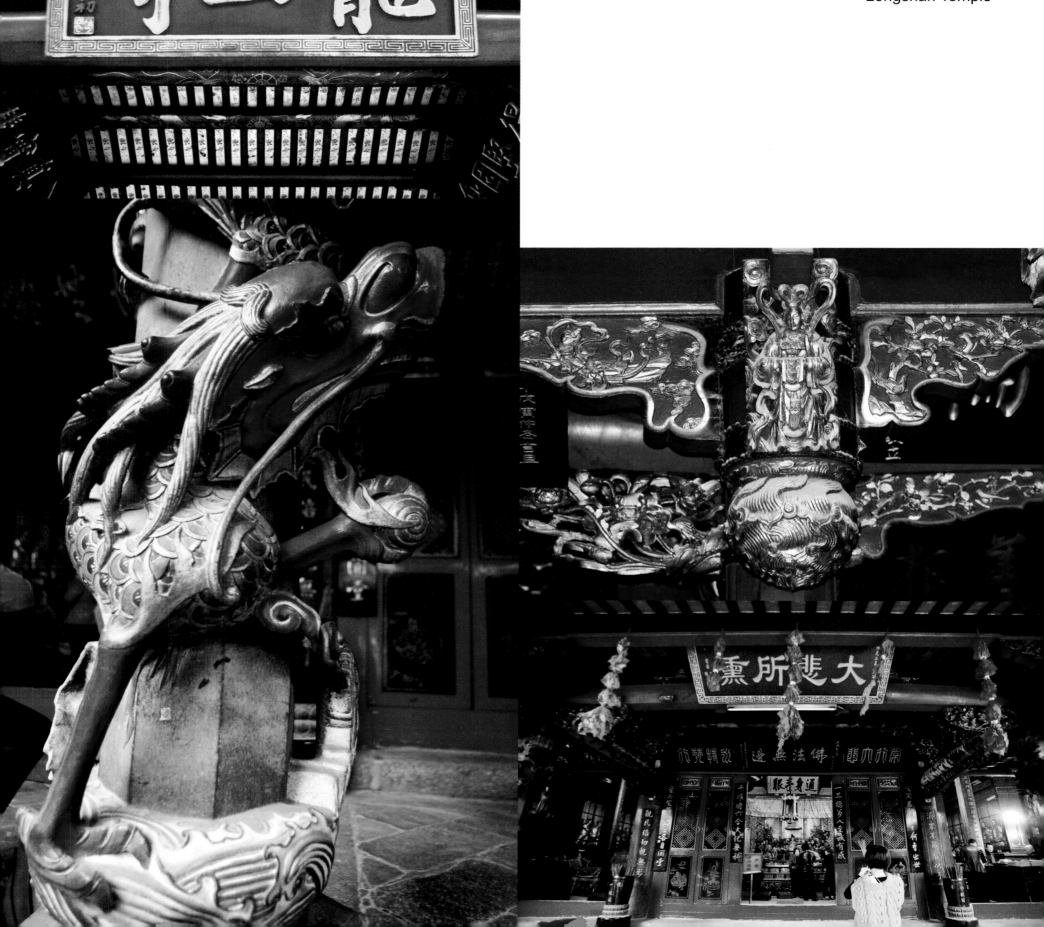

晋江龙山寺
Jinjiang
Longshan Temple

初名普现寺，又名天竺寺，在晋江市安海镇。始建于隋皇泰年间（公元618-619年），明清几经重修。唐宋以来随着海上丝绸之路的兴发，安海龙山寺的香火便随着安平商贾的足迹远涉重洋、传播海外。支庶可谓源远流长，在台湾、东南亚、日本等地尤其突出。

With an original name of Puxian Temple and also known as Tianzhu Temple, the Longshan Temple is located in Anhai Town of Jinjiang. It was first built during the years of Huangtai (618-619 A.D.) of the Sui dynasty, and renovated several times in the Ming and Qing dynasties. Ever since the Tang and Song dynasties, with the rise and development of the Silk Road on the Sea, the followers of Longshan Temple went abroad and spread to the whole world, especially popular in Taiwan, Southeast Asia and Japan.

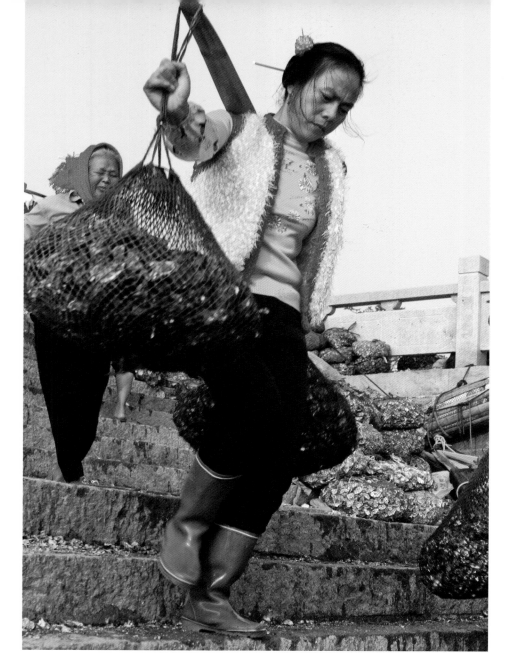

蟳蜅女
Xunpu Women

与湄洲女、惠安女并称为福建三大渔女。蟳蜅女因独特服饰与头饰被人们亲切地称为"蟳蜅阿姨"。爱花是"蟳蜅阿姨"的天性。她们头上梳着圆髻，圆髻上时常环绕着几串四时鲜花串成的花环，具有独特的魅力。蟳蜅女信仰繁多，举凡造大船、盖房子等生活大事，都要举行传统而热烈的庆祝活动。她们勤奋耐劳的天性，充分展现了闽南妇女勤于持家的特质。

The Xunpu Women, together with Meizhou Women and Hui'an Women, are known as the Three Fishing Women in Fujian. The Xunpu Women are kindly called Xunpu Auntie because of the unique dressing and head wear. Out of the inherent nature of loving flowers, the Xunpu Auntie often put several flower garlands which are made out of seasonal flowers, sending out a unique charm. With numerous faiths, the Xunpu Women hold traditional and glowing celebrations when it comes to some big events in their life such as building ships or houses. Their diligence and hardworking spirit help shape a typical figure of the diligent women in south Fujian. major Gods worshipped by people in Taiwan.

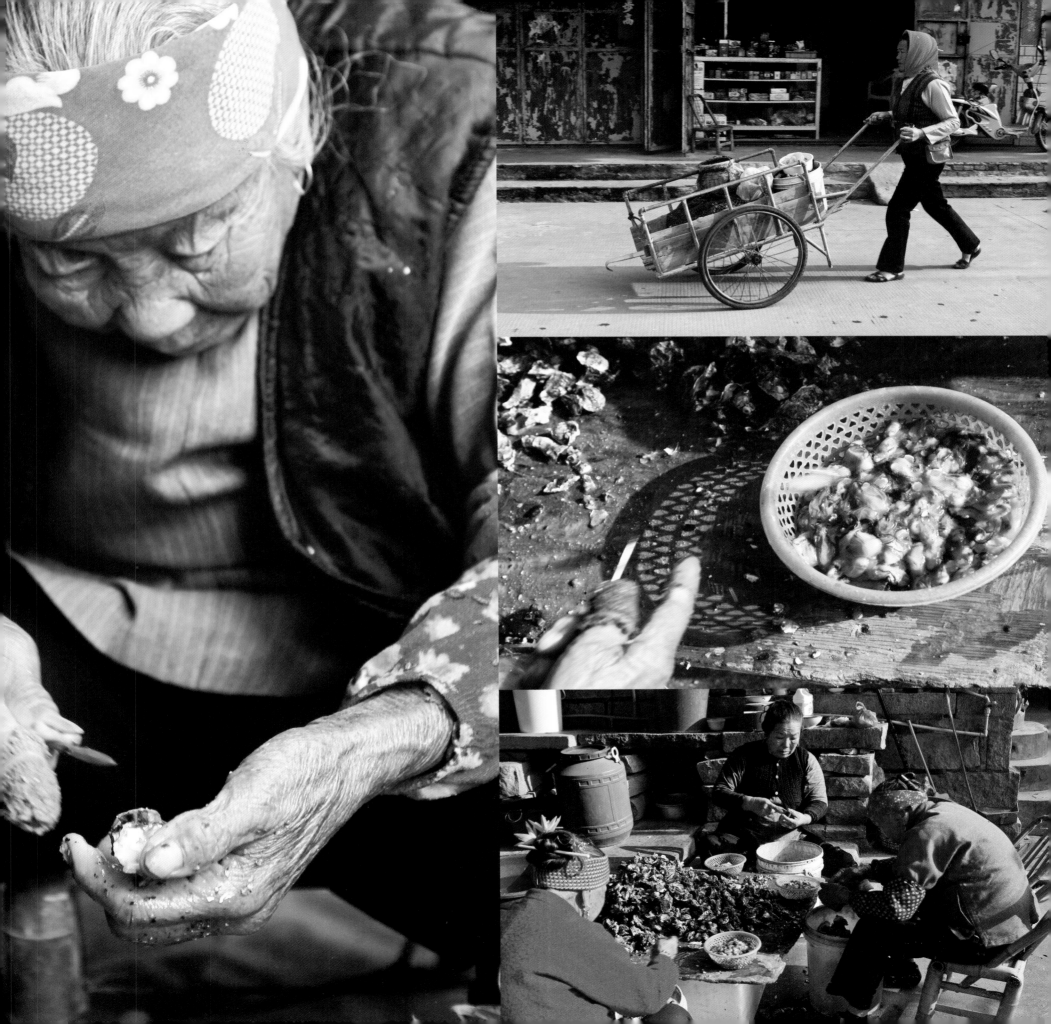

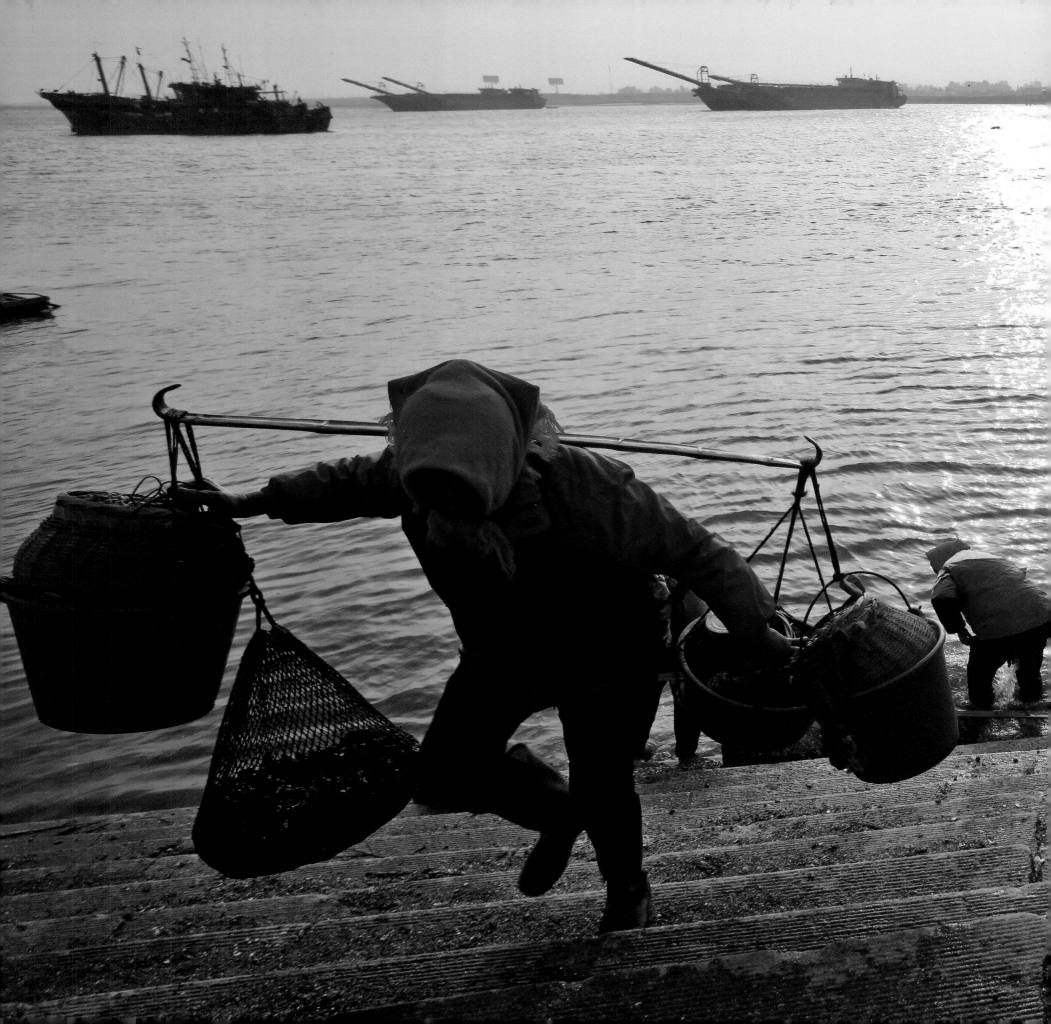

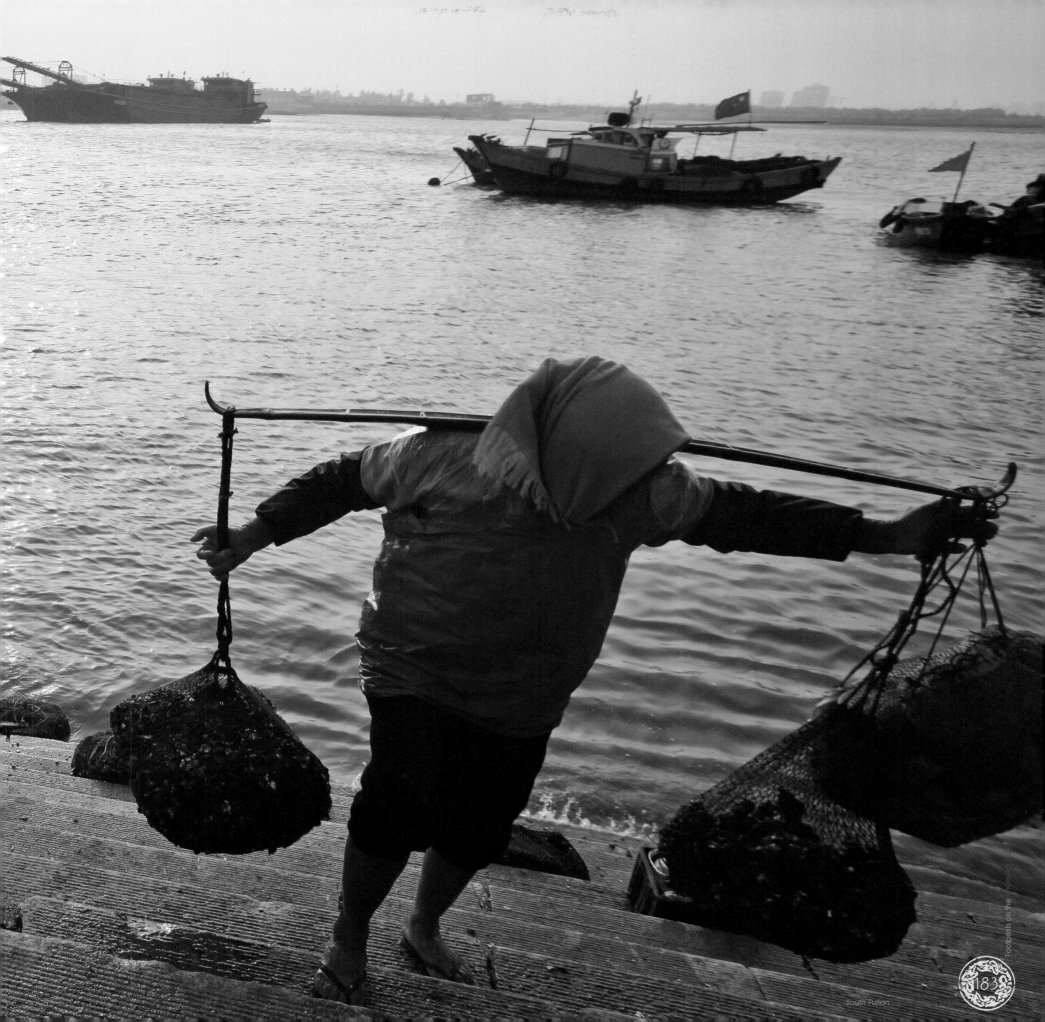

South Fujian

183

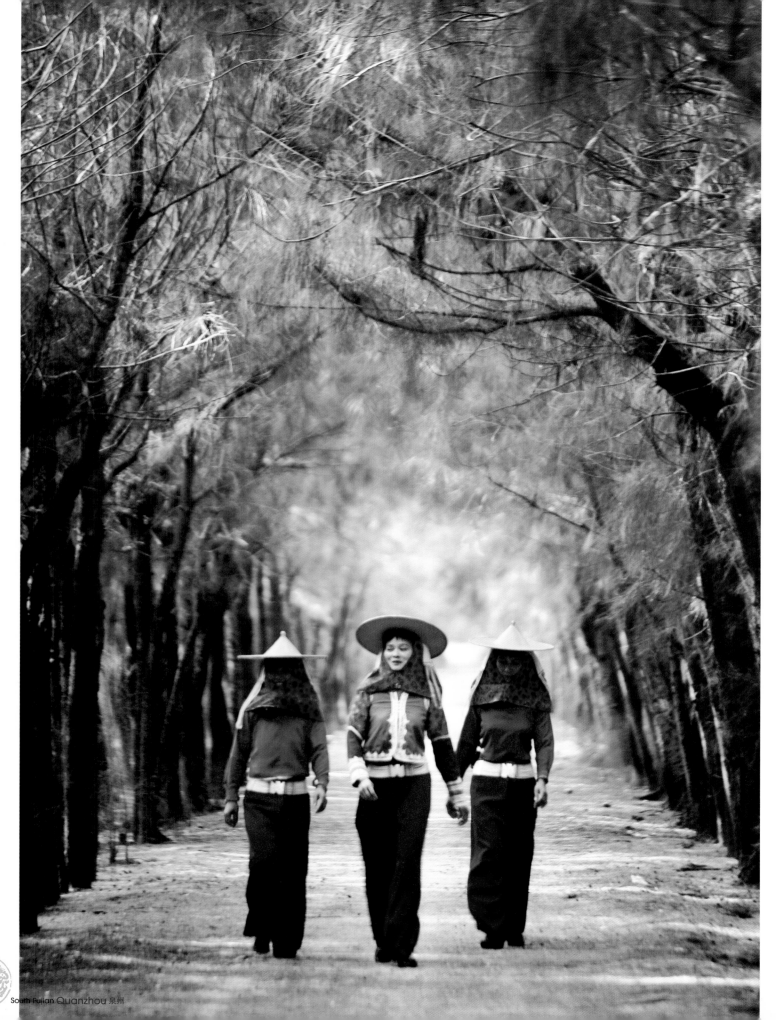

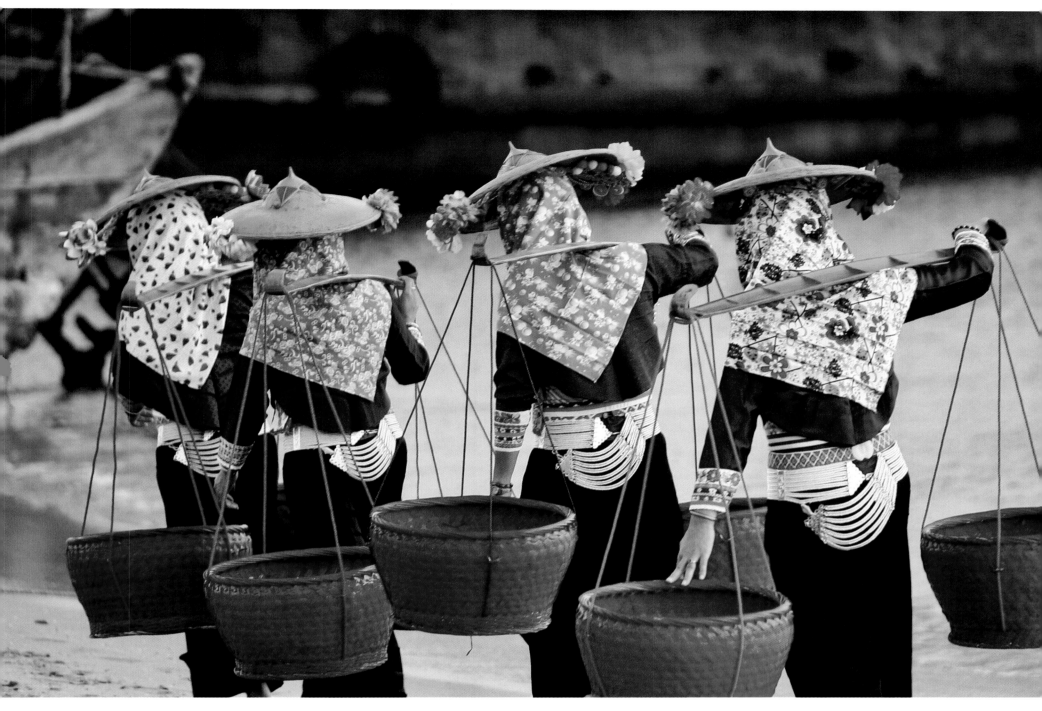

惠安女
Hui'an Women

是惠东半岛海边的一个特殊族群，主要分布于崇武、山霞、净峰和小岞四个乡镇。她们因美丽、勤劳、贤惠和一身奇装异服闻名于世，不仅成了独特的人文景观，也为崇武古城增添了几许魅力。

As a special group at the coastal Huidong Peninsular, the Hui'an Women are mainly distributed in the four towns of Chongwu, Shanxia, Jingfeng and Xiaozuo. They are famous for their beauty, diligence, virtue and fancy dressing, not only making them a unique cultural landscape, but also adding some charm of the ancient city of Chongwu.

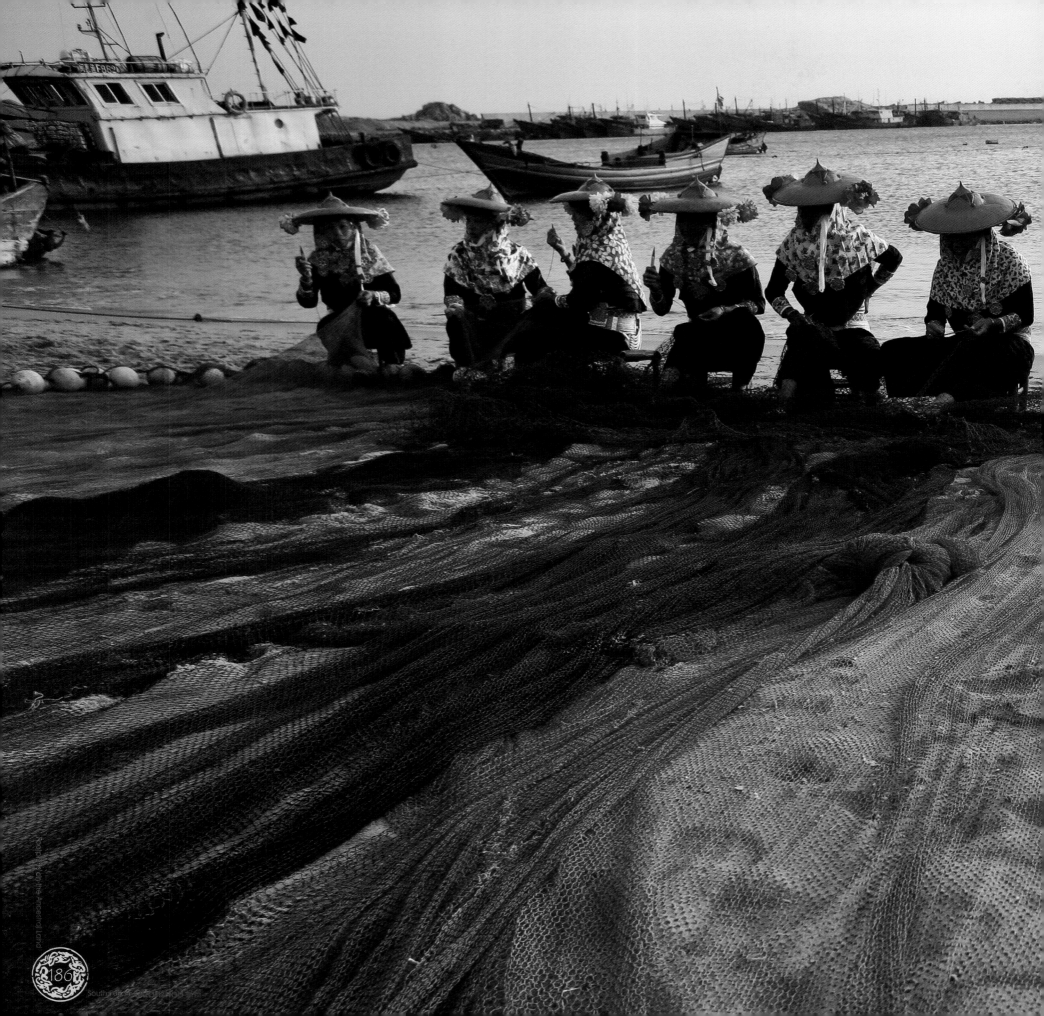

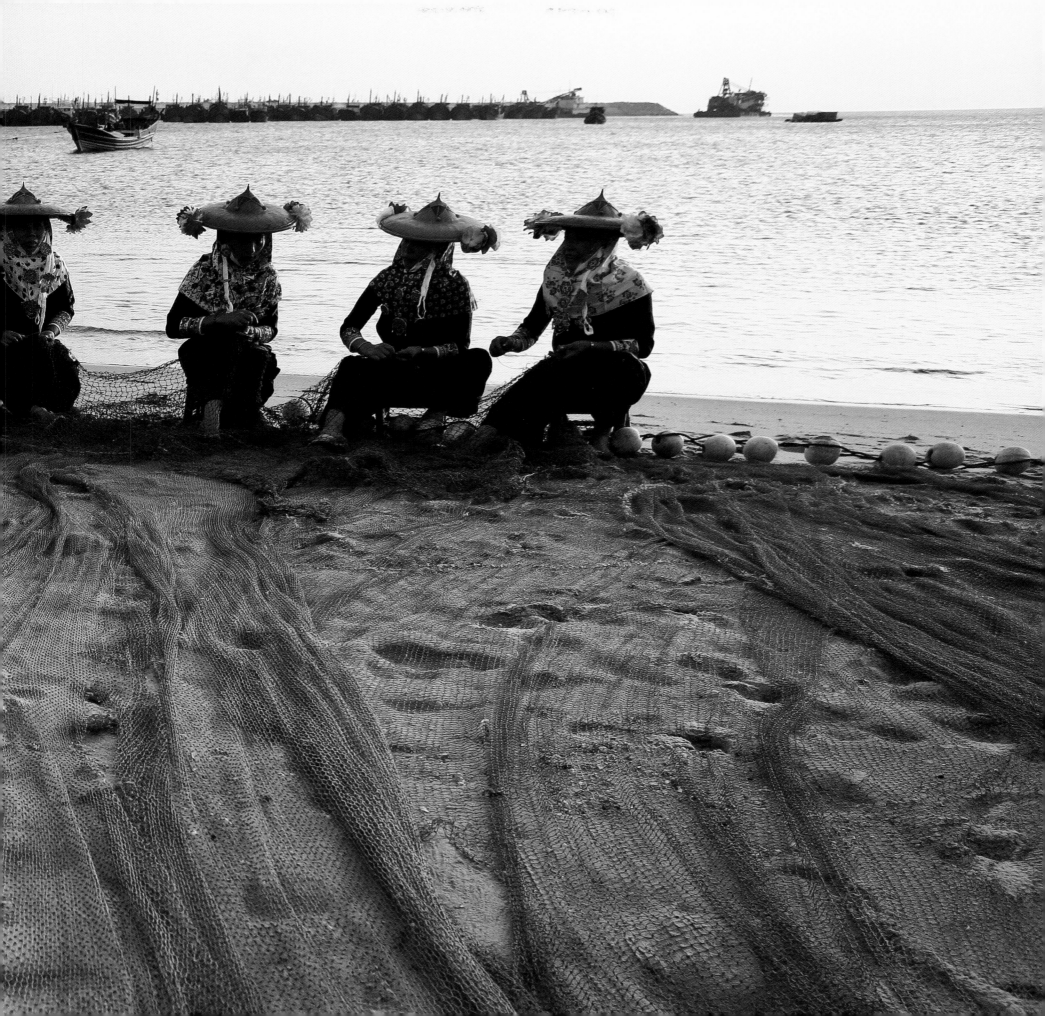

蔡氏古民居 |
Ancient House Group
of the Tsai Family

位于泉州南安市官桥镇漳里村，由菲律宾华侨蔡启昌、
蔡资深父子于清同治四年至宣统三年（公元1865-
1911年）返乡兴建。因其极富闽南特色，故与永定
土楼并称为福建民居两朵奇葩。现存较为完整的共15
座宅第、一座宗祠和近400个房间，已被列为全国重
点文物保护单位。置身祖地，作者儿时的记忆涌现心
头，思古幽情油然而生，也为"寻根之旅"留下完美
的脚注！

The ancient house group of Tsai family lie at Zhangli Village,
Guanqiao Twon, Nan'an. The house group was built mainly
by the Pilipino Chinese Tsai Qichang and his son Tsai Zizhen
from the reign of Emperor Tongzhi in the Qing dynasty (1862
A.D.) to the 3rd year of Xuantong(1911 A.D.). The typical
Southern Fujian architectural characteristics of the house
group made it one of the two miracles of Fujian folk house, with
Yongding Tulou as the other. The well-preserved 15 houses,
one ancestral temple and nearly 400 rooms are listed as the
key National Cultural Relics Protection unit. With my foot on
my ancestral homeland, my childhood memories come to my
mind, making a perfect footnote of my "ancestral land trip".

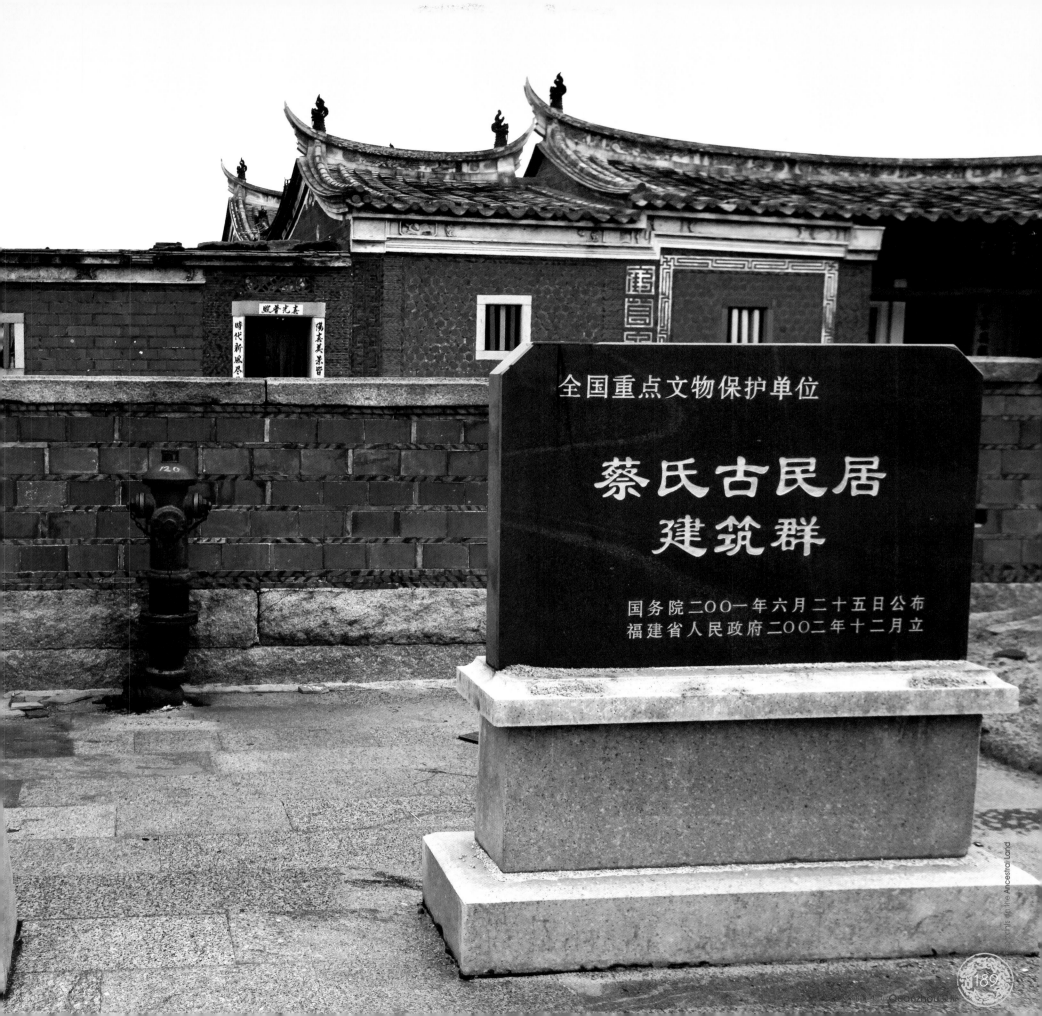

全国重点文物保护单位

蔡氏古民居
建筑群

国务院二〇〇一年六月二十五日公布
福建省人民政府二〇〇二年十二月立

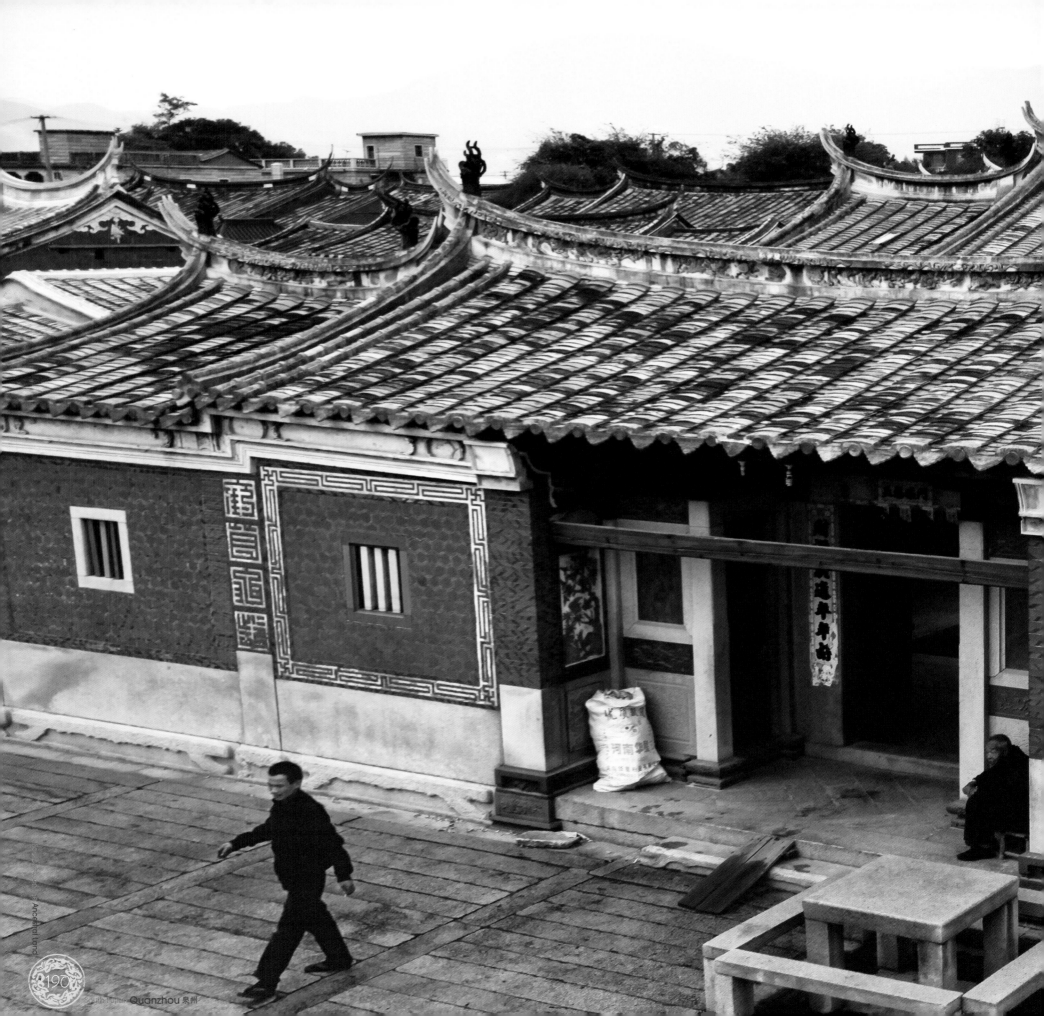

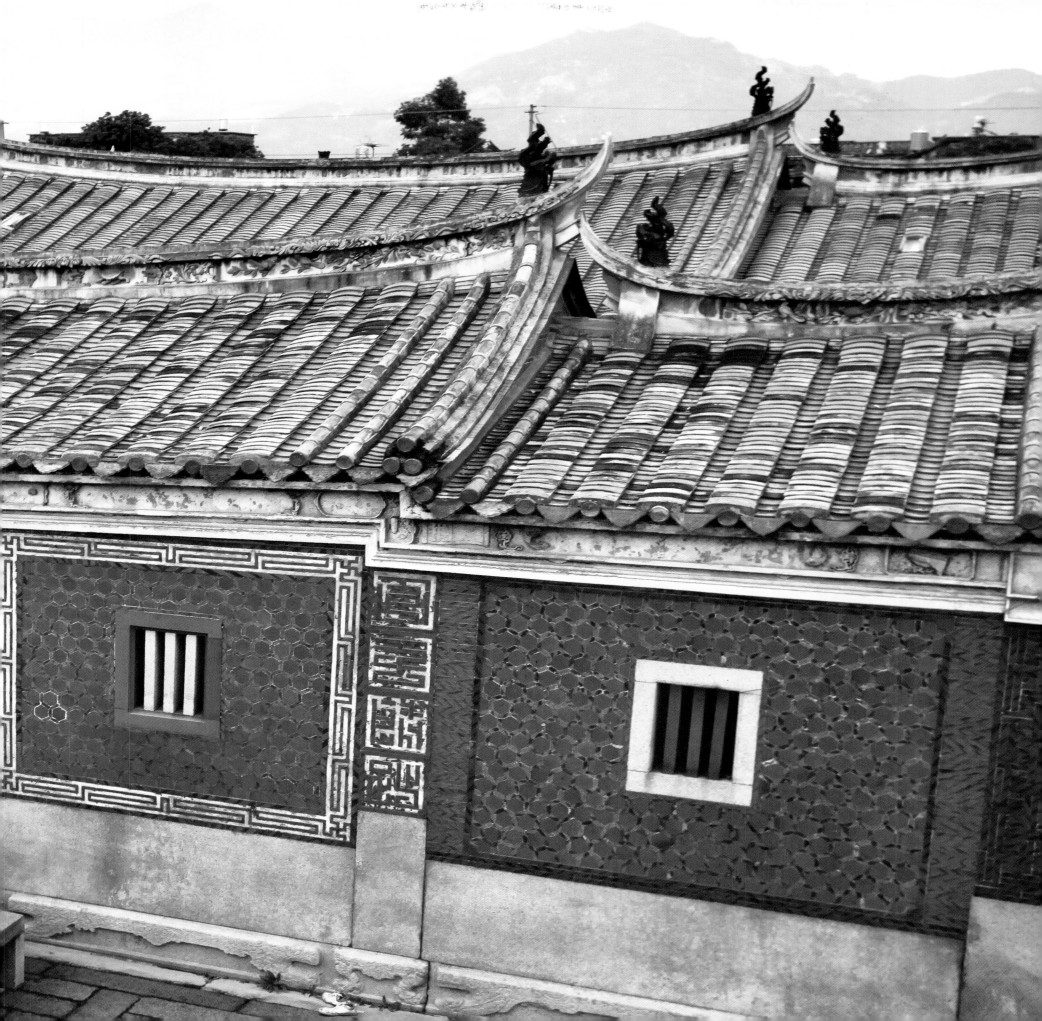

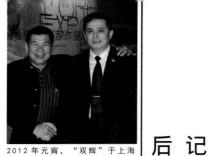

2012年元宵，"双辉"于上海

后 记

　　我与登辉兄有缘。名同辉，物同类，艺同路，事同心，志同坚。

　　时光流逝。我与登辉兄相识至今，已过去整整十二年。 十二年间，我们不停地穿梭两岸，共同引领着两岸摄影家，行摄在华夏大地、名山大川，穿越在几千年的中华文化时空中。十二年的光影聚焦，见证了两岸的潮起潮落和风云变幻，也留下了我们一串串印迹和辛勤耕耘的汗水，更是用影像写下了中华文化的丰厚篇章。

　　十二年的往来和交流，我和登辉兄从相识、相知到相亲，彼此间建立了兄弟般的珍贵感情。他透过摄影"存真、凝变"的本体特性，凭着一身耗不尽的热情和几十年练就的十八般武艺，几乎是眼不离窗，机不离手，且眼到手到，猎摄了无数张珍贵影像，凝结了大量两岸民俗文化的历史瞬间。

　　十二年的同吃、同行、同摄，在两岸摄影家的共同努力和推进下，我们共享了一次次收获和成果，同时，也共同承载着一次次艰辛付出甚至险象……

　　武夷山的冬夜寒风，窥证了我们如行窃者似的翻墙入内，为的是能有幸遇见天游峰上的晨雾仙境；凉山火把节上的纯朴彝俗，累倒了因心力衰竭几近窒息的台湾影友，面对突发的生死险情，在远离医院的情况下，两岸影友沉着应对，正确处置，挽救了同胞的重要生命……

　　最令我难忘的是，登辉兄因长期致力于两岸文化交流，有一年终累卧病床。在连续半个月的输液禁食的情况下，仍竭尽其力，在病床上坚持筹备影展事宜。当我们飞抵台北桃园机场，看见昔日十分健壮的登辉瘦若两人（瘦了三十多斤），我不禁情涌难抑，心泪难忍……

　　岁月如梭。生命历程中的两鬓苍苍已渐袭"双辉"，沧桑的印痕在我和登辉兄的脸上日趋深陷。所幸不懈的付出有影像作证，两岸日渐浓厚的同胞亲情让人欣慰。愿登辉兄《祖地寄情》这本渗浸着赤子乡情的纪实摄影专集，为两岸摄影文化的不断交流，为"两辉相映"能光华长存，为两岸的明天更美好，带来深深的祈福！

2013年11月　福州

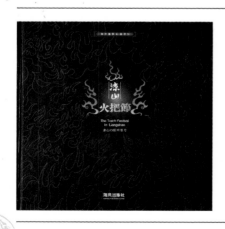

In the Lantern Festival of 2012, Denghui and Honghui were in Shanghai.

Afterword

Denghuei and I are destined to be close friends. We have the same surname, love the same kind of art, devote ourselves to the same career, and possess the same ambition.

Time flies. It has been twelve years since my acquaintance with Denghuei. In these years, we were busy shuttling across the straits, led the photographers from both sides of the straits to photograph well-known mountains and rivers in China together, and traveled in China's thousands of years of civilization. Twelve-year photographing has witnessed the ebb and flow across the straits. We have left our strings of imprints and hard-working sweat, and wrote a fruitful chapter of Chinese culture.

During the twelve years of exchanges, Denghuei and I have developed a treasured brotherly relationship from our initial meeting to our making acquaintance with each other. Denghuei tends to carry the camera with him and photograph whatever he sees. By utilizing photography's nature of "preserving realities and freezing changes", with his inexhaustible passions and the skills practiced for decades, he has captured lots of treasured images and freezes plenty of historical instants of the cross-strait folk culture.

In these years, photographers from both sides of the straits ate together, traveled together and photographed together. With the joint efforts of cross-strait photographers, we have shared the achievements many times and endured painstaking work and even risk together···
In Wuyi Mountain, the cold wind in winter evening watched our climbing over the wall into the scenic area to see the wonderland of the Tianyou Peak in the morning fog. In the Liangshan Torch Festival, in order to explore the simple customs of the Yi nationality, a photographer from Taiwan dropped with overwork. He was half suffocated with heart failure. Facing the sudden life-and-death situation, photographers from both sides of the straits stayed calmly and handled properly, thus successfully saving the compatriot's life···

One thing impressed me most. One year, because of his long-term devotion to the cross-strait cultural exchanges, Denghuei got ill in bed. He was given infusions and put in fasting state for half a month. During this period, he still did his utmost and insisted in preparing the photography exhibition in bed. When I arrived at the Taipei Taoyuan International Airport and saw Denghuei had became a different person for losing too much weight (more than 30 catties), I couldn't help feeling the ache in my heart···

As time goes on, the hair of Denghuei and I have turned gray at our temples and traces of age have deepened on our faces. Fortunately, photos have given evidence to our consistent efforts. And it is delighted to see the relations between people across the straits deepen day by day.

The documentary photography collection Footprints on the Ancestral Land is saturated with Denghuei's affections for his homeland. I hope it could bring blessings to the cross-strait photography exchanges, to the forever-existence of the glory of "two Huis' setting each other off brilliantly", and to a better tomorrow for both sides of the straits!

Jiao HongHui

Footprints on the Ancestral Land

Afterword By Jiao Honghui

作者简历 Author's Preface

Footprints on the Ancestral Land

194

Author's Resume

Birth / 出生
Yun-lin county of Taiwan, 1951 — 1951 年生于台湾省云林县

Educational background / 学历
Master of Arts in Management Dominican University of California, U.S.A. — 美国柏克莱加州大学 — 高阶经营管理
Executive Management Program University of California, Berkeley, U.S.A. — 美国加州多明尼肯大学 — 管理艺术硕士

Professional Experience / 现任
President, Synctel Technology Co., Ltd. — 台湾名辉科技股份有限公司 — 董事长
Innovative Management Association of Taiwan — 台湾创新经营管理研究协会 — 副理事长
Deputy Chairman, Taiwan Peaceful Cross-Strait Cultural and Artistic Union — 台湾两岸和平文化艺术联盟 — 副主任委员
Deputy Chairman, CMI and Big Eight Universities Alumni Association — 美国 CMI 暨八大院校在台校友会 — 副会长
Special Consultant, The international Association of Lions Clubs , District 300A1 — 国际狮子会 300A1 区 — 特别顾问
Board of Trustee, Bo- Ai Welfare Foundation, Taipei — 台北市博爱福利基金会 — 董事

Other Professional Experience / 经历
Lounge singer	'70~'71	餐厅、酒店	驻唱歌手
Primary school Substitute Teacher	'71	国民小学	代课老师
Combat Skills Instructor, Police and Gendarmerie Forces	'71~'72	宪、警部队	战技教官
Procurement & Sales, Ta -Tung Company	'73~'92	大同公司	采购、业务
Director & Coach, Hui- hua Chinese Martial Arts Institution	'76~'82	辉华国术馆	馆长、教练
Professional Affiliations	'83~	媒体、杂志	摄影记者
Chairman, Lung-Teng Business Association	'94~'97	龙腾商业联谊会	会长
Chairman, Taipei DanDan Photography Club	'94~'97	台北点点摄影俱乐部	
Consultant, County city and Ta-tung Photography Society	'95~	县、市及大同摄影学会	顾问
Regional director & Vice executive, Corresponding Center of Taipei Reserve MP	'95~	大专院校、机关团体	摄影讲师
Vice President, Li-san Junior High School Parent Association	'96~	台北市后备宪兵联络中心	区主任、副执行长
President, Song-san Senior High School Parent Association	'96~'97	台北市丽山国中家长会	副会长
Vice Chairman, Taipei Parent Association Federation	'96~'98	台北市松山高中家长会	会长
Chairman, The Photography Society of Taipei	'97~'98	台北市家长会联合会	副理事长
Chairman, Taipei Engineering Technology Administration Association	'99~'03	台北市摄影学会	理事长
Chairman, National Photography Groups Joint Exhibition and Competition	'99~'03	台北市工程技术管理协会	理事长
Preparatory Member, Taiwan Fine Art Exhibition	'01	台湾摄影团体联展联赛	主任委员
Committee Member, National Taiwan Arts Education Center	'02~	台湾艺术教育馆	审议委员
Committee Member, Taiwan Fine Art Exhibition	'02~	台湾美术展览会	筹备委员
Chairman, Taipei Overseas Lions Club	'02~'03	台北市华侨国际狮子会	会长
Art Director, Uni Airways Unity Magazine	'03~'05	立荣航空 Unity 杂志	艺术指导
Chairman, Chinese Engineering Technology Administration Association	'04~'06	中华工程技术管理协会	理事长
Chief Administrator, The international Association of Lions Clubs , District 300A1	'07~'08	国际狮子会 300A1 区	事务长
Supervisor, Taipei Volunteer Police Brigade	'07~'11	台北市义勇警察大队	督导
District Advisor, The International Association of Lions Clubs, Taiwan Federation	'09~'10	国际狮子会台湾总会	区务顾问

Honors / 荣誉
MP Iron Model	'72	"铁一般的宪兵典型"	
Reserve MP Model	'95	"后备宪兵楷模"	
Honorary doctorate member of Taipei Photographic Society	'97	台北市摄影学会	荣誉博学会士
Honorary Chairman, Song-san Senior High School Parent Association	'98~'00	台北市松山高中家长会	荣誉会长
2000 Taiwan Cross-Century Elites Biographies	'99~'00	台湾跨世纪菁英列传	进榜
Honorary doctorate member of Kaohsiung Creative Photographic Association	'00	高雄市创意摄影家协会	荣誉博学会士
Gold medal, Wen Xinjiang Award, Culture Cultivation Committee of Taiwan	'00	台湾 "文化建设委员会" 文馨奖	金奖
Gold medal, Jin Juj Award, Ten Most Potential manager and Customer Satisfaction of Taiwan	'08	台湾十大潜力经理人及顾客满意度金钜奖	双料得主

Honorary Titles / 荣衔
1985~1993 Doctorate member of Taiwan, Taipei, New York, Ta-tung photographic societies — '85~'93 — 台北市、台湾省、美国纽约、大同等摄影学会 — 博学会士

Prizes / 获奖
Gold medal, Fuji Five Million Photography Competition	'83	FUJI 500 万摄影比赛	金牌奖
Gold and Silver medals, Jia-Yi Second Photography Exhibition	'84	第二届嘉义影展	金、银牌奖
Creative medal, 18th Provincial Photography Exhibition	'86	第十八届全省影展	最佳创意奖
First prize, CTV Gold Rainbow Photography Competition	'86	华视 "金虹奖" 摄影比赛	第一名
Second prize, Literature and Art Creation Award of Taiwan	'89	台湾文艺创作奖	摄影类第二名
First prize, Kyoto Second International Photography Exchange Exhibition	'95	日本京都第二回国际交流合同写真展	最佳作品奖
Outstanding prize, United Exhibition of Photography Society of Taiwan	'95	第十九届台湾摄影团体联合展览	优秀作品奖
Gold medal, Toyota Hi Taiwan Photography Competition	'96	TOYOTA "你好！台湾" 摄影比赛	金牌奖（独得轿车一辆）
Dozens of prizes from national and foreign photography exhibitions and competitions	'80~'96	国内外沙龙、影展、影赛等	首奖多次
Numerous prizes from national, provincial, municipal, and regional photography	'84~'98	全国、省、市及地方美展	获奖多次

Exhibitions / 参展
Contemporary Fine Art Exhibition	'80~	国内外各项影艺展览
Japanese Two-Subject Society Photography Exhibition	'85	当代美术大展
International Photographic Art exhibition	'86~'87	日本二科会写真展
Various photography exhibitions in and out of Taiwan	'92	国际摄影艺术大观

Solo Exhibitions / 个展
Message Conveying I Exhibition	'94	"寄情" 摄影个展
Message Conveying II Exhibition	'96	"寄情 II" 摄影个展
Scenes of Taiwan Folklore – Yami Canoe Festival Roving Exhibition,	'02~'03	台湾民俗采风－"雅美船祭" 巡回邀请展
The Pearl of East Fujian – Matzu Folk songs Collection Exhibition,	'03	闽东之珠－ "马祖采风" 摄影展
Taiwan character and style – The Islands scenery Exhibition,	'03	宝岛风情－ "离岛风光" 摄影展
Taiwan character and style – Matzu Marine Arcadia Exhibition,	'05	宝岛风情——"马祖海上桃花源" 摄影展
Splendid Taitung – Lan yu Natural Scene Exhibition	'05	日月山海富丽台东——"写生兰屿" 摄影展
Taitung County government Collection works – Tsai Deng-huei Photography Exhibition,	'08	台东县政府典藏作品——蔡登辉摄影展

Juror / 评审
Universities, government agencies and organizations Photography Competition	'95~	大专院校、机关团体摄影比赛
Taiwan Army Art Awards	'01~	台湾文艺金像奖
Taiwan Fine Art Exhibition	'02~	台湾美术展览会
National photography grand prize contest of Chinese traditional holiday	'03	中华传统节日全国摄影大奖赛
New literary arts Jin Huan Award of Taiwan	'07~	台湾青溪新文艺金环奖
Beauty Feast – Taiwan government employees and teachers fine arts Exhibition	'09~	台湾公教美展——美之飨宴

Publication / 出版
Annual "Feelings Expression" photography works collection series: — '99~ — 《寄情》摄影作品集系列
(01) Loving of the water stone (02) Having a bright future (03) King's ship Sacrificial offering (04) Yami Canoe Festival
(05) Collecting folk songs of Wu island (06) Elegant demeanor of Matzu (07) Beauty Lan yu (08) Chrysanthemum island Reflection
(09) Yan Shui Fireworks Festival (10) The Spirit Messenger (11) Sacrifice of Cold Shan Yah (12) Waving World Expo
(13) Varied Flora Expo (14) Bless of the Dragon Lantern (15) A Journey to the Roots

（01）水石之恋（02）鹏程万里（03）王醮大典（04）雅美船祭
（05）浯岛采风（06）马祖风采（07）兰屿之美（08）菊岛映像
（09）盐水蜂炮（10）将使神差（11）寒单海祭（12）舞动世博
（13）璀璨花博（14）龙灯赐福（15）祖地寄情

Works / 著作
Yami Canoe Festival, Scenes of Taiwan Folklore	'02	《台湾民俗采风——雅美船祭摄影作品集》
Footprints on the Ancestral Land , Documentary photography collection of Fujian	'13	《祖地寄情——蔡登辉福建纪实摄影集》

图书在版编目（CIP）数据

祖地寄情：蔡登辉福建纪实摄影集 / 蔡登辉著 . --
福州：海风出版社，2013.12
ISBN978-7-5512-0132-2

Ⅰ . ①祖… Ⅱ . ①蔡… Ⅲ . ①风光摄影—中国—现代
—摄影集②福建省—摄影集 Ⅳ . ① J424

中国版本图书馆 CIP 数据核字（2013）第 305370 号

Footprints on the Ancestral Land

祖地寄情——蔡登辉福建纪实摄影集

蔡登辉　著

责任编辑：张　力

文字编辑：胡立昀

书籍设计：蔡铠骏（台湾）

英文翻译：牟　珊　耿桂珍

出版发行：海风出版社

（福州市鼓东路 187 号　邮编：350001）

印　　刷：福建彩色印刷有限公司

开　　本：889×1194　1/12

印　　张：16.5 印张

字　　数：260 千字　　　图：350 幅

印　　数：1-1000 册

版　　次：2014 年 1 月第 1 版

印　　次：2014 年 1 月第 1 次印刷

书　　号：ISBN978-7-5512-0132-2

定　　价：198.00 元